Neoclassicism
& Romanticism

Neoclassicism & Romanticism

Neoclassicism & Romanticism 1770–1840

Silvestra Bietoletti

Neoclassicism & Romanticism 1770–1840

STERLING

New York / London
www.sterlingpublishing.com

Library of Congress Cataloging-in-Publication Data

Bietoletti, Silvestra.
 [Neoclassicismo e Romanticismo. English]
 Neoclassicism and romanticism / Silvestra Bietoletti ; [English translation by Angela Arnone].
 p. cm.
 Originally published.: Neoclassicismo e Romanticismo. Florence : Giunti Editore, c2005.
 Includes bibliographical references and index.
 ISBN 978-1-4027-5923-9
 1. Neoclassicism (Art) 2. Romanticism in art. I. Title.
 N6425.N4B5413 2009
 709.03'41--dc22

 2008047457

10 9 8 7 6 5 4 3 2 1

This book originally published under the title *Neoclassicismo e Romanticismo,* written by
Silvestra Bietoletti.

English translation by Angela Arnone

Managing Editor and Art Consultant: Gloria Fossi

Iconographical research: Cristina Reggioli

Series graphic design and Italian layout: Lorenzo Pacini

Italian Indexes: Maria Lucrezia Galleschi

Copyright © 2005 Giunti Editore S.p.A., Florence-Milano

www.giunti.it

Translation copyright © 2009 Sterling Publishing Co., Inc.

Published by Sterling Publishing Co., Inc.

387 Park Avenue South, New York, NY 10016

Distributed in Canada by Sterling Publishing

c/o Canadian Manda Group, 165 Dufferin Street

Toronto, Ontario, Canada M6K 3H6

Distributed in the United Kingdom by GMC Distribution Services

Castle Place, 166 High Street, Lewes, East Sussex, England BN7 1XU

Distributed in Australia by Capricorn Link (Australia) Pty. Ltd.

P.O. Box 704, Windsor, NSW 2756, Australia

Printed in China

All rights reserved

Sterling ISBN 978-1-4027-5923-9

For information about custom editions, special sales, premium and corporate purchases, please
contact Sterling Special Sales Department at 800-805-5489 or specialsales@sterlingpublishing.com.

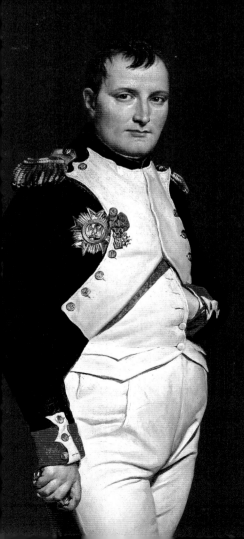

Neoclassicism

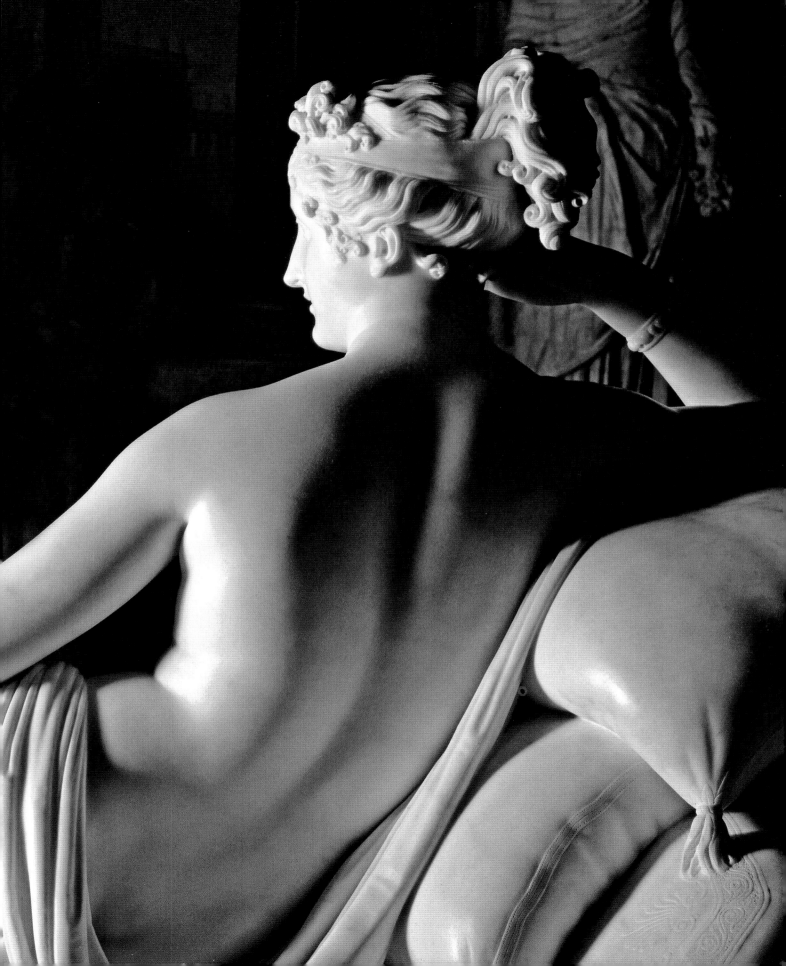

Neoclassicism and the Enlightenment

Neoclassical art was the aesthetic expression of the eighteenth-century philosophical movement founded on the principle of freedom of thought, known as the "Enlightenment." Growing awareness of rationality gradually detached politics, morality, and knowledge from absolutism and religion: the society appearing on the horizon was regenerating itself by making use of every individual's intellectual faculties. The culture of an age that placed such trust in individuality could only be free, unprejudiced, and subjective.

Winckelmann, Rome, and a New Notion of Antiquity

"Cardinal [Albani] is building a villa, an artistic miracle . . . I saw the foundations being laid. We go there in the evenings to stroll . . . it is the most stupendous work ever conceived in our days . . .

what other sovereigns have created is child's play by comparison," wrote Johann Joachim Winckelmann to a distant friend, after arriving in Rome in 1755 as a Dresden Court *pensioner* (resident student). Two years later, the German scholar was appointed librarian to Cardinal Alessandro Albani, one of the period's most cultured and refined collectors. This was the time when the villa outside Porta Salaria began to take shape, under the direction of architect Carlo Marchionni, and was the result of the Cardinal's passion for antiques, as well as his talent for blending architecture, painted decoration, and historical items (including the Antinous relief from Villa Adriana at Tivoli) in harmonious unity. One example of his very personal way of conceiving the ancient "with creativity, with courage, with a strong determination to make something vibrant and original, incorporating it confidently into the mood of continual and contemporary decoration, without compunction" (Ottani Cavina 1982, 626) is a stela mantelpiece arrangement set in an elegant Louis XV frame. With similar sentiments, the German painter Anton Raphael

Previous page:
Antonio Canova
Pauline Bonaparte, detail
1804–8, marble.
Rome, Borghese Gallery.

Philipp Otto Runge
Color Spheres
1809, copper engraving
with watercolor.
Hamburg, Kunsthalle.

Carlo Marchionni
*Design for a fireplace in
Villa Albani, decorated
with a bas-relief of
Antinous on a stele*
c. 1757, ink on paper.
New York, Cooper-
Hewitt Museum.

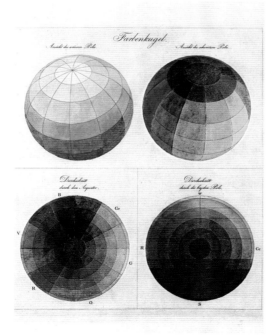

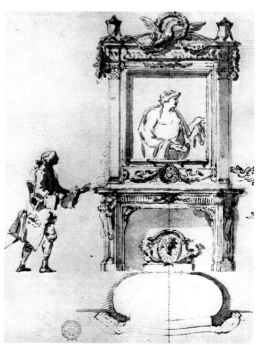

Mengs painted the *Parnassus* (1760–61) on the Villa Albani gallery vault, where the beauty of Greek statuary interacts with the superb quality of Raphael's art and the "simplicity" of seventeenth-century classicism—an excellent example of a new interpretation of classical antiquity. The fresco expressed in visual terms Winckelmann's aesthetic conviction of the cyclic evolution of art following a process of growth and decline, repeated in the Renaissance as it had been in antiquity. The German archaeologist was then involved in writing *Geschichte der Kunst des Alterthums* (*The History of Ancient Art among the Greeks*), using an innovative research method—style analysis—that laid the foundations of modern art history. Winckelmann combined historiography, dictated by the Enlightenment's rational thinking, with an emotional and subjective interpretation of the works. He proposed the elaboration of an aesthetic model through the study of ancient, above all Greek, art, which he considered the epitome of universal beauty, thus "imitating the ancients," to use his own expression, and thereby "becoming great, even inimitable [artists]."

In the mid-eighteenth century, Winckelmann defined the cultural concept of neoclassicism with absolute clarity, expressed from an aesthetic viewpoint as the communion of "noble simplicity and quiet grandeur," essential and inseparable elements for rendering "beauty." The simplicity and quiet grandeur were obtained thanks to an intellectual process that turned the fire of invention into the solemn nobility of form, as seen in the *Dancers* frescoed in the so-called Villa di Cicerone, in Pompeii (recovered in 1749), and judged by Winckelmann to be beautiful because they were as "fluid as thought and as lovely as if they had been crafted by hand of the Graces." These images subsequently also inspired artists like Antonio Canova, who produced numerous tempera sketches at the end of the century, and later created—among other works—the famous *Dancer with Cymbals* sculpture (1815).

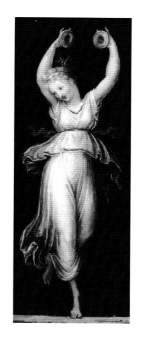

Antonio Canova
Dancer with Cymbals
c. 1798–99, tempera on paper.
Possagno, Plaster Cast Gallery.

Johann Joachim Winckelmann
History of the Argonauts: Pollux's Victory over Amycus, and Minerva, from *Geschichte der Kunst des Alterthums (The History of Ancient Art among the Greeks)* 1779, engraving. Milan, Imperial Monastery of Saint Ambrogio.

Jacob Philipp Hackert
Ruins of the Antique Theatre of Pompeii
1793, oil on canvas.
Weimar, Goethe-National Museum.

The Excavations of Herculaneum and Pompeii

The excavations of Herculaneum and Pompeii, resumed in 1738 after initial isolated discoveries in 1711, involved and excited an increasing number of artists, antiquarians, and men of learning, and became an endless source of satisfaction even for refined, slightly blasé intellectuals like Sir Horace Walpole. Bored by the predictability of the "grand tour"—a journey through Italy that was an inexorable episode in an aristocratic education—the English writer was unreservedly captivated by the sight of Herculaneum, "a whole Roman town, with all its edifices, remaining under ground." The discovery of this sunken realm, which finally allowed the ancient world to be studied "live" rather than just through literature, was a watershed in European culture. From then on, antiquity became a basic element of every educational process as knowledge of it gradually increased.

Like Winckelmann, the Scottish architect Robert Adam believed the past to be a source of knowledge and aesthetic taste, and Rome's past epitomized this conviction. Adam's buildings, with ornamental motifs

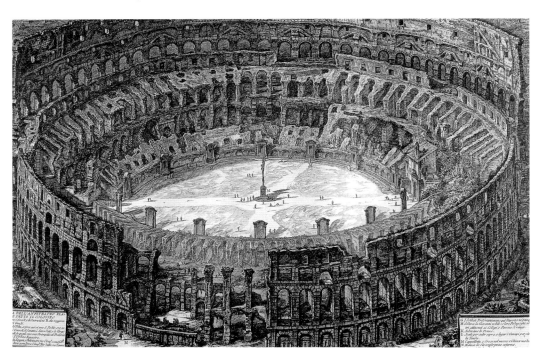

based on drawings he brought back from Italy, Split, and Palmyra, contributed decisively to the diffusion of an austere, elegant style in England. The style's refined architectural elements—nymphaea, niches, pilaster strips, coffered ceilings—were emphasized by bright stucco and refined pink, green, and gold backgrounds, evoking the beauty of Roman homes and bringing them to life in the mind's eye.

In 1755, Adam met Giovanni Battista Piranesi, another passionate advocate of the architectural grandeur of ancient Rome. In 1748, Piranesi began etching Roman monuments, with an imagination so "extraordinary" and "ingenious" that the corpus became an extremely varied and stimulating source of

Giovanni Battista Piranesi
The Coliseum
1746–50, etching.
Rome, Casanatense Library.

Facing page:
Robert Adam
Doric Order Atrium at Syon House
1762.
West London.

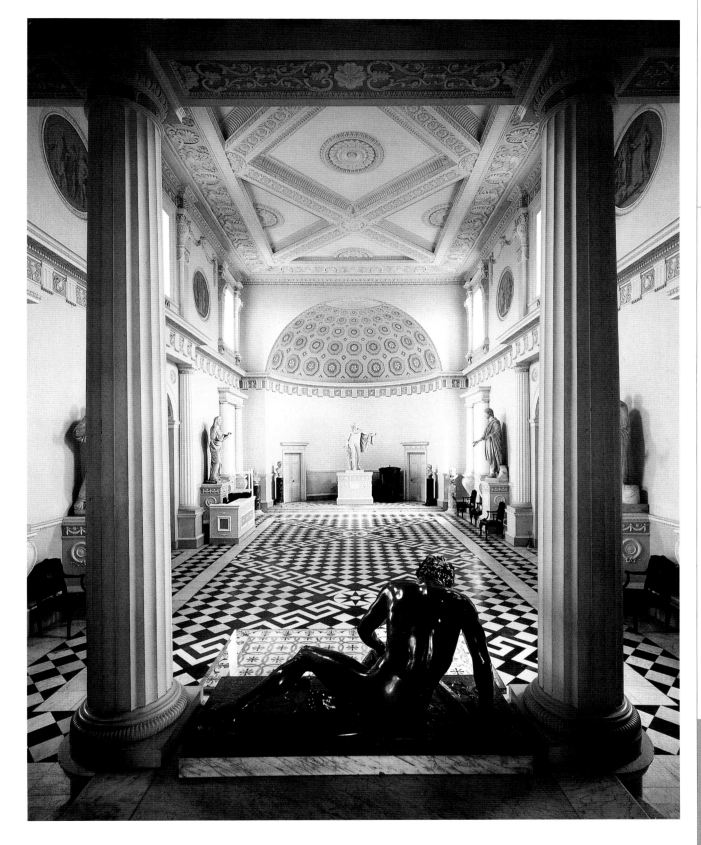

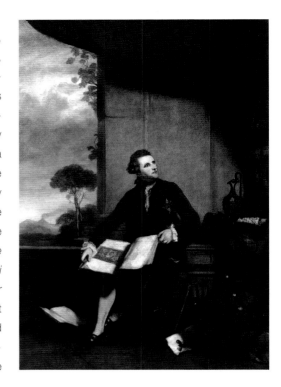

Giovanni Battista Piranesi
The Staircase with Trophies (Prison VII), from *Prisons*
1749–50, first edition etching.

Joshua Reynolds
Portrait of Sir William Hamilton
c. 1780, oil on canvas. London, National Portrait Gallery.

inspiration for architects (Honour 1980, 35). Indeed, these views of Rome (later collated in four volumes), despite being straightforward documentary descriptions, echo with dramatic tones that express Piranesi's relationship with antiquity, considered an age of incomparable grandeur that modern humanity could only view in total awe. Piranesi was a visionary and a creative figure who enhanced the impression of space and exaggerated perspective. This is particularly evident in the engravings known as the *Prisons* (the original title was *Carceri d'Invenzione* and the definitive edition is dated 1761), but also in *Diverse maniere d'adornare i camini ed ogni altra parte degli edifici (Different ways of adorning fireplaces and every other part of buildings)* (1769), a repertoire of furnishings that once again reconfigured Greek, Roman, Etruscan, and Egyptian motifs in highly personal, ingenious interpretations of the ancient world, achieving considerable success in neoclassical Europe.

The International World of Collectors, Artists, Architects, and Scholars

A short time before Piranesi published his work on fireplaces, Pierre-François Hugues d'Hancarville edited four folio volumes, which he published in Naples (1766–67) and which illustrated the collection of ancient vases of Sir William Hamilton, the English court's special ambassador to the court kingdom of Naples. Hamilton, an exemplary "enlightened" figure who loved both ancient art and science (he was a renowned volcanologist), was so aware of the importance of the publication of his

Pierre-François Hugues, known as **Baron d'Hancarville**
from *Antiquités Etrusques, Grecques et Romaines, tirées du cabinet de M. William Hamilton . . .* (Collection of Etruscan, Greek, and Roman Antiquities, from the Study of M. William Hamilton . . .)
Naples, by F. Morelli. 1767–76, engraving with watercolor.

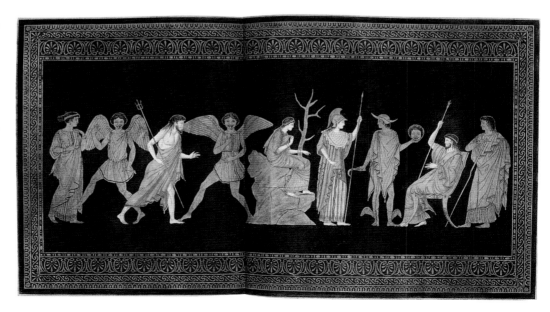

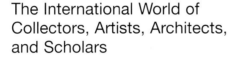

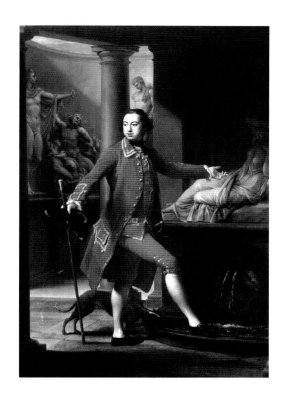

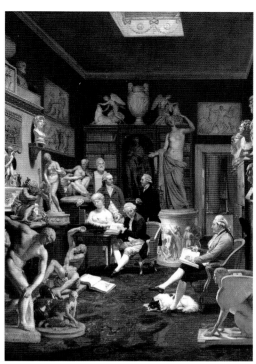

collection that he had Joshua Reynolds paint him in the act of leafing through one of the volumes, surrounded by some of his archaeological findings, against an open window with a view of smoking Vesuvius.

The portrait's suggestion of the intrinsic bond between the subject and the works around him served to instill new meanings in the image of the "grand tourist" as defined by Pompeo Batoni and John Singleton Copley, and it actually became a new model for portraying the antiques collector in his *cabinet d'amateur*. Perhaps the most evocative paintings in this manner are Johann Zoffany's *The Tribuna of the Uffizi* (1772–78), in which painters and collectors are gathered to admire Raphael's *Madonna* (now known as the *Cowper Madonna*) and his painting of the library of Charles Towneley, an English gentleman with a passion for antiquity (1781–83).

Baron d'Hancarville's plates isolated scenes from vase decorations (engraved and hand-colored from drawings by Giuseppe Bracci), thus removing the narrative sequence, and enhanced two-dimensionality, removing shadows and chiaroscuros. The images

therefore acquired an abstracting quality that was reinforced by the shattering effect of the contours. The surprisingly innovative style of a linear stroke was a return to the essence of form, and these illustrations did not evoke an imitation but rather an analogical, fervidly imaginative reference to the ancient model, in keeping with Winckelmann's concept of emulation.

It was no coincidence that Josiah Wedgwood, the English potter, was one of the first to buy the plates, which were also sold singly. Wedgwood was

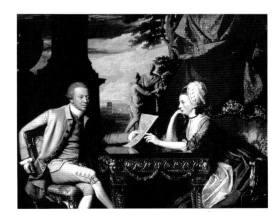

*Weaver at a low-warp
loom working by
candlelight, Tapisserie de
basse lisse des Gobelins*
(*Basse-Lisse Tapestry*
from the *Gobelins*), from
Encyclopédie by Diderot
and d'Alembert, ed.
Livorno 1770–79, IX,
1776, plate I.

*Low-warp workshop,
Tapisserie de basse lisse
des Gobelins* (*Basse-Lisse
Tapestry* from the
Gobelins), from
Encyclopédie by Diderot
and d'Alembert, Livorno
1770–79, IX, 1776,
plate XVIII.

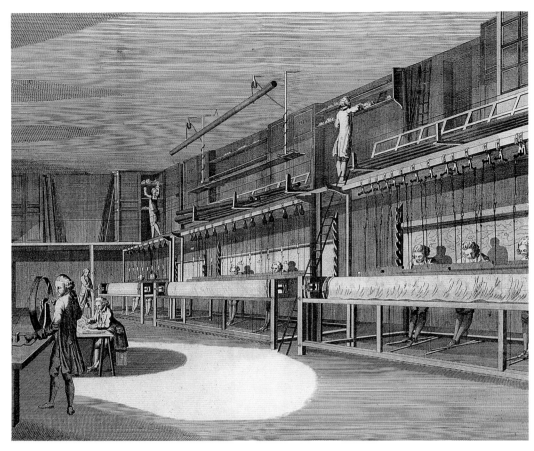

Giacomo Quarenghi
Design for a Library
c. 1780, engraving.
Bergamo, Angelo Mai
Civic Library.

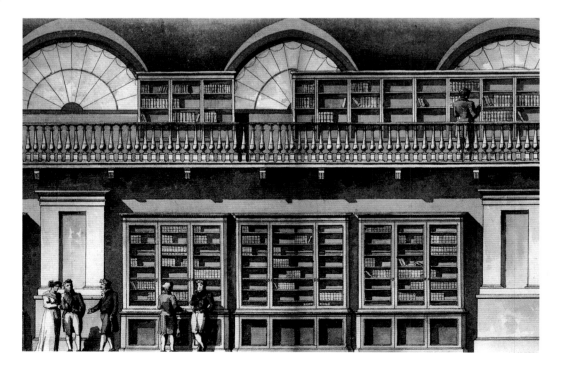

the founder of the Etruria Works, which produced many objects based on the Hamilton vase collection model, and he recruited John Flaxman, perhaps the staunchest supporter of the formal and evocative values of the linear design, to work for him.

The simple, abstract severity of line engravings had obvious correspondence in the coeval figurative and literary translations of Homer, and in Shakespeare's texts. Flaxman's illustrations for the *Iliad* and the *Odyssey* closely matched translations of these texts by William Cowper, Heinrich Voss, and the Italian Melchiorre Cesarotti. The last of these also translated, from English, the poems attributed to Ossian, the mythical Gaelic bard created in the imagination of James Macpherson. Ossian's epic poetry, published in 1762–63, was an immediate success all over Europe, becoming a cherished topic in the imagination of the literati and painters. The poetry had such an impact that in 1774 Goethe's Werther stated: "Ossian has displaced Homer in my heart."

The aesthetic concept that saw the perfection of formal beauty in the graphic continuity of the stroke was also apparent in architecture, reinforcing the standard values of purity, simplicity, and clean volume, in marked contrast with complex baroque and rococo volutes. If neoclassicism, a result of the Enlightenment, considered culture to be an active tool for society's intellectual, moral, and economic growth, then architecture had to be the highest expression of art. Thus it was architecture that established order, measure, and function, combining convenience with beauty, embracing a mind-set that was inescapable at that time.

Denis Diderot, who in 1751 was editor (with Jean-Baptiste d'Alembert) of the *Encyclopédie,* for which he wrote the "Arts" and "Trades" entries, actually declared in his *Traité du beau (Treatise on Beauty)* (1750) that sculpture and painting descended from architecture, whose beauty was based on the harmonious relationship of five distinct qualities: variety, unity, regularity, order, and propor-

Étienne-Louis Boullée
Plan for a Metropolitan Basilica, detail
c. 1780–82, engraving.

tion. These classicist values, therefore, openly express the late eighteenth century's admiration of Palladio's work, taken as a reference model for much neoclassical architecture, from George III's Great Britain to Catherine II's Russia and the America of Thomas Jefferson (future president of the United States and architect of the Virginia State Capitol building in Richmond, modeled on Nîmes's Maison Carrée). An important role was also played by Bergamo architect Giacomo Quarenghi, who studied under Mengs in Rome and was active at the Russian court from 1780. Quarenghi's idiom of composed and harmonious form, with an eye to technical innovations, had international impact (Gabetti 1982, 670).

Order, symmetry, and function are the foundation of designs by Ledoux and Boullée, perhaps the two most famous French architects of the late eighteenth century, not so much for the quality of the buildings they erected (some of which had considerable formal and social value, like Ledoux's Royal Saltworks at Arc-et-Senans, 1775–79, and the Paris Wall of the Farmers-General, 1784–89) as for their designs of public works and monuments. Antiquity was evoked

Claude-Nicolas Ledoux
Entrance to the Royal Saltworks
1775–79.
Arc-et-Senans
(Franche-Comté).

in such a grand style that it was almost disquieting in its symbolic ostentation, dictated moreover by an exaggerated interpretation of the functional concept assigned to the geometric perfection of the sphere. In line with this architectural model, Ledoux even simplified the Doric order, with the Tuscan order the most austere of those distinguishing the buildings of antiquity, and the most prized in the neoclassical age precisely for its linear sobriety.

Rome: A Melting Pot of New Ideas

The distinct philosophical differences between how Winckelmann and Piranesi considered the ancient world established, to some extent, two reference models for artists: on one hand "the past as a reassuring and positive myth"; on the other, the crippling presence of the ruins as "admonishment and reproach" (Ottani Cavina 1982, 613). Rome was the preferred arena, where many disparate ways of

looking at the ancient world coexisted, and at times competed, in a lively and profitable confrontation of artistic ideas. The cosmopolitan culture reached its height in the city from the turn of the 1700s, and for most of the century ensured that Rome emerged as the arena of primary figurative study, in a dynamic cultural exchange.

The artistic policy of the popes brought about a new interest in archaeology, with ensuing excavation and restoration of artifacts, activities of the Accademia di San Luca, and the creation of the Vatican Museums. The internationally renowned collectors, artists, and literati who chose Rome as their home and the importance of the city's numerous foreign art academies contributed significantly to the liveliness of artistic debate and rapid changes in taste. The studios of painters like Pompeo Batoni, Raphael Mengs, and Gavin Hamilton and sculptors like Antonio Canova (who arrived in 1779 and immediately found fame) were real "melting pots" of neoclassical thought, while the *pensionnaires* of the prestigious European art academies, actually

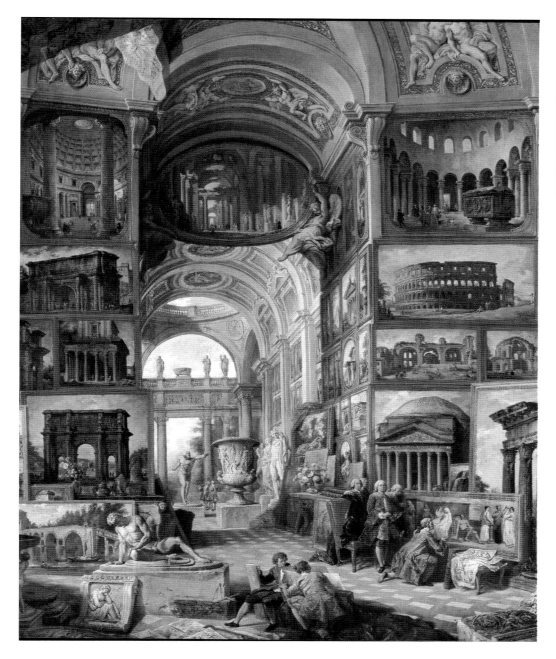

George Romney
Portrait of William Beckford
c. 1782, oil on canvas. Warwickshire, Upton House.

Giovanni Paolo Pannini
Gallery with a View of Ancient Rome, detail
c. 1755, oil on canvas. Stuttgart, State Gallery.

conceived by progressive governments as schools, played a leading role in the modernization of art. The different attitude toward the ancient world triggered theoretical controversy, which brought about contrasting positions—mentioned only briefly here—between the English-Nordic and the French environments. The calm, stately quality of the historical paintings of the French Academy *pensionnaires*, whose ideal reference was Nicolas Poussin's classicism, diverged from the emotional, subjective tone pervading the works of James Barry, Johann Heinrich Füssli, George Romney, and Nicolai Abraham Abildgaard. However, Poussin's authority as a model for classical antiquity was so strongly felt in Rome that in 1782 his bust was placed in the Pantheon, along with those of Winckelmann and Mengs.

Jacques Sablet
Visitors in the Sala degli Animali
c. 1786–92, oil on canvas.
Pius Clementine
Museum, Vatican
Museums.

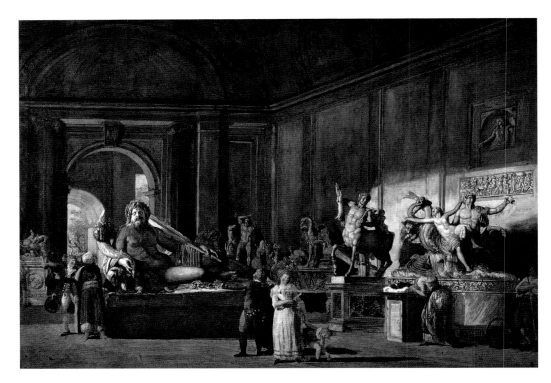

Hubert Robert
Plan for the Grande Galerie of the Louvre
1790, oil on canvas.
Paris, Louvre.

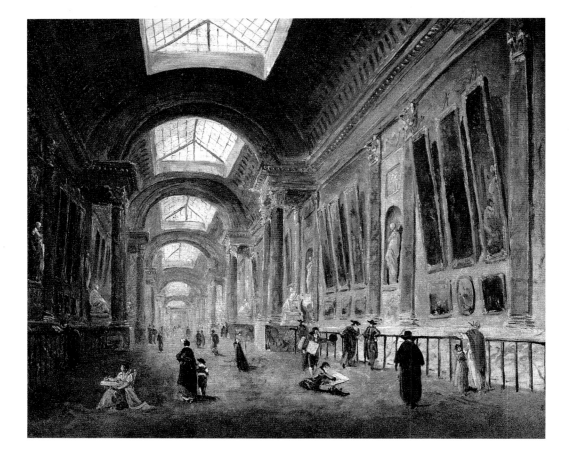

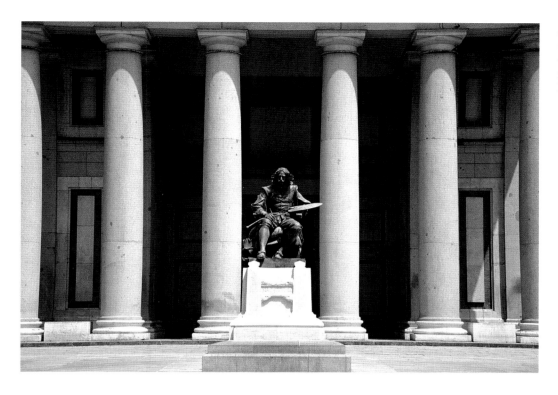

Jacques-Louis David also looked to Poussin when he painted the *Oath of the Horatii:* the artist had studied in Rome in previous years and returned to complete this royal commission, almost as if he felt the need to participate more intensely in the climate that had inspired his subject. In August 1785, when the painting was finished, it was shown in the painter's studio, and aroused surprise and admiration for its masterful composition and noble formal quality, with an evocative strength sharing the dramatic essentiality of Italian playwright Vittorio Alfieri's tragedies. Two years later, Canova's monument to Clement XIV (erected in the church of Santi Apostoli) generated similar interest. In Canova's sculpture, however, the schematized arrangement of the David painting was replaced by graceful invention, expressed with such ease that, as Francesco Milizia wrote, it all seemed very simple. Milizia was an enthusiastic supporter of the neoclassical style and viewed the work, in which "sculpture and architecture, both in the whole and in the parts [were] in the ancient style," as a model for the revival of the arts.

One of the most significant consequences of modern ideas of science on Enlightenment culture, apart from the establishment of museums to divulge scientific discoveries (the Prado was the first of these, designed for that scope by Juan de Villanueva in 1785), was the clear distinction between the scientific and aesthetic interpretation of nature. As methodologies and rules implied an objective knowledge of the world, aesthetics were offered as a means of protecting the animated, sensitive, and mysterious aspects of nature. Thus if nature was increasingly accepted as an entity regulated by mathematical

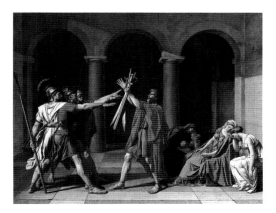

Jacques-Louis David
Oath of the Horatii
1784, oil on canvas.
Paris, Louvre.

principles on one hand, on an aesthetic level there were an increasing number of ways, dictated by sentiment and imagination, to understand and depict nature. In art, as in literature, many different interpretations coexisted, from the order and equilibrium of a skillfully controlled and governed nature to the suggestive charm of the "picturesque," where rational thought gave way to sentiment and eventually to the awe-inspiring "sublime," which generated in humanity the thrill of contrasting emotions dictated by helplessness before the unknowable. If so many ways of understanding nature affected mainly mythological and historical subjects (certainly the most suited to the contemporary zeitgeist for

Jean-Honoré Fragonard
The Grand Cascade at Tivoli
c. 1760, oil on canvas.
Paris, Louvre.

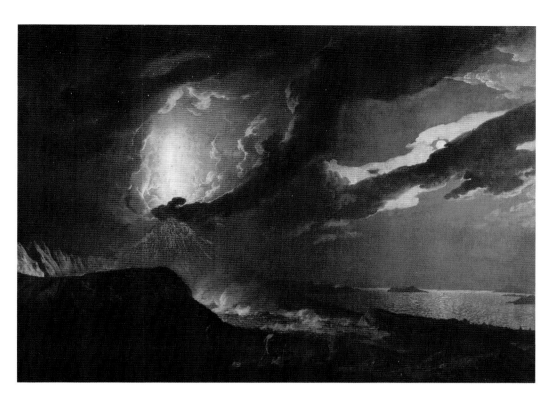

Joseph Wright of Derby
The Eruption of Mount Vesuvius
c. 1776–80.
London, Tate Britain.

suggesting the variegated complexities of the world and its spirit), landscape painting also obviously reflected considerable disparity. In the French circle, for example, the enchanting grace of landscapes by Jean-Honoré Fragonard and Hubert Robert (which reflect Piranesi's poetics in cadences suffused with comprehension of human transience) followed the Claude Lorrain–style classicist expressions of Nicolas Didier-Boguet or Henri de Valenciennes. In England, however, Joseph Wright of Derby dedicated himself to surprising countryside and candlelit scenes; his studies of light depiction were an expedient for creating intensely evocative, moving canvases, especially when the subjects were of natural phenomena or references to industrial or scientific progress, from which Wright seized the "sublime." From the 1780s, the work of Claude Lorrain was the subject of veneration and inspiration for many British landscapists; in addition to the beauty of the seventeenth-century artist's finished works, they also admired his

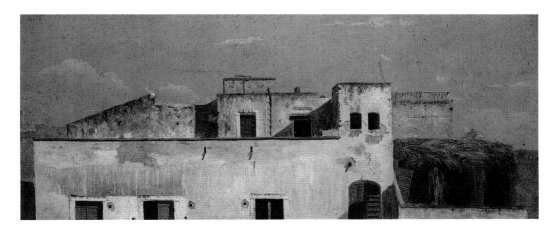

Thomas Jones
Roofs in Naples
1782, oil on paper.
Oxford, Ashmolean Museum.

Giovanni Battista D'Ellera
Angelica Kauffmann's "Sitting Room" in the Garden of Her House at Trinità dei Monti
c. 1786.
Rome, private collection (Rossi Pinelli 2000, xv).

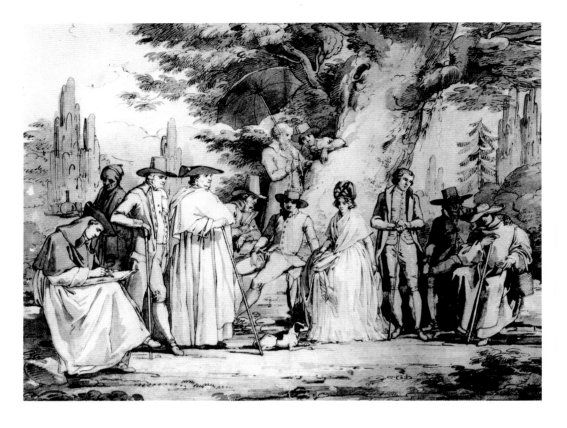

sketches, where an exquisite sensitivity for light effects blended with the work's immediacy and simplicity. These were precisely the aspects that caused a renewal in painting, and not just of landscapes; following in Lorrain's footsteps, Henri de Valenciennes and Thomas Jones, with many others in their wake, began to paint oils incorporating unusual stretches of landscape or views, perhaps focusing on the view of a roof or a white wall drenched in sunlight, against the sky. The graphic purity and clarity of the light are typical of Jacob Philipp Hackert, a German artist and leading neoclassical landscapist, who lived in Italy from the 1760s, working assiduously for the Bourbon court in Naples. It was thanks to Hackert that Wilhelm Tischbein—a friend of Goethe's who had painted the poet in an opus rightly defined as momentous in consecrating the poet and the city of Rome—was appointed director of the Naples Academy of Fine Arts in 1789, thereby adding significant impulse to the revitalization of the city's style. Another important artist of German origin, Angelica Kauffmann, chose Italy as her home. She arrived in Rome in 1781 and joined a circle of foreign and Italian intellectuals and artists dedicated to classicist subjects, imbued with jovial sentimentality, and aligned with the preferences of Frenchman Joseph-Marie Vien, whose mythical compositions did not necessarily imply severe philosophical or ethical concepts, unlike his pupil Jacques-Louis David.

Wilhelm Tischbein
Goethe in the Roman Campagna
1787, oil on canvas.
Frankfurt, Städel.

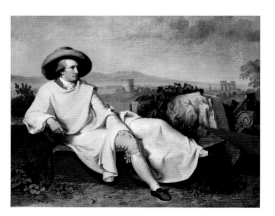

Jacques-Louis David
*The Death of Joseph
Bara*
1794, oil on canvas.
Avignon, Calvet
Museum.

David and History on Canvas

David took antiquity as a strict model, renewing its concepts and style. This conviction continued to intensify after his return to France, when his Republican ideals spurred him to join the revolutionary movement. At that time, David produced works that are memorable for their austere composition and stately, dramatic quality of content, like *The Death of Marat* (1793) and *The Death of Joseph Bara* (1794). The contemporary history theme, expressed with the lofty formal language usually applied to scenes from ancient history or literature, acquired the same implications of great spirit, heroism, moral strength, and passion. Thus the Enlightenment's cultural intentions were fully realized, since reappraisal of the ancient world as a model of exemplary values fortified contemporary society, and the figures of the time were then depicted as examples of moral or civic virtue. So it was no coincidence that it was a group of David's young pupils, the *Primitifs,* fired by ideals that were as aesthetic as they were ethical, developed a deliberately archaizing style—between 1796 and 1801—precisely for the moral values

intrinsic to form lacking naturalism (Rossi Pinelli 2000, 336). Further corroboration of how modern heroes would emulate ancient heroes in the attitude of Revolutionary France came a few years later, when David painted Napoleon Bonaparte. The portrait of the young French army general, astride his rearing horse at the Great Saint Bernard Pass, declared that the Alpine pass was no longer just the glory of Hannibal or Charlemagne. Canova also depicted First Consul Napoleon soon after, heightening his resolute features to suggest boldness, strong will, and intelligence. Nonetheless, the portrait of the future French emperor is permeated with deep pathos and human sentiment: it does not bear the classicist rigor of David and his pupils, which intensified with the arrival of the Directoire style, when a preference for the ancient became dominant and influenced every aspect of everyday life, from ornaments to furniture, and clothing *à la grecque*. Canova's greatness, his ability—or rather his talent—for conveying grace, action in repose, or worldliness in marble sculpture, enabled him to evoke sensations whose intensity shifted in response to a host of chance factors, making him Europe's most

Jean-Auguste-Dominique Ingres
The Dream of Ossian
1813, oil on canvas.
Montauban, Ingres
Museum.

acclaimed artist in the late 1700s–early 1800s. The sculptor was popular with English patrons, who were educated to skepticism of the senses and understood aspirations to create art that was fantasy and not a deviation of truth. Canova had quickly become the sculptor most sought after by European rulers, from the Hapsburgs to the Bourbons and Napoleon's family, for whom he created some of his most famous works, still admired today, such as his *Pauline Bonaparte* (1804–8).

The Empire Style

Napoleon's Empire facilitated the birth of a style that rapidly spread across the whole of Europe: the "Empire style," which replaced the French Directoire's sober elegance and studied simplicity.

The precepts of the Empire style were defined by Charles Percier and Pierre-François-Léonard Fontaine, who were Napoleon's favorite architects and interior designers. They are also authors of, among other volumes, a *Recueil de décorations intérieures*, published in Paris in 1801 and adopted as a manual by interior designers and cabinet-makers. In addition to the antique models, Percini and Fontaine referred to the French Gothic tradition, promoting an interest in a less distant past—an

Charles Percier and Pierre-François-Léonard Fontaine *Palais, maisons et autres edifices modernes dessinés à Rome* (*Palaces, Houses, and Other Modern Buildings Designed in Rome*), detail of a plate from the volume dedicated to Josephine Bonaparte Beauharnais in 1798.

Christoffer Wilhelm
Eckersberg
*Portrait of Bertel
Thorvaldsen as a
Professor at San Luca,
with the Frieze "The
Entrance of Alexander
into Babylonia" in the
Background*
1814, oil on canvas.
Copenhagen,
Copenhagen Art
Academy.

interest that soon spread throughout Europe, and was certainly more closely connected with each country's own history than with classical antiquity's universal impact. Percier and Fontaine were also the architects of the Arc de Triomphe du Carrousel (1806–7), one of the Parisian monuments aspiring to the greatness of imperial Rome and celebrating the glory of Napoleon Bonaparte. Another famous monument was the Place Vendôme Column (Jacques Gondoin and Jean-Baptiste Lepère, 1806–10), imitating Trajan's Column; the obelisk supported a statue of the emperor and was installed in Place Vendôme. If Paris enjoyed a revival of its image thanks to Napoleon, France's satellite states were no different, as the emperor's brothers pursued his policies even in the arts. Arenas, triumphal arches, and barracks were built in Milan, Naples, and Würzburg, while excavation and demolition were undertaken, with the aim of enhancing the urban fabric, so cities were embellished with squares, avenues, and parade grounds. Above all, however, it was the modernization of government buildings to the Empire style that imposed the new aesthetics, initiating a production trend that began with royal palaces and reached such a wide range of patrons

that these models—purified of allegorical and celebratory meanings—endured long after the fall of the Empire and molded Restoration culture. The most significant site in Rome, elected the Empire's second capital in 1809, was for the development of the new Quirinal quarters, the papal palace of Monte Cavallo chosen by Napoleon as his residence. The work was entrusted to the architect Raffaele Stern, with the supervision of Canova and the painters Vincenzo Camuccini and Gaspare Landi, two of Italy's best purveyors of the neoclassical trend. The theme of decoration, which involved some of the most fashionable artists in Rome at that time, from Bertel Thorvaldsen to Felice Giani and Jean-Auguste-Dominique Ingres, was the rule of enlightened sovereigns from antiquity to the Renaissance. The subject was Ossianic only in Napoleon's chamber—entrusted to David's pupil Ingres, a French Academy *pensionnaire* at the time—as a tribute to the emperor's love for that literary genre. In the Napoleonic years, the events and activities on the Roman art scene intensified further. Public and private art academies, studios of sculptors and painters of international acclaim, "brotherhoods" of young foreign artists, alongside prestigious patrons and urban restoration sites whose scope was to celebrate the beauty of Rome, were all stirred by the lingering charm of a glorious past. Thus the city's artistic life was one of the most vibrant in Europe, confirming its inevitable role of cultural supremacy. Naturally, such a dynamic, opulent situation fostered a reopening of the aesthetic argument, contributing decisively to a renewal of art. In just a few years, figurative taste detached from the canons of neoclassical culture to approach Nazarene primitivism and the stylistic purism of Ingres and Thorvaldsen, the two most innovative artists of those involved in the Quirinal refurbishment. Thorvaldsen sculpted the bas-relief depicting the *Arrival of Alexander in Babylon* (1812), and Ingres painted *The Dream of Ossian* (1813). Both artists soon became vanguards in a new figurative concept that leaned

towards relative beauty, leaving behind the idealistic forms of neoclassicism, and awe-inspiring "sublime," preferring a more subdued style of communication, inspired by the imitation of nature, of which modern art declared itself a disciple.

Goya and *The Disasters of War*

In Madrid, meanwhile, Francisco Goya (who had obtained his first important commissions in the 1770s, thanks to Anton Raphael Mengs, director of the city's Academy of Fine Arts at the time) produced *The Disasters of War* (1810), a series of dramatic prints evoking the violence and brutality of imperial military repression of the anti-French uprisings. The Spanish artist later created his masterful large-scale oil painting commemorating the insurrection, *The Third of May, 1808: The Execution of the Defenders of Madrid*. The formal precedent for the painting can be pinpointed in Rembrandt, and despite its dignity, it is light-years away from the canons of neoclassical beauty. In the yellow lamplight that pierces the darkness of the night, the victims appear hopelessly exposed to the rifle shots of the closed ranks of soldiers. The figures, humiliated by death, are not redeemed by history, and the scene's evident frustration with humanity seems to offer an emblematic closure of an era that had opened on a surge of hope that rational thought would triumph over superstition, ignorance, and the arrogance of absolutisms.

Francisco Goya y Lucientes
The Third of May 1808
1814, oil on canvas.
Madrid, Prado Museum.

Page 28:
Angelica Kauffmann
Self-portrait, detail
1787, oil on canvas.
Florence, Uffizi Gallery.

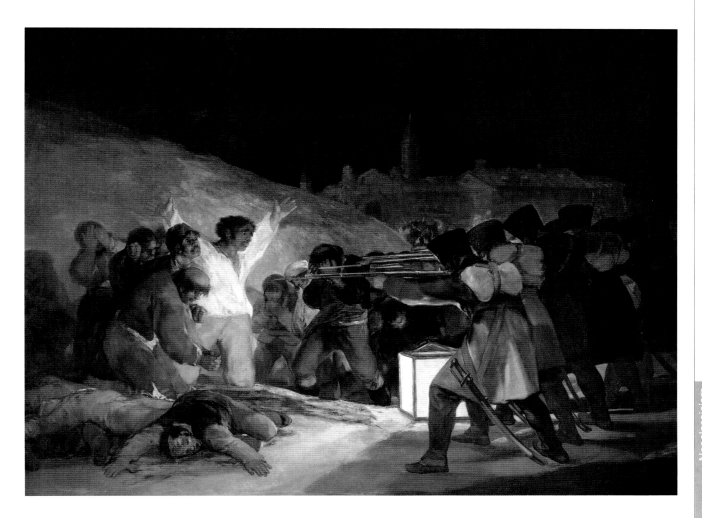

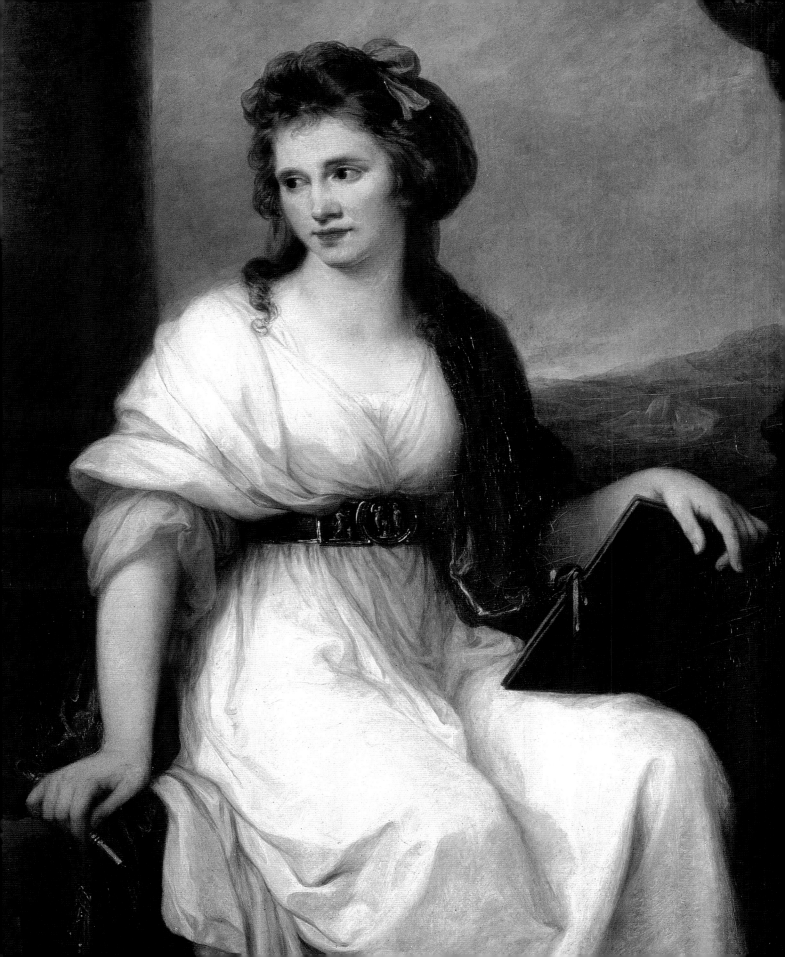

Leading Figures

Artists and Works of the Neoclassical Period

Artists and Works of the Neoclassical Period

Giovanni Battista Piranesi

(b. Maiano di Mestre 1720, d. Rome 1778)

Piranesi studied in Venice and then established himself in Rome, where he started to publish engravings of his architectural fantasies. After traveling to Naples and Venice (1744–45), he worked on his *Grotesques,* inspired by remains of Roman architecture. Piranesi was convinced that Rome epitomized ancient grandeur, and he brought its magnificence to life in his *Views of Rome*, on which he had worked since 1748, influencing European, especially British, culture. His farsighted creativity and reflections on antiquity led him to design striking, dramatic architecture. The *Imaginary Prisons* date to 1760; *Diverse maniere d'adornare i camini . . .* (*Diverse Ways of Adorning Fireplaces . . .*) to 1769; *Vasi, candelabri, cippi, . . .* (*Vases, Candelabras, Memorial Stones, . . .*) to 1778. In the meantime, in 1761 he wrote *Della magnificenza ed architettura de' Romani* (*Concerning Roman Architecture and Magnificence*) and created the Piazzetta and Santa Maria del Priorato sull'Aventino church for the Knights of Malta (1764–69).

Giovanni Battista Piranesi
(engraver **Felice Polanzani**)
Self-portrait, detail
1750, copper engraving.

Giovanni Battista Piranesi
Egyptian decoration in the Caffè degli Inglesi, from *Diverse maniere d'adornare I camini ed ogni altra parte degli edifizi . . . (Diverse Ways to Decorate Fireplaces and Other Building Elements . . .)*
1769, copper engraving.
Rome.

Piranesi created this valuable collection of ornamental and decorative models for interior architecture to demonstrate "how a judicious architect can make use of ancient monuments for today's fashions." In fact, an array of decorators, set designers, and English and French architects treasured Piranesi's designs, which stimulated the imagination by interweaving Egyptian, Etruscan, Greek, and Roman influences, thus breathing new life into neoclassical decoration.

AL CHIARISSIMO SIGNORE

IL SIG. ROBERTO ADAM

GIOVAN BATTISTA PIRANESI

SOmiglianti∫∫ima, anzi gemella, io giudico, CHIARISSIMO SIGNORE, che ∫ia la condizione di chi da altri in altri pae∫i va trasferendo∫i non men per diporto, che per apprendere più agevolmente, dopo aver o∫∫ervati i co∫tumi de' popoli, il maneggio de' pubblici e privati affari; e di chi s' applica per sì fatta maniera ad inve∫tigare gli antichi monumenti, che come ∫e vive∫∫e ne' trapa∫∫ati ∫ecoli, diligentemente ricerca, qual co∫a ∫ia ∫tata fatta di que' tempi, quale ∫ia ∫tata la maniera di fabbricare, quale la pulitezza, quale l' u∫o di trattare i pubblici ed i privati intere∫∫i. E da tale ∫tudio, e, per così dire, pellegrinaggio, non v'è chi non vegga, quanto piacere ne ritraggono quelli, che lo intraprendono, quanto utile gli altri. Per la qual co∫a, ∫e cotanto da Omero vien commendato Uli∫∫e, per aver o∫∫ervati i pae∫i, che allora era-
a 2 no in

Giovanni Battista Piranesi
Various models of tables, sedan-chairs, and panels, from *Diverse maniere d'adornare i camini ed ogni altra parte degli edifizi . . . (Diverse Ways to Decorate Fireplaces and Other Building Elements . . .)* 1769, copper engraving. Rome.

This work exemplifies Piranesi's conviction that "medals, cameos, bas-relief sculptures . . . and others can make antiquity useful not only to critics and scholars in their studies but also to craftsmen in their work."

Above: **Giovanni Battista Piranesi**
Title page with dedication to Robert Adam, from *Campo Marzio dell'Antica Roma* 1762, copper engraving. Rome.

Piranesi met Robert Adam in 1755 and immediately established a bond of respect and friendship with the English architect. Adam subsequently made direct references to Piranesi's ideas, faithfully copying Piranesi's creations for his most challenging works, including Syon House.

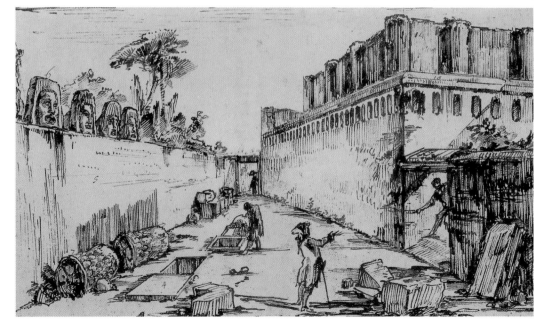

Giovanni Battista Piranesi
Street in Pompeii with the Tomb of the Istacidi
1770, pen and ink on paper.
Copenhagen, National Gallery of Art.

Piranesi traveled to Herculaneum and Pompeii in 1770. In contrast to the splendid, visionary images inspired by his first overwhelming visit to the ruins twenty years earlier, Piranesi here depicts a pleasant landscape filled with amateurs and connoisseurs among the archeological finds they prize as objects of study.

Anton Raphael Mengs
(b. Aussig, Bohemia 1728, d. Rome 1779)

Anton Raphael Mengs
Self-portrait, detail, 1773, oil on canvas. Florence, Uffizi Gallery.

Brought up in Dresden, Mengs was given an art education by his father. In 1741 he became a pupil of Marco Benefial in Rome, where he studied ancient and Renaissance art. He returned home in 1745 to become court painter to Augustus III of Saxony, but returned to Rome in 1750, where he met Johann Winckelmann and shared the latter's enthusiasm for the ancient world. It was thanks to Winckelmann that Mengs frescoed the *Parnassus* for Cardinal Albani (1761). From then on, his influence on European artists was decisive for the growth of neoclassicism, which he also fostered with his theoretical writings, including *Gedanken über die Schönheit (Thoughts on Beauty)* in 1762. He frescoed the Roman church of Sant'Eusebio (1758–59) and worked for the king of Naples, who called him to Madrid when he inherited the throne of Spain. There Mengs decorated the royal palace (1761–69) and painted splendid court portraits. He spent 1769–72 in Rome, decorating the Sala dei Papiri (Papyrus Room) in the Vatican. After a last stay in Madrid, he returned to Rome in 1777.

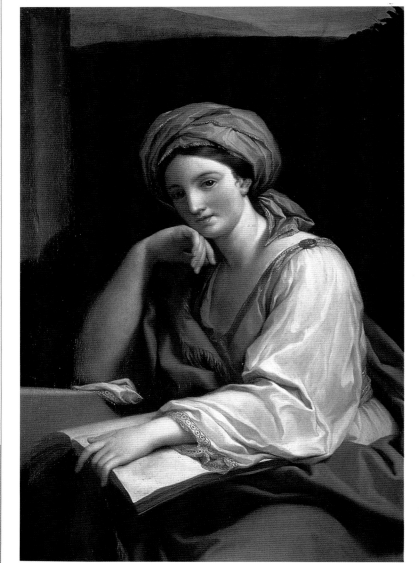

Anton Raphael Mengs
Sibyl
1761, oil on canvas.
London, private collection.

Seated at the base of a fluted column, the figure of the Sibyl in full light stands out against the dark background. The painting shows Mengs's sensitivity in combining contemporary features and sentiments with traditional classical representations emulating the Carracci school and thus Raphael and the old masters.

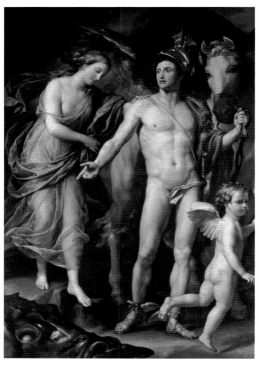

Anton Raphael Mengs
Parnassus
1761, fresco.
Rome, Villa Albani.

On Parnassus, Apollo is surrounded by the Muses, posed in various ways that clearly identify the art or science that each personifies. Created for the Villa's salon, which housed Cardinal Alessandro Albani's collection of antique statues, the fresco reflects Winckelmann's aesthetic principles expressed in the phrase "noble simplicity and tranquil magnificence." These principles can be seen here, as the solemn composure of the composition combines with figural representations that can be traced back to antiquity, emulating Raphael and the great seventeenth-century Emilian painters. Parnassus confirmed Mengs's fame, which was so great that a few years later he was one of the first artists, along with Pompeo Batoni, invited to donate a self-portrait to the Uffizi.

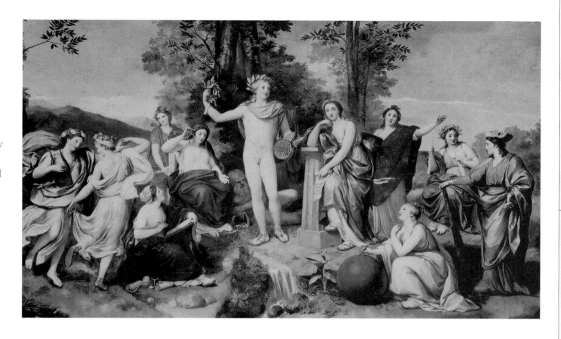

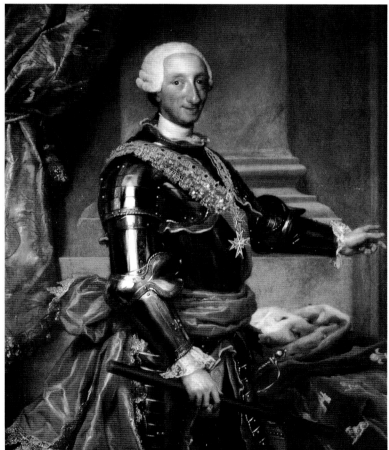

Anton Raphael Mengs
Portrait of Charles III of Bourbon, King of Spain
1761, oil on canvas.
Madrid, Prado Museum.

When he became king of Spain in 1759, Charles III quickly summoned Mengs to Madrid, and one of his first assignments was a portrait of the new monarch. This was an excellent work that modernized models by Antonie Van Dyck, masterfully combining courtly magnificence with incisive spontaneity.

Facing page:
Anton Raphael Mengs
Perseus and Andromeda
1773–78, oil on canvas.
Saint Petersburg,
Hermitage Museum.

Gavin Hamilton
(b. Lanark, Scotland 1723, d. Rome 1798)

After an apprenticeship in Scotland, Hamilton went to Rome in 1748 and spent the rest of his life there, involved in archaeology and the arts. He participated in the neoclassical figurative revival and his paintings stand out for their solemn, composed quality, inspired by great examples of seventeenth-century classicism. His Homeric subjects spread across Europe thanks to Domenico Cunego's prints, and had a great influence on coeval art. From 1782 to 1784, Hamilton was involved in the decoration of Villa Borghese. He was also an esteemed portrait painter and he worked for English travelers; in 1786 he painted the beautiful Emma, wife of Sir William Hamilton and later Admiral Horatio Nelson's lover. Hamilton was also a friend of Antonio Canova and introduced him to the English coterie in Rome, giving him suggestions for his artistic work.

Gavin Hamilton, *The Eighth Duke of Hamilton,*
detail of Portrait of the Duke with Doctor John Moore
and Ensign Moore in Rome, c. 1775–77, oil on canvas.
Edinburgh, Scottish National Portrait Gallery
(previously Hamilton Collection, Lennoxlove House).

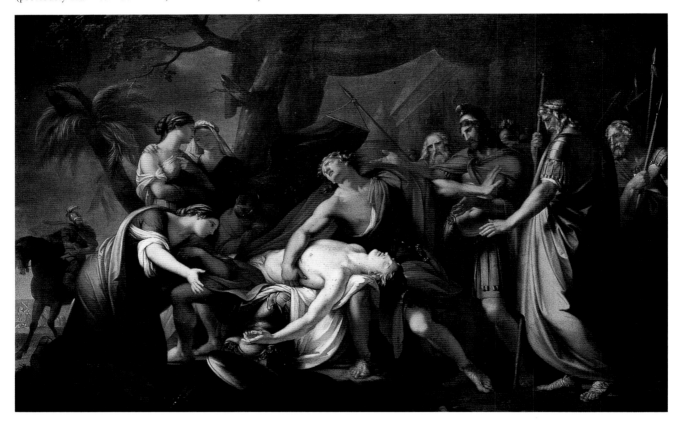

Gavin Hamilton
Achilles Lamenting the Death of Patroclus
1760, oil on canvas.
Edinburgh, National Galleries of Scotland.

This composition, with its many mythological figures, develops with measured sobriety around a central image echoing both the postures and pathos of the many seventeenth-century Pietàs by artists ranging from Annibale Carracci to Nicolas Poussin. There were, nevertheless, more modern models in neoclassical Rome, thanks to Hamilton, Mengs, and Batoni; these artists referred to the solemn tone of seventeenth-century classicism to renew the form and moral significance of art, distancing themselves from the fervor and excitement of Rococo painting, which they considered to be frivolous and stylistically inconsistent.

John Singleton Copley
(b. Boston 1738, d. London 1815)

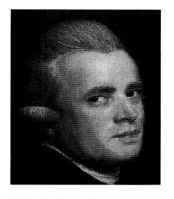

Educated in art by his stepfather, the English engraver Peter Pelham, Copley showed exceptional gifts as a portrait painter even as a child. Spurred on by the admiration of Sir Joshua Reynolds and Benjamin West, in 1774 he settled in London where he devoted himself to painting contemporary history and portraiture, succeeding in devising an unusual way of combining the two genres, which can be seen in *The Death of Lord Chatham* (1779–80), a work that confirmed the success achieved by the artist in 1778 with *Watson and the Shark*. His first trip to Italy was also in 1774, offering him a great opportunity to study the Renaissance masters, especially the Venetians. He then went on to Rome and Naples (1777), and during this trip the artist painted one of his best-known portraits, *Mr. and Mrs. Ralph Izard*.

John Singleton Copley
Self-portrait, detail of *The Copley Family*
c. 1776, oil on canvas. Washington, National
Gallery of Art, Andrew W. Mellon Foundation.

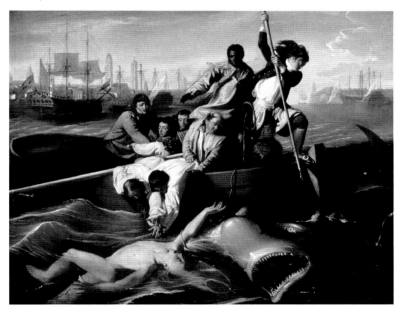

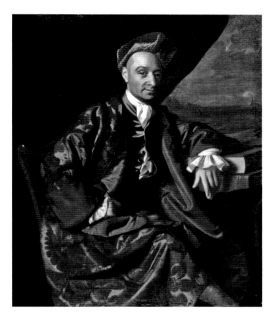

John Singleton Copley
Watson and the Shark
1778, oil on canvas.
Boston, Museum of Fine Arts.

John Singleton Copley
Nicholas Boylston
c. 1767, oil on canvas.
Boston, Museum of Fine Arts.

This painting depicts the rescue of Brook Watson, a young English sailor attacked by a shark while swimming in the port of Havana in 1749. Copley focuses on the most dramatic moment of the event, without indicating a successful outcome; the ferocious shark rushes towards the bare, defenseless man, while the reckless swimmer's companions frantically lean out of the boat in an attempt to save him. Evoking the great works of Hellenistic sculpture, the impressive and complex compositions of sixteenth- and seventeenth-century Italian painting, and the visionary quality of contemporary English painting, the artist created a highly emotional scene, intensified by the gray light and the dark colors, harmonizing with the greenish tones of the sea and sky. The great success of the painting, currently in the National Gallery in Washington, prompted Copley to produce this larger-scale replica.

An example of a typical portrait by Copley, an artist who masterfully conveyed the personality of the portrait's subject.

Robert Adam
(b. Kirkcaldy 1728, d. London 1792)

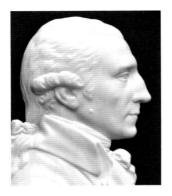

James Tassie, *Portrait of Robert Adam*, detail, 1792, medallion. Edinburgh, Scottish National Portrait Gallery.

Adam learned the trade in the studio of his father, who was a well-known Scottish architect. In 1754–58, Adam undertook the "grand tour" to Rome, also visiting Split and Palmyra, an experience decisive for his career. Settling in London, he worked on the installation of the colonnade in front of the Admiralty (1759–60), but his main project was the refurbishment and decoration of prestigious city and country homes, managing every detail of interiors with the help of his brother James. He designed residential complexes like the Adelphi, built on the banks of the Thames (1768), and Portland Place (1773). From then on, he was offered important commissions in Edinburgh for public buildings, including the General Register House (1774–92), the University building (1789), and Charlotte Square (1791). In the meantime, he built castles in distinct neo-Gothic style, including Culzean Castle (1777–90) and Seton Castle (1789–91).

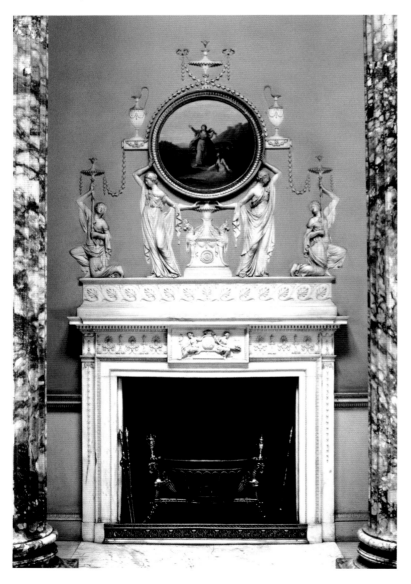

Robert Adam
Fireplace
1759–65.
Derbyshire, Kedleston Hall.

The fireplace was created for the Curzon family's country residence, built in an austere neoclassical style and surrounded by a typical English park. Adam was responsible for the interior decorations. The fireplace's light, ephemeral grace reflects a cultivated and poetic interpretation of antiquity, undoubtedly influenced by the fluidity of the Hellenistic decorations he admired in Split: a refined and exquisitely evocative version of Alexandrian Age interiors that soon became the model for many European residences. *The Works in Architecture of Robert and James Adam*, published in three volumes between 1773 and 1782, contributed greatly to the diffusion of the style he created, known as the "Adam style."

Robert Adam
Staircase at Home House
1773–76.
London, Portman Square.

This exceptionally elegant staircase, designed by Adam for the London residence that is now the home of the Courtauld Institute of Art, blends harmoniously with the grisaille decorations by Angelica Kauffmann and her husband Antonio Zucchi.

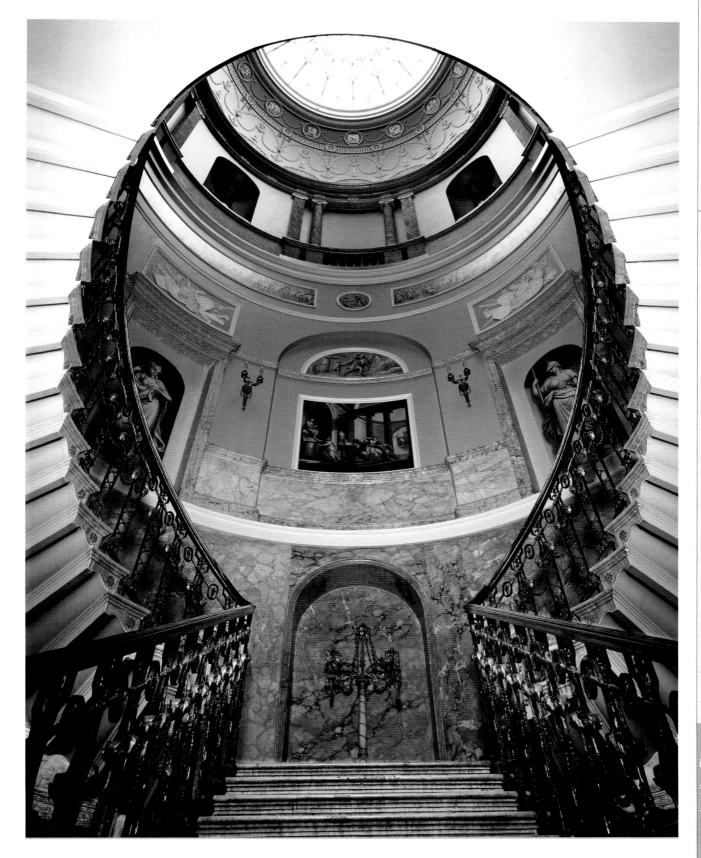

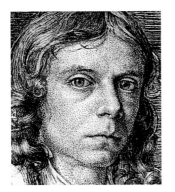

John Flaxman
(b. York 1755, d. London 1826)

Growing up in his father's plaster-casting workshop, Flaxman began sculpting as a child. He enrolled in the Royal Academy in 1770 and became a close friend of the painter William Blake. In 1775 he started to work for Josiah Wedgwood's pottery factory. In 1787 he settled in Rome as the creator of models for the factory, in the meantime acquiring commissions for various funeral monuments. In Rome, where he mixed with Angelica Kauffmann and Antonio Canova, Flaxman made line-drawing illustrations for Homer's poems (1793) and the tragedies of Aeschylus (1794), and he sculpted the *Fury of Athamas* for Lord Bristol. He returned to London in 1794 and devoted himself mainly to sculpture, obtaining important commissions for the tombs of illustrious contemporaries, including the painter Joshua Reynolds and Admiral Horatio Nelson, both of whom are buried in Saint Paul's Cathedral.

John Flaxman, *Self-portrait,*
detail, 1778–79, pen and ink
with watercolor.
Dudley, Museum and Art Gallery.

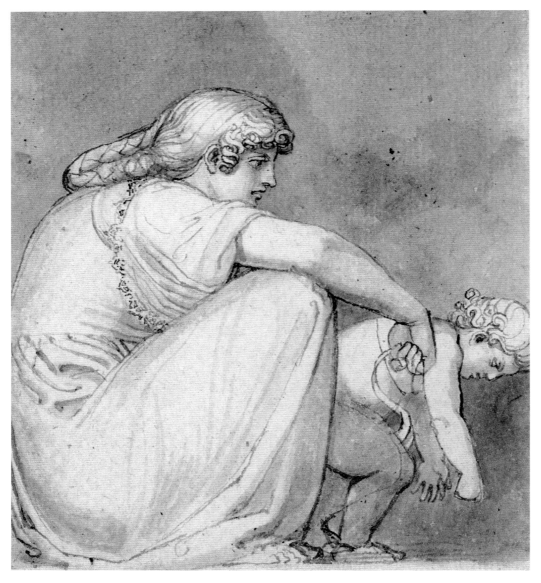

John Flaxman
Mother with Child
1790, pen and ink with
watercolor on white
paper.
London, University
College.

The artist's fascination
with the ancient world
infuses this scene from
daily life—possibly
inspired by a plebeian
Roman woman—with
the solemn, abstracting
nuance of a classical
bas-relief.

Leading Figures | *John Flaxman*

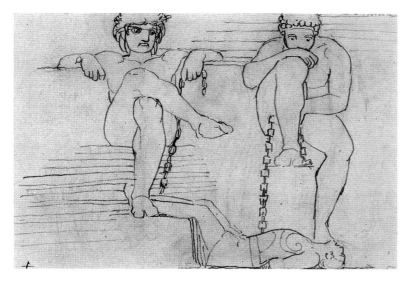

John Flaxman
Otus and Ephialtes Holding Mars Captive
1793, pen and ink with pencil on white paper. London, Royal Academy.

This scene is taken from Book V of the *Iliad*. The artist drew the figures of the two giants with a sure, and apparently spontaneous, hand. Just a few strokes were sufficient to suggest their emotional state, ranging from delight to amazement, upon seeing the god Mars at their feet and seemingly defeated.

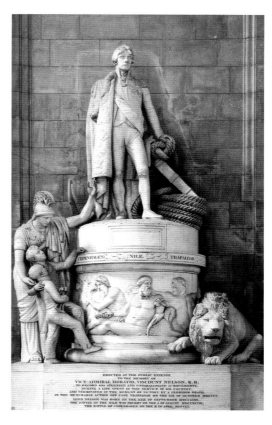

John Flaxman
Penelope Surprised by Her Suitors while Unraveling Her Weaving
1793, pen and ink with pencil on white paper. London, Royal Academy.

In this composition, a reinterpretation of vase paintings, Penelope is seated at the center, flanked by the servant who has betrayed her and the suitors who surprised her as she unraveled her weaving (*Odyssey*, II, verses 138–44). Flaxman's use of linear strokes in the design emphasizes the two-dimensionality of the image, a trait of his style.

John Flaxman
Monument to Horatio Nelson
1808–18, marble. London, Saint Paul's Cathedral.

The admiral stands gazing towards the horizon, wearing all his decorations of honor, on a circular pedestal decorated with bas-relief allegorical figures representing his victories at sea. There is a lion on one side, the symbol of strength; on the other side, Athena indicates to two boys the man who is a noble example of patriotic and military virtue. The monument's complex composition is a harmonious combination of Nelson in modern dress with elements inspired by the work of Canova (the lion and the goddess's tender expression are obvious references) and with ancient-style decorations created by Flaxman for Wedgwood vases. The work indicates the sculptor's evolution away from the abstractive clarity of simplified forms towards more unrestrained expressions, interwoven with sentiment, already displaying the new sensibilities that became widespread during the Restoration.

Joseph Wright of Derby
(b. Derby 1734, d. 1797)

Wright studied in London and in 1755 executed his first portrait, the genre in which he specialized. *The Orrery* dates to 1766 and was his first painting with a scientific theme. This was followed by *An Experiment on a Bird in the Air Pump*. They are candlelit nocturnes, whose contemporary themes revived Caravaggio's compositions in homage to the Dutch 1600s. In 1774 Wright went to Rome and visited Naples; the following year, before returning home, he visited Florence, Venice, Parma, and Lyon. In 1776 he painted erupting Vesuvius for the first time, a subject that he then repeated many times. Light phenomena aroused his scientific curiosity (in fact, like Josiah Wedgwood, he was a member of the Lunar Society). Thus, flashes shattering night darkness often recur in his landscapes, the genre he preferred in later life.

Joseph Wright of Derby
Self-portrait, detail, c. 1765,
drawing on paper glued to canvas.
Derby, Museum and Art Gallery.

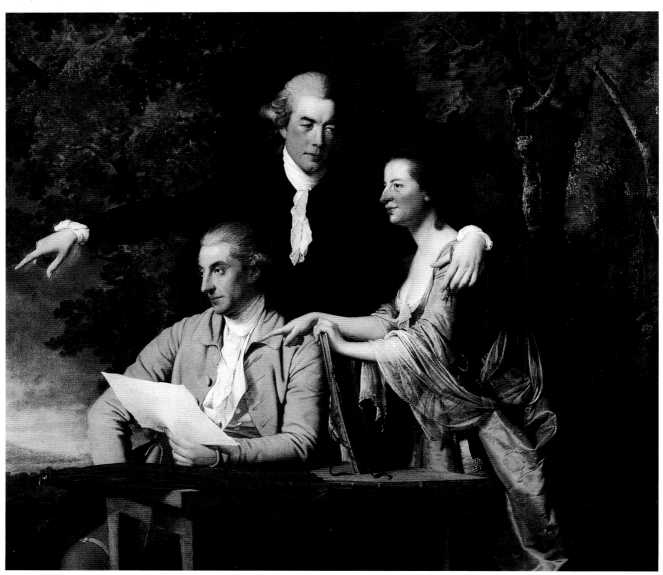

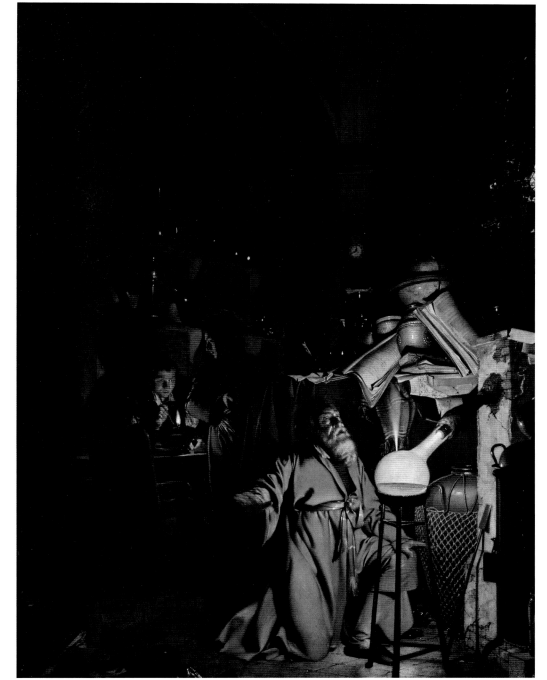

Opposite page:
Joseph Wright of Derby
The Reverend d'Ewes Coke with His Wife Hannah and Cousin Daniel Parker Coke
c. 1781–82, oil on canvas.
Derby, Museum and Art Gallery.

The family group is depicted outdoors, in the English fashion coined by Thomas Gainsborough. The natural light emphasizes the painting's pale tones and suggests the bonds of affection and respect among the three subjects, who are studying designs for the park at their new residence in Derbyshire.

Joseph Wright of Derby
The Alchemist, in Search of the Philosopher's Stone, Discovers Phosphorus, and Prays for the Successful Conclusion of His Operation
c. 1771–95, oil on canvas.
Derby, Museum and Art Gallery.

The gleam of phosphorus rends the darkness of the Renaissance alchemist's laboratory, and the man seeking to create gold kneels before the greatness of nature, in an obvious metaphor of the importance of science—in its modern sense—for world progress.

Johann Heinrich Füssli
(b. Zürich 1741, d. London 1825)

Born into the profession, Füssli drew and copied from German and Dutch masters while he studied classical literature and the essential texts of European culture, from Dante to Shakespeare, Milton, and the *Nibelungenlied*. In 1762 he was forced to leave Zürich for political reasons and spent a year in Berlin. He then went to London, where he translated Johann J. Winckelmann's *Gedanken* into English; in 1766 he met Jean-Jacques Rousseau in Paris. From 1770 to 1778, he lived in Rome, where he mixed with English artists and, attuned to their ideas, he created fantastical, imaginative compositions, influenced by Edmund Burke's *Sublime*. Füssli then decided to change his German name to an Anglicized form (Henry Fuseli). On returning to London in 1779, he was appointed professor of painting by the Royal Academy. In 1816, thanks to Antonio Canova, he was elected as an academician of San Luca.

Johann Heinrich Füssli
Self-portrait, detail, 1780–90, black crayon on white paper. London, Victoria and Albert Museum.

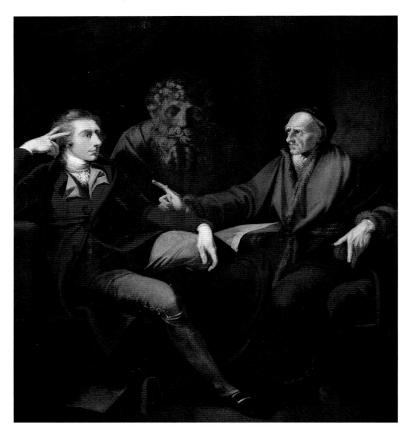

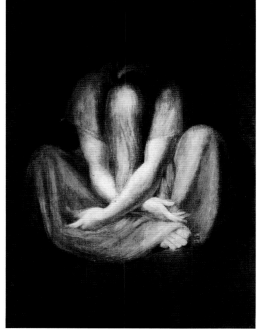

Johann Heinrich Füssli
Silence
c. 1799–1801, oil on canvas.
Zurich, Kunsthaus.

A female figure, legs crossed and head bowed, sits on the ground in front of a dark cave, a startling allegory of silence and the painful sense of loneliness that can derive from it. The muted tones of the reduced palette also contribute to the painting's mood of suspense.

Johann Heinrich Füssli
The Artist in Conversation with Johann Jakob Bodmer
1779–80, oil on canvas.
Zurich, Kunsthaus.

Seated in an apparently informal pose that actually derives from classical sculpture, the young artist listens attentively to the words of Bodmer, an elderly Swiss man of letters and aesthete (born in 1698), whose writings exalted the creative force of emotions and the imagination, and who also significantly influenced Goethe.

Johann Heinrich Füssli
Hamlet and Queen Gertrude Frightened by the Ghost (*Hamlet*, III, 4)
c. 1780–82, pen and ink, watercolor, and pencil on white paper.
Zurich, Kunsthaus.

The ink strokes retrace the pencil sketch and imbue the figures, inspired by classical sculpture, with dramatic character. Hamlet and the Queen appear shocked before the impassivity of the ghost who, with outstretched arm, seems to judge Hamlet and punish him for his violence; behind them, a striking flowered curtain falls on Polonius's lifeless body, leaving only his legs visible. The literary cue stimulated the artist's imagination, fueled by aesthetic theories of the sublime and Michelangelo's action-in-repose device.

Johann Heinrich Füssli
Dante and Virgil with Cavalcante and Farinata
1774, black ink and watercolor on white paper.
Zurich, Kunsthaus.

The striking compositional device indicates how Dante was considered "sublime" by eighteenth-century English culture.

Leading Figures *Johann Heinrich Füssli*

Johann Heinrich Füssli
Portrait of a Young Woman
1810–20, black ink, watercolor on white paper. Oxford, Ashmolean Museum.

Johann Heinrich Füssli
Brunhilde Observing Gunther, Whom She Has Tied to the Ceiling (*Song of the Nibelungs, X*) 1807, pencil, ink, and watercolor on white paper. Nottingham, City Museum and Art Gallery.

Füssli brought to life scenes taken from Nordic sagas, as well as classical literature, Dante, and Shakespeare, with a visionary imagination that successfully combined contemplations on the ancient, the aesthetics of the sublime, and intelligent irony.

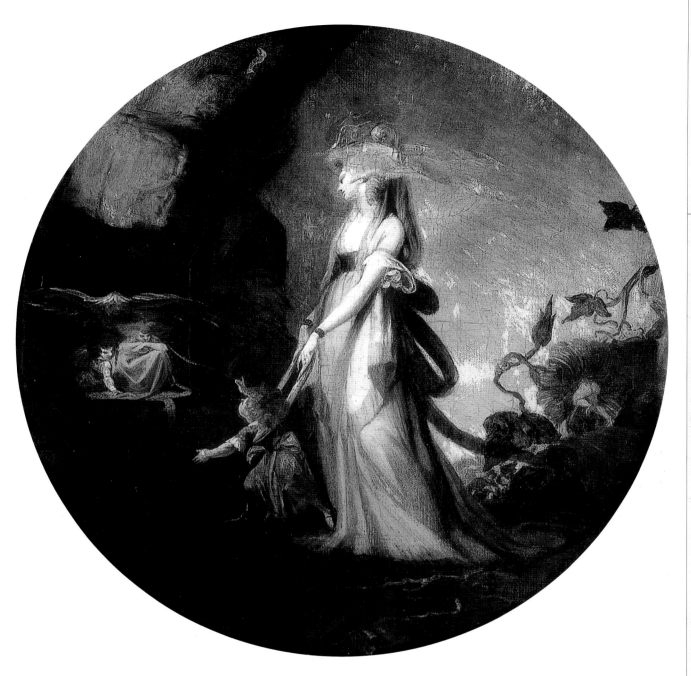

Johann Heinrich Füssli
Mamillius in Charge of a
Lady of the Court
1785–86, oil on canvas.
National Trust, Hinton,
Hampshire, Ampner
House, Ralph Dutton
Collection.

This subject is taken from the second act of *The Winter's Tale*, William
Shakespeare's 1611 play. A lady walks pensively, holding the ribbons of a baby
whose open arms indicate the fantastical characters that populate the enchanted
garden in which they stroll. The flowing brushstrokes skillfully depict the strange
features of the gnomes but also the woman's graceful beauty in her elegant
seventeenth-century garb.

Thomas Phillips, *Portrait of William Blake,* detail, 1807, oil on canvas. London, National Portrait Gallery.

William Blake
(b. London 1757, d. 1827)

Encouraged by his family to pursue a career in the arts, in 1767 Blake attended the Henry Pars Drawing Academy. He then undertook a long apprenticeship with the engraver James Basire, developing a deep interest in Gothic art and architecture. He was admitted to the Royal Academy in 1779, but he left in 1780. In the same year, he met Johann H. Füssli, who became a lifelong friend. Blake was an active participant in the English cultural scene of the late eighteenth century, when classicism and vivid visionary imagination were closely interwoven: his verses, in addition to his art, with its great visionary intensity, demonstrate this well. In 1783, he published his first volume of poetry, *Poetical Sketches*, but it was his verse works—*Songs of Innocence* (1789) and *Songs of*

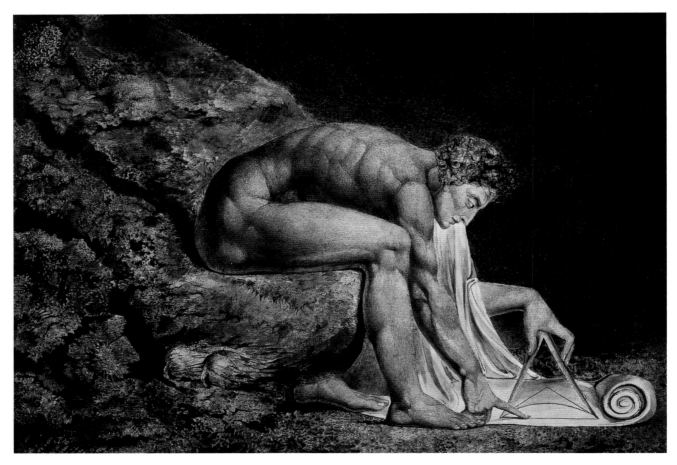

William Blake
Isaac Newton
1795, color print, finished with ink and watercolor.
London, Tate Britain.

Newton, the great seventeenth-century English scientist (who is credited with, among other things, the theory of universal gravitation and color theory), is seated on a rock spur that seems to teem with life and leans over his papers, intent on making a geometric illustration of one of his ideas with the aid of a compass. Portraying Newton naked, like an ancient hero, indicates Blake's perception of the quest for scientific knowledge as an expression of human intelligence on a par with imagination.

Experience (1794)—that fully revealed his gifts. He also devoted himself to a series of "prophetic books"—*The Marriage of Heaven and Hell* (1793), *America* (1793), *The First Book of Urizen* (1794), *Milton* (1804–8), and *Jerusalem* (1804–20). Convinced that text and illustrations formed a whole, Blake planned and designed the entire page that he printed himself. With the help of his wife, he opened his own copper plate engraving workshop (London, 1787), using a new technique he called "illuminated printing." In painting he preferred biblical subjects (*Jacob's Ladder*, 1800, and *Ezekiel's Vision*, 1805), which emphasized spirituality, turning tangible fact into fantastic images, which from a formal viewpoint combine Michelangelo Buonarroti's action in repose with the linear abstractness of John Flaxman's illustrations. In later life, Blake illustrated the *Book of Job*, *Night Thoughts of E. Young*, and *The Divine Comedy;* the last was unfinished at the time he died—in poverty and obscurity.

William Blake
The Dance of Albion
1794–96, color print.
London, British
Museum.

A few verses describe this theme so dear to Blake's imagination that he dealt with it several times: "Albion rose from where he labour'd at the Mill with Slaves / Giving himself for the Nations he danc'd the dance of Eternal Death."

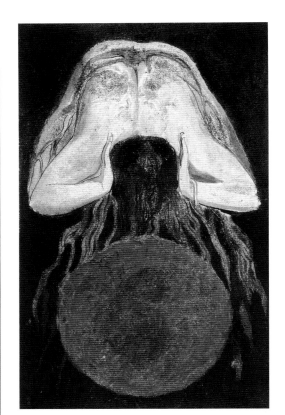

William Blake
Los Creates Enitharmon
(*First Book of Urizen*, plate 11)
1794, engraving with pen and
ink and watercolor.
New Haven, Connecticut, Yale Center for British Art, Yale University.

This is one of the illustrations from the *First Book of Urizen*. The text contains twenty-eight illustrations, ten of which are full page, the largest number in any of Blake's work up to that time. The artist's extraordinary imagination imbues the depiction of Los as procreator with all the allure and mystery that surrounds the creation of the world.

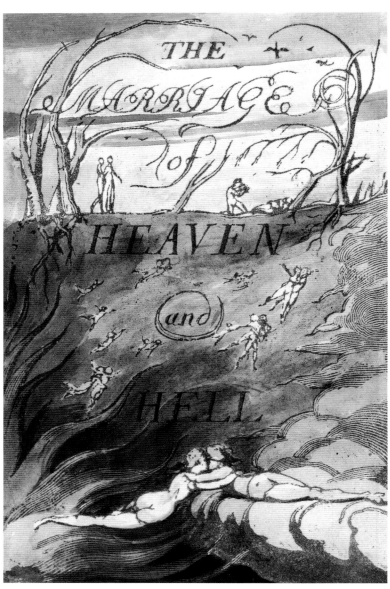

William Blake
The Marriage of Heaven and Hell
c. 1793, color print.
New York, Pierpont Morgan Library.

This illustration, conceived as the title page for the poem, is a reinterpretation of the traditional conception of the depths of hell and the migration of spirits towards the airy brilliance of paradise. The wide, delicate line of the engraving enhances the sinuous style of the etching, creating figures and letters in an almost uninterrupted flow.

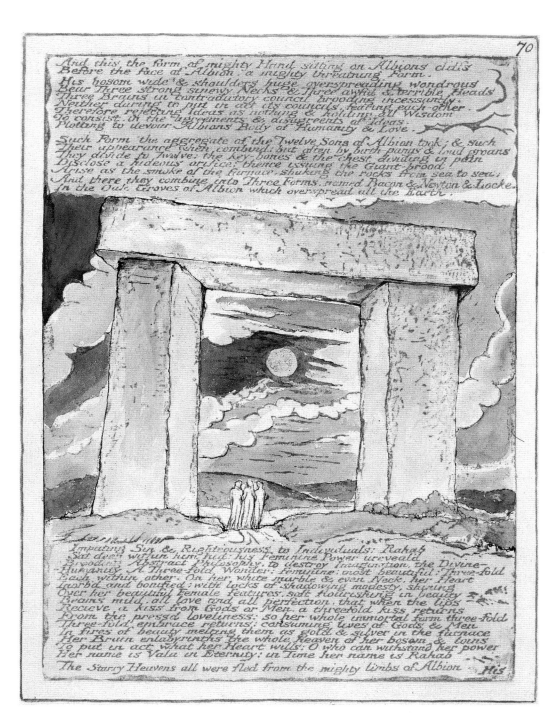

And this the form of mighty Hand sitting on Albions cliffs
Before the face of Albion; a mighty threatning Form.
His bosom wide & shoulders huge overspreading wondrous
Bear Three strong sinewy Necks & Three awful & terrible Heads
Three Brains in contradictory council brooding incessantly.
Neither daring to put in act its councils, fearing each other.
Therefore rejecting Ideas as nothing & holding all Wisdom
To consist in the agreements & disagreements of Ideas
Plotting to devour Albions Body of Humanity & Love.

Such Form the aggregate of the Twelve Sons of Albion took; & such
Their appearance when combind: but often by birth-pangs & loud groans
They divide to Twelve: the key-bones & the chest dividing in pain
Disclose a hideous orifice; thence issuing the Giant-brood
Arise as the smoke of the furnace. shaking the rocks from sea to sea.
And there they combine into Three Forms. named Bacon & Newton & Locke.
In the Oak Groves of Albion which overspread all the Earth.

Imputing Sin & Righteousness to Individuals: Rahab
Sat deep within him hid: his Feminine Power unreveald
Brooding Abstract Philosophy. to destroy Imagination. the Divine-
Humanity A Three-fold Wonder: feminine: most beautiful: Three-fold
Each within other. On her white marble & even Neck. her Heart
Inorbd and bonified: with locks of shadowing modesty. shining
Over her beautiful Female features. soft flourishing in beauty
Beams mild. all love and all perfection. that when the lips
Recieve a kiss from Gods or Men. a threefold kiss returns
From the pressd loveliness: so her whole immortal form three-fold
Three-fold embrace returns: consuming lives of Gods & Men
In fires of beauty melting them as gold & silver in the furnace
Her Brain enlabyrinths the whole heaven of her bosom & loins
To put in act what her Heart wills: O who can withstand her power
Her name is Vala in Eternity: in Time her name is Rahab

The Starry Heavens all were fled from the mighty limbs of Albion

William Blake
Jerusalem (The Emanation of the Giant Albion, plate 70)
c. 1820, engraving with pen and ink and watercolor.
New Haven, Connecticut, Yale Center for British Art, Yale University.

In a reference to medieval miniatures, Blake conceived the page as a harmonious continuum between text and illustration. Here, the sublime vision of the moon framed by imposing megalithic architecture is rendered more mysterious by the two surrounding compact bands of writing.

Leading Figures William Blake

Nicolai Abraham Abildgaard
(b. Copenhagen 1743, d. 1809)

Abildgaard attended Copenhagen Academy of Fine Arts and in 1772 won the Prix de Rome scholarship, allowing him to study the old masters (Raphael, the Carraccis, Poussin). He was, however, equally enthusiastic about the work of Mengs and, above all, about the creative, visionary work of his friend John Tobias Sergel, Füssli, and the English coterie, which left clear traces in his art. On returning to Denmark in 1779, after one trip to Naples and another across central Europe, he devoted himself with the same talent to painting and interior design. Attuned to neoclassical culture, his preferred subjects including the works of Homer, the Bible, and the *Poems of Ossian*, which the artist interpreted with heartfelt sentiment. From his position as professor of painting at Copenhagen Academy, Abildgaard became its director in 1789; Bertel Thorvaldsen and Christoffer Eckersberg were two of his pupils.

Portrait of Nicolai Abraham Abildgaard, detail, c. 1768, engraving based on a painting by Jens Juel.

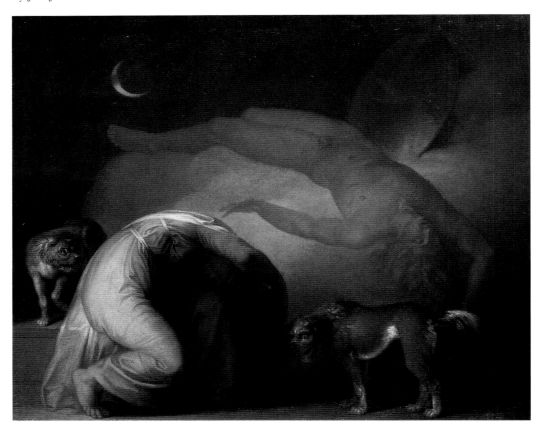

Nicolai Abraham Abildgaard
The Spirit of Culmin Appears to His Mother 1794, oil on canvas. Stockholm, Stockholm National Museum.

The painting illustrates a passage from Book V of the *Poems of Ossian*. The artist interpreted the emotional impact with surprising intensity, creating a scene balanced seamlessly between the real world and dreams: only the touching pose of the slumbering woman suggests that the image of the dead hero's body, abandoned between two restless dogs and a shield, is the result of a dream. The artist worked on the subject for many years—his first preparatory drawing dates to about 1780, but the painting was not exhibited until 1794, in Copenhagen.

Thomas Jefferson

(b. Shadwell, Virginia 1743, d. Monticello, Virginia 1826)

Jefferson was an archetypal Enlightenment figure whose interests ranged from legislation to economics, education, and architecture. He was a rich landowner and on his Monticello estate he demonstrated his skills as a designer for the first time, building his own house in 1769. In 1785 he traveled to Europe, which allowed him to study both ancient and contemporary architecture. His style was originally nuanced with Palladian grace, but it increased in austerity, turning into programmatic classicism. He received his first public commission that same year: the Virginia State Capitol building in Richmond, which he based on the model of the Maison Carrée at Nîmes. Jefferson was secretary of state to George Washington, and prepared the urban plan for the American capital, with the help of Benjamin Latrobe, who also assisted him with the work for the University of Charlottesville (Virginia).

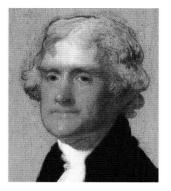

Gilbert Stuart, *Portrait of Thomas Jefferson,* detail, 1805, oil on canvas. National Portrait Gallery, Smithsonian Institution.

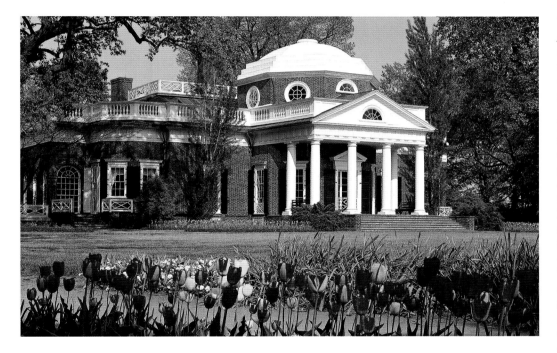

Thomas Jefferson
Jefferson House, Monticello
1769–75.
Charlottesville
(Virginia).

Jefferson's clear references to Palladio's work, combined with the typically neoclassical decorative elements (including the Roman Doric order used for columns and architrave), imbue the building with a solemn character. The white stucco accents contrast against the brick structure, simultaneously defining architectural volumes and ornamentation. This beautiful manor for the future president of the United States was used as a model for developing an American architectural style that was more cultivated and ornate than the colonial style.

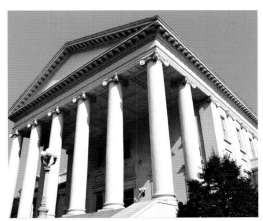

Thomas Jefferson
Capitol
1785–96.
Richmond (Virginia).

Aleksander Orlowski, *Portrait of Giacomo Quarenghi*, detail, 1811, pastel on paper. Saint Petersburg, State Russian Museum.

Giacomo Quarenghi
(b. Valle Imagna, Bergamo 1744, d. Saint Petersburg 1817)

Initially Quarenghi was a painter, studying in 1763 with Mengs and Stefano Pozzi in Rome. Here he turned to architecture, studying and surveying classical buildings. His interest in Renaissance art combined with the contemporary art of Claude-Nicolas Ledoux, Étienne-Louis Boullé, and Robert Adam. In 1771 he began to renovate the interior of Santa Scolastica at Subiaco in a neoclassical style. In 1779, thanks to Baron Grimm, minister to Empress Catherine the Great, he moved to Russia as court architect. His intervention gave a Palladian feel to Saint Petersburg, where he erected the state bank, the Hermitage theater, the Academy of Sciences, and many private buildings. His last works have an even greater measure of solemnity, as seen in the Alexander building at Tsarskoye (now Pushkin, 1791–96) and the Smolny Institute (Saint Petersburg, 1806–7).

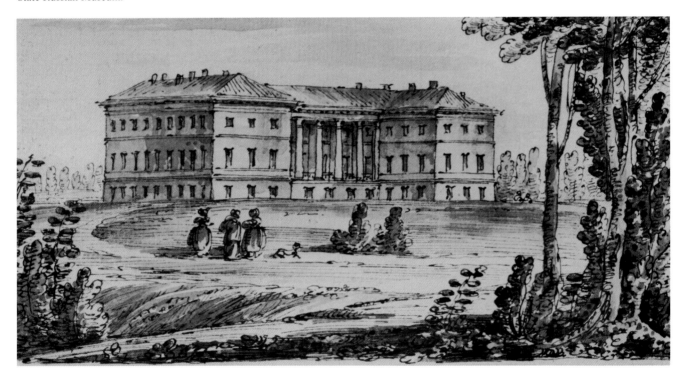

Giacomo Quarenghi
Horse Guards' Riding School
1805–7.
Saint Petersburg, State Russian Museum.

Giacomo Quarenghi
The English Palace at Peterhof
1781–89, ink sketch.
Bergamo, Angelo Mai Civic Library.

The drawing illustrates the rear façade of the suburban residence of Catherine the Great at Peterhof, now called Petrodvorec, the Russian town on the Gulf of Finland. The imperial palace was destroyed by the Soviet government after it was damaged during World War II.

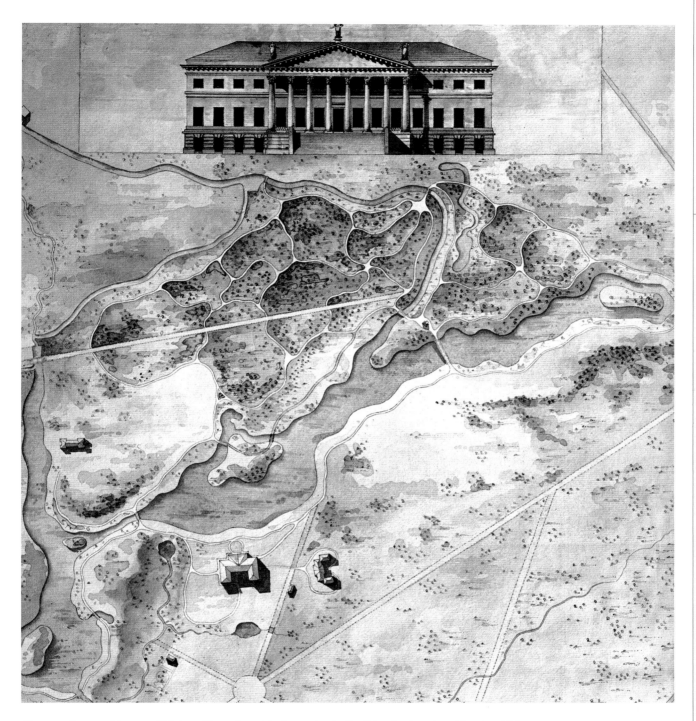

Giacomo Quarenghi
Peterhof Park
1781–89, pen and ink
with watercolor on
white paper.
Bergamo, Angelo Mai
Civic Library.

This is an illustration of the layout for the English palace's park and façade, which
were designed, along with houses for the court and annexes, for the imperial estate at
Peterhof. The estate was the most challenging of Quarenghi's projects after his arrival
in Russia and undoubtedly the work that best represented his neoclassical syntax,
which would soon epitomize the architecture of Saint Petersburg.

Angelica Kauffmann
(b. Chur 1741, d. Rome 1807)

Schooled in Lombardy, between Como and Milan, Kauffmann exhibited remarkable talent from a young age. In 1763 she moved to Rome, where she met Johann J. Winckelmann and painted his portrait. From 1766 to 1781 she lived in London, where she worked as a decorator and was so successful on the city's art scene that she was involved in founding the Royal Academy. Subsequently, after marrying the painter Antonio Zucchi, she moved to Rome and there lived among Italian, English, Nordic, and above all German artists and literati (including Flaxman, Tischbein, Hackert, Goethe, and Thorvaldsen). She essentially devoted herself to the easel painting of historical and mythological subjects, evolving a neoclassical style interwoven with subtle sentimental cadences and refined color, but she was perhaps best at portraiture, which brought her fame and financial security.

Angelica Kauffmann, *Self-portrait with a Bust of Minerva*, detail, c. 1780, oil on canvas. Chur, Bündner Fine Arts Museum (on permanent loan from the Federal Commission of the Gottfried Keller Foundation, Winterthur).

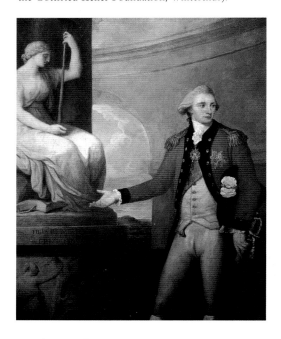

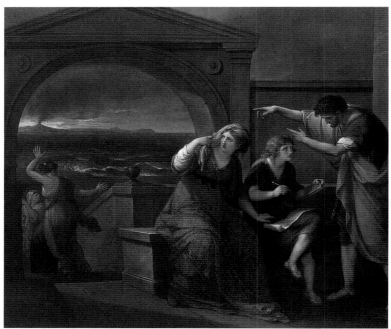

Angelica Kauffmann
Portrait of Stanislaus III Poniatowski
1788, oil on canvas.
Florence, Gallery of the Mozzi Bardini Palace.

The prince was nephew of the king of Poland and is portrayed in full-dress uniform, indicating an allegorical statue of Liberty, holding a staff with a Phrygian hat. The Polish aristocrat, champion of the moral and economic growth of a free society, was the first to abolish serfdom in his territories. Alluding to the nobility of this gesture, the artist chose majestic "classical" architecture as the setting for the portrait.

Angelica Kauffmann
Pliny the Younger and His Mother at Miseno during the Eruption of Vesuvius
1785, oil on canvas.
Princeton, Art Museum.

To narrate an event as dramatic as the disappearance of the cities of Herculaneum and Pompeii under a mudslide following the eruption of Vesuvius (AD 79), the Swiss painter lingers with a penetrating, attentive approach on the private turmoil of a mother and son, united in the anxiety of awaiting the catastrophe from the eruption of the volcano (whose smoking form can be glimpsed in the painting's background), and from the raging sea in the storm. The gentle and restrained expression of emotions in this work corresponds exactly to Guido Reni's and Nicolas Poussin's classical paintings, which Kauffmann adopted as her ideal references.

Jacob Philipp Hackert

(b. Prenzlau 1737, d. Florence 1807)

The son of a court portrait painter, Hackert lived in Berlin until 1761, the year in which two of his views of the Tiergarten, bought by Frederick II of Prussia, established him as a landscapist. From 1765 to 1768 he lived in Paris, then in Italy, preferring in his early years what were considered unusual destinations like Pisa and Florence. In Rome he obtained important commissions from Empress Catherine II (1771), for whom he painted six large canvases of the victory of the Russian fleet at Çe me (1771–73). In 1782, endorsed by Ferdinand IV, the Bourbon king of Naples, Hackert's success peaked when he was appointed court painter in 1786. In Naples, in 1787, he met Goethe, who became his friend and admirer, publishing his diary posthumously in Florence, where Hackert had taken refuge in 1799, following the French occupation and expulsion of the Bourbons.

Wilhelm Titel (attributed), after
François-Xavier Fabre, *Half-Bust Portrait*
of Jacob Philipp Hackert, detail, 1806, oil on
canvas. Düsseldorf, Goethe Museum/Anton
and Katharina Kippenberg Foundation.

Jacob Philipp Hackert
The View from Campi
Flegrei
1797, oil on canvas.
Mâcon, Ursulines
Museum.

The enchanting Neapolitan countryside is depicted with clean lines and pure colors, enhanced by an immobile bright light, typical of the German artist's work. This analytical interpretation of the landscape, almost dizzying in its meticulous detail, though created in the taste of the classical tradition, was the key to Hackert's success, until newly conceived romantic culture started to prefer more emotional and intimate expressions.

Jean-Michel Moreau (engraved by Augustin de Saint-Aubin), *Pierre-Henri de Valenciennes*, 1788, etching. Toulouse, Paul-Dupuy Museum.

Pierre-Henri de Valenciennes
(b. Toulouse 1750, d. Paris 1819)

De Valenciennes went to Italy for the first time in 1769; on his return he settled in Paris, where he studied at the atelier of Gabriel-François Doyen. In 1777 he returned to Italy, to Rome, remaining there until 1785. During this time, he visited Naples, Stromboli, Sicily, Pompeii, and Paestum. He produced endless *plein air* studies, using oil on paper to depict unassuming day-to-day scenes and unusual views of towns and countryside, instead of ancient monuments. These studies provided the artist with inspiration for his "official" paintings on his return to Paris, and he kept them until his death. From 1787, when he presented *Cicero Discovering the Tomb of Archimedes in Syracuse*, his presence at Salons was constant and ensured him such fame that he was offered a studio at the Louvre in 1804. De Valenciennes was responsible for the École des Beaux-Arts instituting a Prix de Rome for landscapes in 1817.

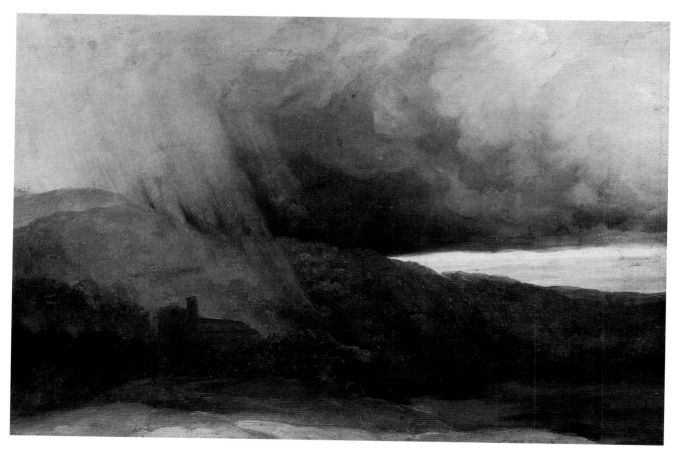

Pierre-Henri de Valenciennes
Storm on a Lake
c. 1782–84, oil on paper laid on board.
Paris, Louvre.

The rain pours down, clouding the view of the hillside monastery; beyond the looming black cloud, the horizon is already tinted with a soft blue, hinting at the calm that will soon arrive. An unexpected storm caught the painter off guard during a walk through the Latium countryside; while waiting for the rain to stop, he recorded an impression of the light in a sketch "executed quickly, to capture nature in the act," following the procedure that he himself had suggested to colleagues, theorizing new methods for conceiving landscape paintings.

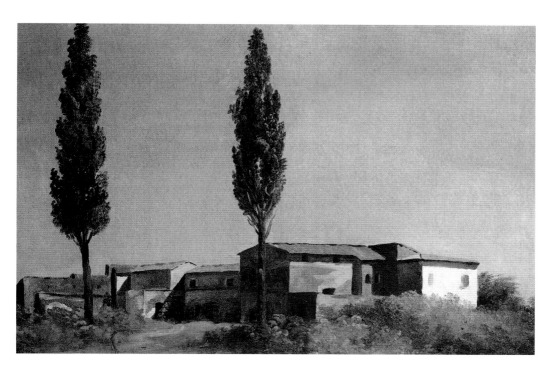

Pierre-Henri de Valenciennes
Two Poplars at Villa Farnese,
c. 1782–84, oil on paper laid on board.
Paris, Louvre.

The carefully considered arrangement is punctuated by two poplars, outlined against the limpid sky, that give depth to the view, where the villa on the Palatine slopes is depicted with rigorously coordinated color blocks. The austere simplification of the image is interwoven with a dreamlike atmosphere.

Pierre-Henri de Valenciennes
Rome, Roofs in Sunlight; Rome, Roofs in Shade
c. 1782–84, oil on paper laid on board.
Paris, Louvre.

Against the background of a sky filled with fluffy clouds, the rigorously geometric forms of garrets, chimney tops, orderly roof tiles, and poles holding laundry hung out to dry, all come together to create an image suffused with poetry and humanity. "It is good practice to paint the same view at different times of the day, in order to observe the variations in the forms produced by the light," de Valenciennes suggested; he himself was amazed at how differently things appeared at various times of the day, becoming almost unrecognizable in changing plays of light and shadow.

Antonio Canova
(b. Possagno, Treviso 1757, d. Venice 1822)

Canova studied sculpture in Venice from 1768, under the patronage of Senator Giovanni Falier, for whom he created his first sculptures: two fruit baskets (1774) and *Orpheus* (1777). In 1779 he showed his *Daedalus and Icarus*, then he went to Rome and Naples. In 1781, a three-year scholarship granted by the Venetian Senate allowed him to stay in Rome, where, thanks to the engraver Giovanni Volpato, he was commissioned to make the tomb of Clement XIV. This opus ensured his success when it was finished in 1787. From then on, Canova always worked for the most illustrious of European patrons, from popes to royal families, and the erudite, avant-garde English aristocracy. His *Monument to Clement XIII* dates to 1792; this was followed by *Cupid and Psyche, Adonis and Venus*, and *Cupid*

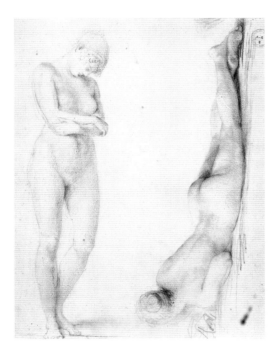

Antonio Canova, *Self-portrait*,
detail, 1792, oil on canvas.
Florence, Uffizi Gallery.

Antonio Canova
Female Nudes
c. 1790, pencil and charcoal on white paper.
Bassano del Grappa, Municipal Museum.

These two drawings, dating to the early 1790s, are from the same sketchbook consisting entirely of female nude figure studies. The delicate grace of the three nudes, drawn without classical references, shows the sculptor's sensitivity and ability to imbue the posed figures with a sense of freshness and spontaneity.

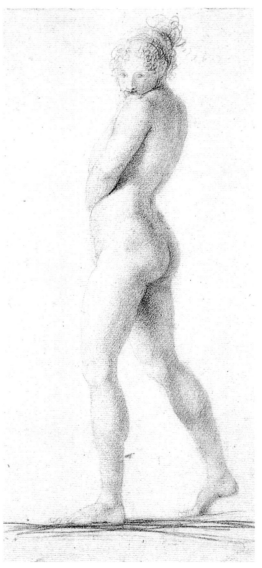

Facing page:
Antonio Canova
Monument to Marie Christine of Austria,
detail
1798–1805, marble.
Vienna, St. Augustine's Church.

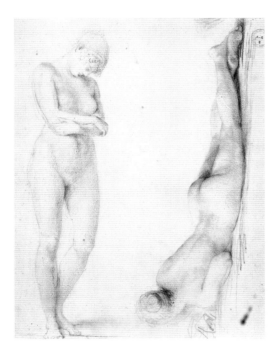

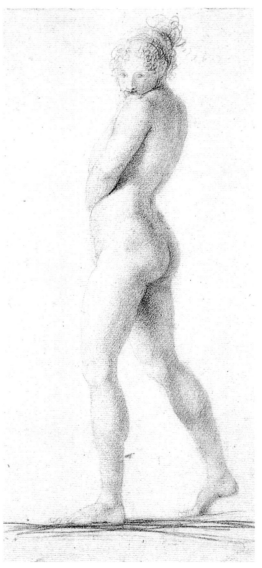

and Psyche Standing. During the same period, he began to work on heroic subjects like Creugas and Damoxenus and Hercules and Lichas, projects that allowed him to show his talent in expressing the strength of action in repose and dramatic tension. In 1798, he was commissioned to make the tomb of Archduchess Maria Christina (in Vienna), which was unveiled in 1805. Pius VII appointed him inspector of fine art for the Papal State in 1802. Canova went to Paris to sculpt the bust of Napoleon and continued to work for the emperor and his large family. Napoleon as Mars the Peacemaker dates to 1806; Pauline Bonaparte and Letizia Ramolino were made in 1808 and exhibited at the Paris Salon with Penitent Magdalene and Cupid and Psyche Standing. He combined teaching and supporting the arts with his sculpting activities. His engagements intensified with the Restoration, as head of the Holy See delegation for the return of artworks taken by the French. In 1815 he finished Hercules and Lichas for the Torlonia family, and went to Paris and London to observe the Parthenon Marbles. From 1816 to 1822, commissions for private and public works never stopped, and he worked incessantly until his death.

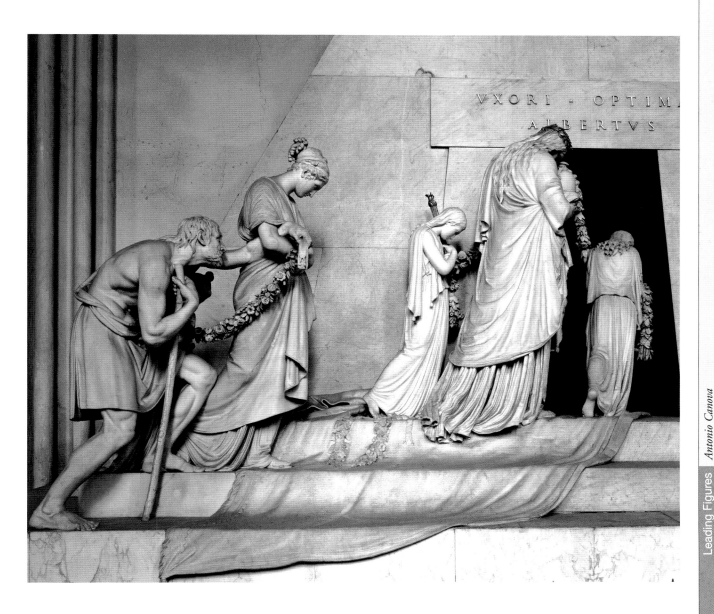

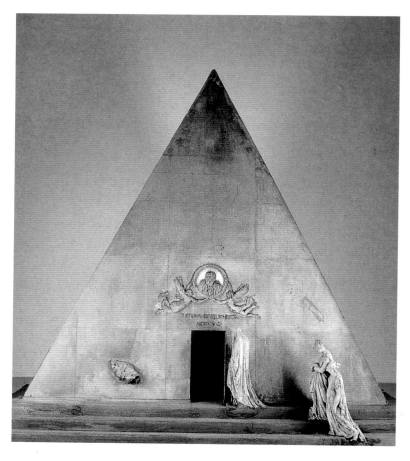

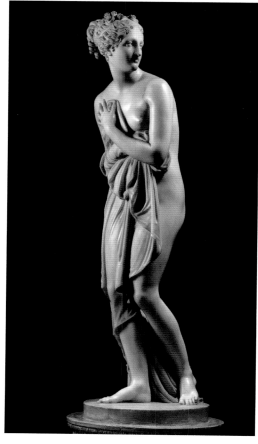

Antonio Canova
Monument to Titian
1791–95, terra-cotta and wood.
Venice, Correr Museum.

Antonio Canova
Venus Italica
1804–12, marble.
Florence, Pitti Palace, Palatina Gallery.

In 1790, Canova was commissioned to make a monument to Titian for Venice's Santa Maria dei Frari church. Canova worked on the monument until 1795 and made various models, all of which focused on a pyramid motif, inspired by the Pyramid of Cestius in Rome. While the pyramid functioned as a backdrop for the sarcophagus in the early models, it later became the actual sepulcher. By substituting the sarcophagus with a door opening onto the unknown, towards which the grieving turn, Canova changed the concept of the funerary monument, no longer perceived as just a celebration of the deceased, but also the medium for profound reflection on the mystery of death. The monument to Titian was never completed, but the artist reworked the project for the tomb of Archduchess Marie Christine of Austria (illustrated on page 59), erected in 1805 inside Vienna's Saint Augustine's Church. This is an extraordinary work, interesting for both its form and its fervently emotional reflections on the complexity of existence.

This statue was commissioned by Maria Luisa of Bourbon-Parma, queen of Etruria at the time, to replace the *Medici Venus* that was removed from the Florentine collection by Napoleon in 1802. The work is a beautiful combination of formal qualities and naturalness, an image of exquisite beauty suffused with spontaneity inspired by several classical Venuses. Canova's goddess is imbued with touching sensuality, as Leopoldo Cicognara (friend and sophisticated admirer of Canova) noted when he pointed out that the "gentle grace" of the head elevated "the real expression" of the posture.

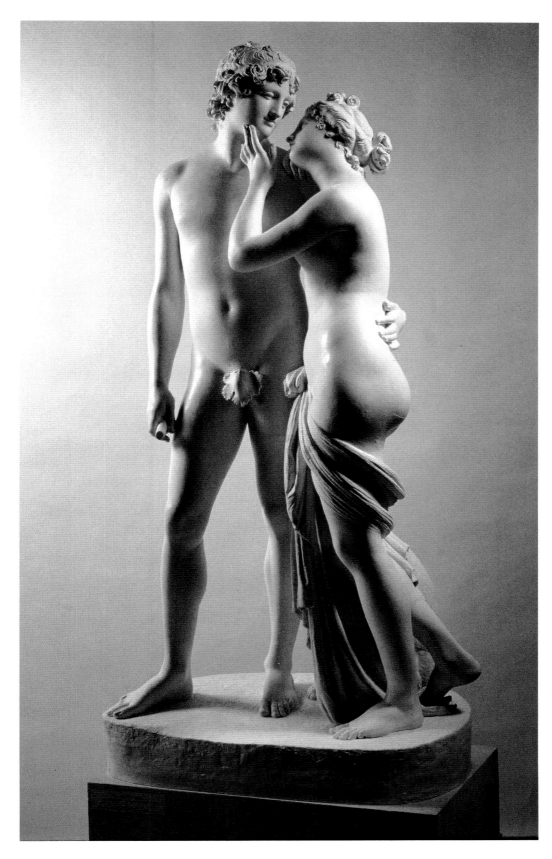

Antonio Canova
Venus and Adonis
1789, plaster.
Possagno, Plaster
Cast Gallery.

This sculpted group
depicts the parting of
two lovers, who
exchange a final, languid
caress; behind them, a
dog waits impatiently for
Adonis to say goodbye
to Venus, so they can
begin the hunt that will
be fatal for Adonis.
Canova produced the
model without a
commission, and it was
only when the marble
was in the roughing-out
phase that he found a
purchaser. The sculpture,
completed in 1794,
aroused universal
admiration for its
combination of
overwhelming beauty
and captivating
sensuality. It was said
that the work's grace
could only be fully
appreciated by the dim
light of candles, when
"the graceful
modulation, richness of
emotion, and masterful
touch" were revealed.

Antonio Canova
Tomb of Pope Clement XIV
1783–87, various types of marble.
Rome, Basilica of the Holy Apostles.

The pyramid-shaped monument, above the sacristy door, culminates in a statue of the pope giving a blessing. The allegorical figures of Temperance and Humility are depicted below, one weeping over the sarcophagus, the other woefully absorbed in sorrowful thought. The work, which Canova sculpted thanks to the intercession of Giovanni Volpato, brought the artist immediate, resounding success. Francesco Milizia enthusiastically described the sculpture, stating that "the composition is of a simplicity that appears as easiness itself, yet it is complexity. What tranquility! What elegance! What design! . . . of all the modern sculptures, this is the most similar to ancient works."

Antonio Canova
Monument to Vittorio Alfieri
1804–10, marble. Florence, Basilica of the Holy Cross (Santa Croce).

In 1804, Canova was entrusted with sculpting the tomb of Vittorio Alfieri for the Basilica of Santa Croce in Florence. A proposed bas-relief was rejected by Alfieri's lover, the countess of Albany, who commissioned the project. Encouraged by the countess's confidante, the painter François-Xavier Fabre, Canova conceived a solemn, majestic group whose tone echoed Alfieri's poetry, as the artist himself pointed out. A tall base, decorated with garlands of corolla in very slight relief, evocative of the elegant grace of Josiah Wedgwood's porcelains, supports the figure of Italy who, saddened by the loss of the great poet, weeps over the sarcophagus with its archaic-style lines. In the monument to Alfieri, as in all of Canova's works, the lofty, regal tone is infused with human sensitivity and tenderness, an emotional quality often lacking in classical statuary.

Andrea Appiani
(b. Milan 1754, d. 1817)

Appiani started his career as set designer at La Scala and became a pupil of Giuliano Traballesi at Brera Academy in 1776. He was a figure in the Milan Enlightenment movement, with Giuseppi Parini, Pietro and Alessandro Verri, and Giuseppi Piermarini. His commission for the *Stories of Psyche* for Monza's Villa Reale dates to 1789. A trip to Rome, in 1791, allowed him to study Correggio, the Emilia classicists, Raphael, and the old masters. In 1795 he frescoed the dome of Santa Maria presso San Celso, and in 1796 he painted the first of many portraits—including that of Napoleon Bonaparte—that revealed a remarkable psychological shrewdness. Napoleon's rule was a watershed in the painter's career, bringing him public commissions from 1800 to 1813, including the *Napoleonic Frieze* (1800–7) for the Sala delle Cariatidi, and the *Apotheosis of Napoleon* for the throne room, both in the Milan Palazzo Reale. *Apollo and the Muses*, for the Milan Villa Reale, dates to 1811.

Andrea Appiani, *Self-portrait,* detail, c. 1805, oil on panel. Milan, Brera Art Gallery.

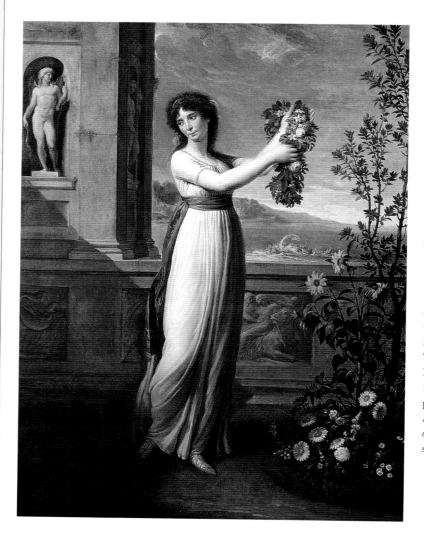

Andrea Appiani
Josephine Bonaparte
Beauharnais as Venus
1796, oil on canvas.
Private collection.

The statues of Venus and Cupid, the bas-reliefs depicting the Loves of Jupiter and the Triumph of Amphitrite on the placid sea waters, lend a mythological sensuality to the scene in which Josephine moves majestically, with elegant grace. The flowing Directoire-style dress emphasizes Josephine's slender figure, and her face, framed by curls, has almost childlike features. The work was painted in Milan, in the summer of 1796, to complement the portrait *General Bonaparte after the Battle of Lodi*, completed shortly before.

Andrea Appiani
Portrait of Claude-Louis Petiet,
President of the Special
Commission for Governing the
Cisalpine Republic, with His Sons
1800, oil on canvas.
Private collection.

In his fine red suit, Minister Petiet poses seated with his older sons standing beside him, dressed in military uniforms. The setting is a room decorated with allegorical bas-reliefs representing the reestablished Cisalpine Republic and the Napoleonic victory at Marengo. It is precisely the latter bas-relief that suggests Petiet was the person who commissioned the Napoleonic frieze for the Sala delle Cariatidi in Milan's Reale Palace, and thus suggests that the decorative cycle was started in 1800.

Andrea Appiani
The Apotheosis of
Napoleon
1808–12, fresco.
Tremezzo (Como), Villa Carlotta.

Painted in the throne room in the Milan Reale Palace, the fresco depicts Napoleon Bonaparte as a reigning Jupiter. The fresco was severely damaged during World War II, and after its restoration was installed in a beautiful villa in Como that once belonged to the eccentric Giovanni Battista Sommariva (an admirer of the sculpture of Canova and his contemporary Bertel Thorvaldsen). The villa is now a museum for Lombard neoclassical art.

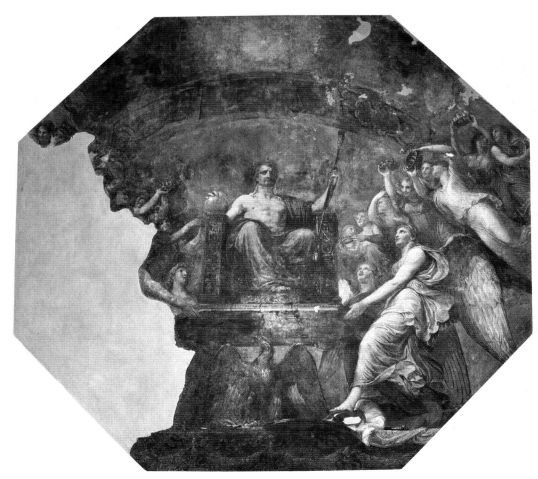

Jean-Antoine Houdon
(b. Paris 1741, d. 1828)

From 1764 to 1768 Houdon studied at the French Academy in Rome, also producing anatomical studies, including *Ecorché*, and two statues for Santa Maria degli Angeli. On his return to Paris, he created *Diana the Huntress*, which brought him success, confirmed by the many portraits of intellectuals, artists, and politicians that he created with mastery and subtle psychological introspection. Diderot, Gluck, Voltaire—also depicted in a full-figure piece in 1781 (Paris, Comédie Française)—are some of the figures portrayed by the sculptor, whose realistic rendering of the features, inspired by antiquity, was free from classical rigidity and Rococo affectation. In 1785, after portraying Benjamin Franklin, Houdon went to North America and sculpted the statue of George Washington at the State Capitol building in Richmond. On his return, he worked for the "new" men of the Revolution and the Empire.

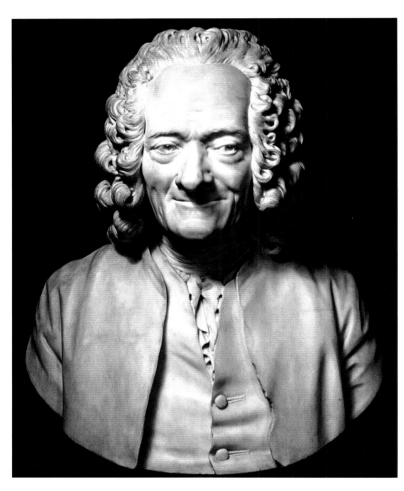

Leopold Boilly, *Jean-Antoine Houdon*, detail from *Houdon's Studio,* 1804, oil on canvas. Paris, Museum of Decorative Art.

Facing page:
Jean-Antoine Houdon
La Frileuse
1783, marble.
Montpellier, Fabre Museum.

This allegorical statue of Winter is decidedly
innovative from a figurative perspective. Rather than
the typical image of a haggard old man, Houdon
suggests the severity of the winter season and the
conclusion of the cycle of months through the slender
figure of a nude girl, her head and shoulders swathed
in a shawl. The girl's pose is reminiscent of the ancient
Venus Pudica, but Houdon suffused the figure with
the tactility and emotion so in keeping with
seventeenth-century culture, thus assuring the work
great popularity.

Facing page:
Jean-Antoine Houdon
Bust of Voltaire
Wearing a Wig
1778, marble.
Washington, National
Gallery, Widener
Collection.

In 1778, the sculptor
realized two portraits of
the great French writer
and philosopher, an
important figure in the
Enlightenment: the bust
shown here, with a full
and curly wig, and
another of white-haired
Voltaire without his wig.

Above:
Leopold Boilly
Houdon's Studio
1804, oil on canvas.
Paris, Museum of Decorative Art.

The elderly sculptor is depicted intent on modeling a
portrait of the mathematician Pierre-Simon de
Laplace, observed by his wife and daughters, in his
studio at the Palais des Beaux-Arts. Some of the
sculptor's most famous works are set at the back of
the room and along the walls, including *The Flayed
Man* and a version of *La Frileuse*. This painting by
Boilly, exhibited at the 1804 Paris Salon, was initially
conceived as a family portrait, with no intention of
commemorating Houdon's fame.

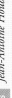

Leading Figures *Jean-Antoine Houdon*

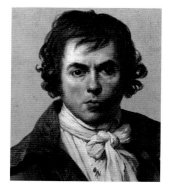

Jacques-Louis David
(b. Paris 1748, d. Brussels 1825)

Born into a middle-class family and related to François Boucher, David was a pupil of Joseph Marie Vien at the École des Beaux-Arts in Paris. In 1774, he won the Prix de Rome and lived in the city from 1775 to 1780. This period, which allowed him to study the works of antiquity and the Renaissance, and also to mix with the figures most involved in Europe's artistic revitalization, influenced his art in a decisive manner, channeling it towards expressions of the most austere classicism. On his return to Paris, he produced historical paintings, including *Belisarius* (1781) and *Andromache Mourns* (1783), but also charming portraits. From 1784 to 1785, he went to Rome to paint the *Oath of the Horatii*, a painting imprinted with neoclassical aesthetic values and ethics that confirmed David's excellence as

Jacques-Louis David
Self-portrait, detail, 1794,
oil on canvas. Paris, Louvre.

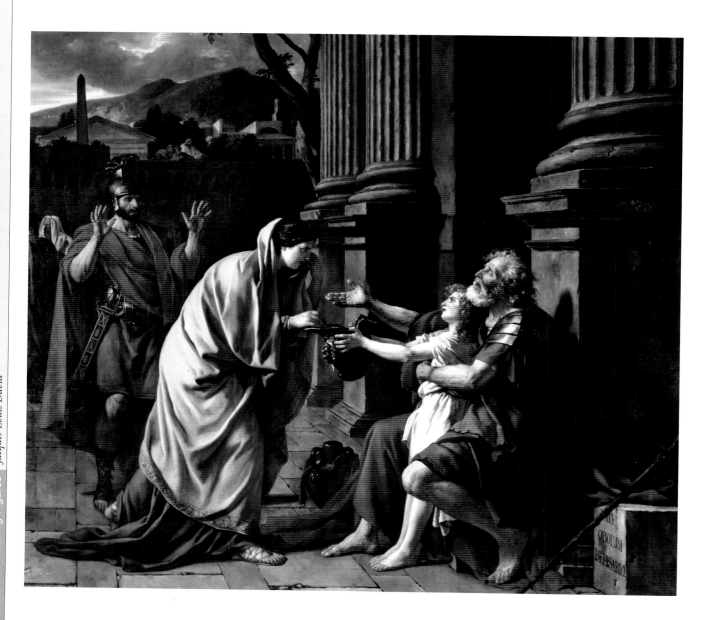

a historical artist. A fervent Jacobin, he depicted subjects related to the French Revolution, like *The Death of Marat* (1793), followed by *The Intervention of the Sabine Women* (1794–99), permeated by the same emotional involvement. He also produced portraits of Napoleon, celebratory subjects of the Empire, first *The Coronation of Napoleon and Josephine* (1805–7), the so-called *Napoleon Crowning Josephine*, then *The Distribution of Eagles* (1810). In the meantime, David continued to devote himself to portraiture: one of his best-known paintings, *Madame Recamier,* an exquisite expression of the feel of that period, is actually dated 1800. David's authoritative influence on the culture and style of Directoire and then Napoleonic France was also attributable to his school of painting, where the most fashionable artists of the time trained, including Anne-Louise Girodet-Trioson, Antoine-Jean Gros, François Gérard, François-Xavier-Pascal Fabre, and Jean-Auguste-Dominique Ingres. In 1815, after Napoleon Bonaparte's defeat at Waterloo, David took refuge in Switzerland and then in Brussels (where he remained in exile until his death, refusing to return to the France of Charles X); here he devoted himself to mythological subjects of beguiling grace, and portraiture.

Facing page:
Jacques-Louis David
Belisarius Recognized by One of His Soldiers while Begging Alms
1781, oil on canvas.
Lille, Museum of Fine Art.

This painting was realized at the end of David's period of artistic study in Rome and exhibited at the 1781 Paris Salon, where it was received as a "marvel." It depicts the moving episode of a disgraced former general of Justinian, who was incarcerated and freed only after going blind. The rigorous compositional plan, with four figures posed to display their feelings and arranged with measured cadence, reflects David's interest in Nicholas Poussin's classical paintings, which had become the artist's primary inspiration together with ancient sculpture, during his years in Rome.

Jacques-Louis David
Portrait of Count Stanislaus Potocki
1781, oil on canvas.
Warsaw, Warsaw National Museum.

The sophisticated grace of the gentleman, astride a fiery horse with a curled mane, is accentuated by the light-colored luminosity of the palette and the verve of the brushwork. Exhibited with Belisarius at the 1781 Salon, the painting portrays a young Polish aristocrat, a relative of the royal family, during his "grand tour" of Italy. Potocki, a refined, cultured collector of "old things" as well as paintings, met David in Rome in 1780, and commissioned the portrait. He paid a considerable sum, as documented in a letter written by a Swedish painter who was amazed and somewhat envious of David's good fortune.

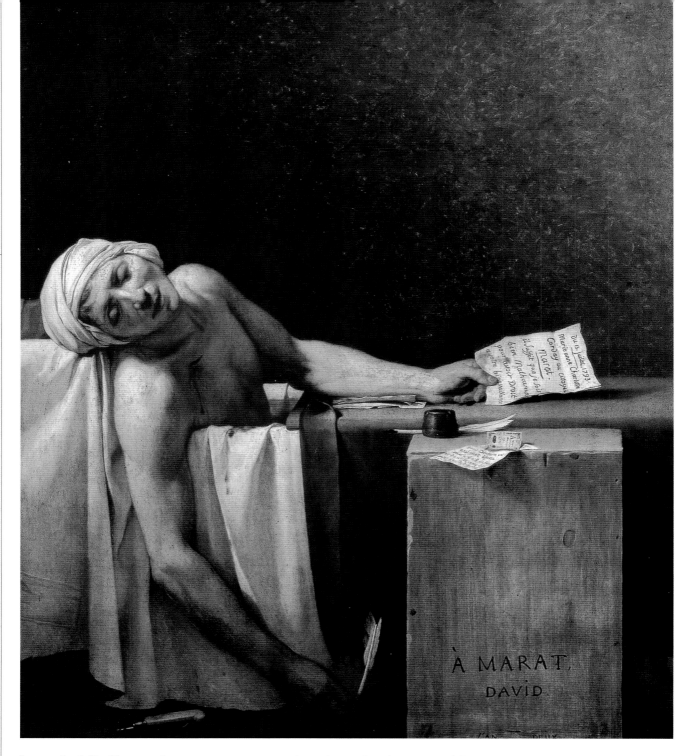

Jacques-Louis David
The Death of Marat
1793, oil on canvas.
Brussels, Royal Museum
of Fine Arts.

The Convention commissioned David to produce this work just after Charlotte Corday murdered Jean-Paul Marat. The painting depicts the body of the important French revolutionary from a very close angle, thrown back in death. The livid colors of the scene, enhanced by the contrasting whites and greens that so rigidly articulate the composition, accentuate the dramatic tone of this moving and austerely solemn image. In an affirmation of the artistic and ethical value of the painting, Charles Baudelaire wrote that it was "as cruel as nature" and had "the fragrance of ideals."

Jacques-Louis David
Portrait of Alphonse Leroy
1783, oil on canvas.
Montpellier, Fabre Museum.

Leroy was a famous gynecologist who was not well liked at the Paris faculty of medicine because of his provocative opinions. As part of an established tradition, Leroy attended the birth of the painter's first son, in 1783. This was probably the reason behind the portrait, which was exhibited in the Salon that same year, and deemed to be "full of truth." Leroy is portrayed in the intimacy of his studio, wearing an iridescent silk robe; turning away from his studies for a moment, the subject gazes at the spectator with intelligence and frankness. The painting, suffused with an intense human sensitivity, can be regarded as a reinterpretation of the characteristics and compositions of Raphael's portraits, adjusted to David's era.

Jacques-Louis David
Napoleon in His Study
1812, oil on canvas.
Washington, National
Gallery.

The emperor is portrayed standing in front of his desk at night, emphasizing his tireless dedication to France. The official nature of the image is tempered by an insightful depiction of the man's features that suggests his sensitivity and frame of mind.

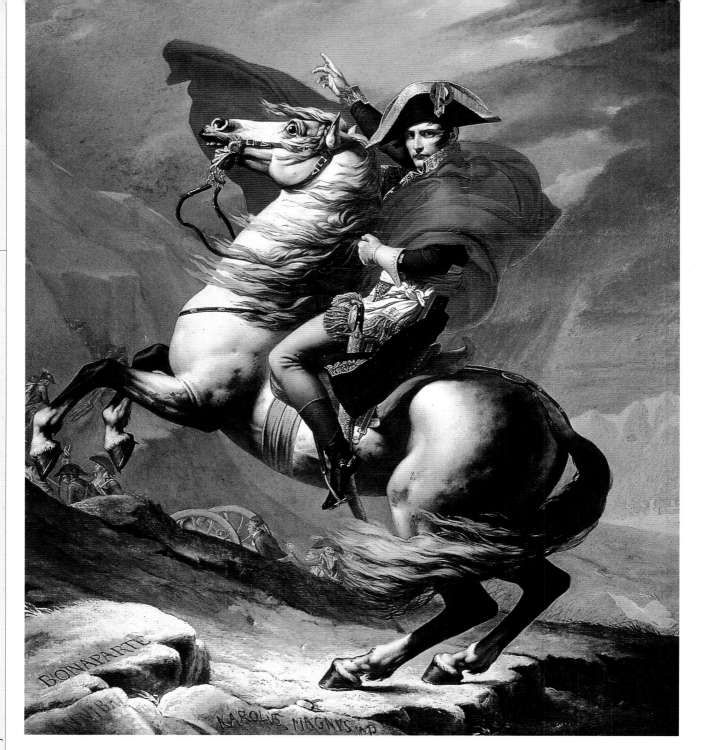

Jacques-Louis David
Napoleon at the Saint Bernard Pass
1801, oil on canvas. Rueil-Malmaison, Malmaison Castle National Museum.

This equestrian portrait of Napoleon glorifies the figure of the young official who, like the great soldiers Hannibal and Charlemagne, defeated the harshness of nature to complete his mission victoriously. The brushwork accentuates the imposing tone of the image, where a tempestuous wind ruffles the clouds, Bonaparte's cloak, and the rearing horse's mane and tail. The painting belies David's many artistic inspirations, which in this case are taken from Baroque pictorial and sculptural equestrian portraits, from Rubens to Bernini.

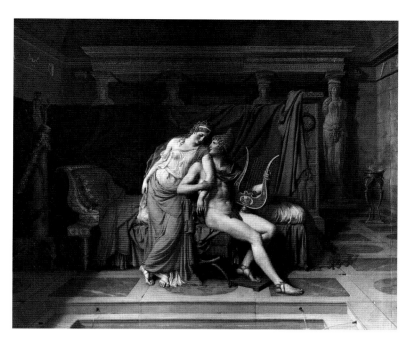

Jacques-Louis David
The Love of Paris and Helen
1788, oil on canvas.
Paris, Louvre.

David depicts the lovers at the center of the composition, in the intimacy of a bedroom appropriately furnished in the ancient fashion, but concordant with the principles of contemporary aesthetics. Though chastely posed in a manner reminiscent of classical art, the figures capture in full the atmosphere of intense sensuality evoked by Homer's text. David masterfully combined the severe perspective of the layout, conceived as an optical box, with the sumptuous elegance of the furnishings, heightened by the warm colors of the disheveled blankets and the tub opening in the colored marble floor. This resulted in an interpretation of antiquity pervaded by a tender sense of beauty, a sentiment that not only characterized the artist's work until his death, but also influenced the style of French artists well into the nineteenth century. The painting was commissioned in 1787 by Louis XVI's younger brother, the future Charles X, and was confiscated during the Revolution. The work was publicly exhibited for the first time in 1820, in the Musée du Luxembourg, dedicated to modern French art at the time.

Jacques-Louis David
Mars Disarmed by Venus and the Three Graces
1824, oil on canvas.
Brussels, Royal Museum of Fine Arts.

David painted this work a year before his death, during his exile in Belgium. It demonstrates how the artist adapted his style to the requirements of the Restoration with more pleasant, appealing nuances, while retaining the distinction of the form. The classical pose of the figures is offset by the authenticity of their features and their surroundings, with beautiful "ancient style" furnishings, albeit suspended among the clouds. The work has an exquisite grace, far removed from the solemn severity that characterized David's paintings before the Congress of Vienna.

Pierre-Paul Prud'hon
(b. Cluny 1758, d. Paris 1823)

Prud'hon studied in Dijon and in 1784 he won the Prix de Rome, allowing him to travel the city, where he remained until 1788, studying antiquity, the Renaissance, and seventeenth-century art. He settled in Paris and began to exhibit historical and religious works, and portraits, at the Salon. His corpus was permeated with the exquisite sensuality that also refined his allegorical paintings of the Revolution. Success smiled on him during the time of the Empire, when he painted the portrait of the empress Josephine, at Malmaison, and *Justice and Divine Vengeance* (1804). His career really reached its peak, however, with the 1808 Salon, where he exhibited, among other works, *The Abduction of Psyche by Zephyrus to the Palace of Eros*. After the Restoration, he obtained some important commissions for religious paintings, including *The Assumption of the Virgin Mary* (1819) and *The Crucifixion* (1823). His final paintings are veined with a subtle melancholy, linked to his personal life and the suicide of the woman he loved.

Pierre-Paul Prud'hon
Self-portrait, detail, 1780–83, engraving from 1876.

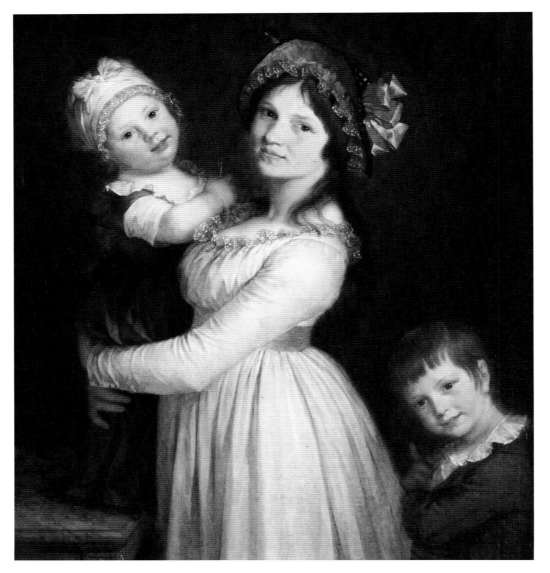

Pierre-Paul Prud'hon
Portrait of Madame Anthony with Her Children
1796, oil on canvas. Lyon, Museum of Fine Arts.

The close perspective accentuates the image of the young woman dressed in white and her children; set against a dark background and illuminated by a strong frontal light, their features are suffused with vivacity and tenderness, inspiring a sentiment of deep human charm. The older child, raising his right index finger, may be pointing towards an image of his father, depicted in a complementary portrait to this opus (now in the Museum of Fine Arts, Dijon).

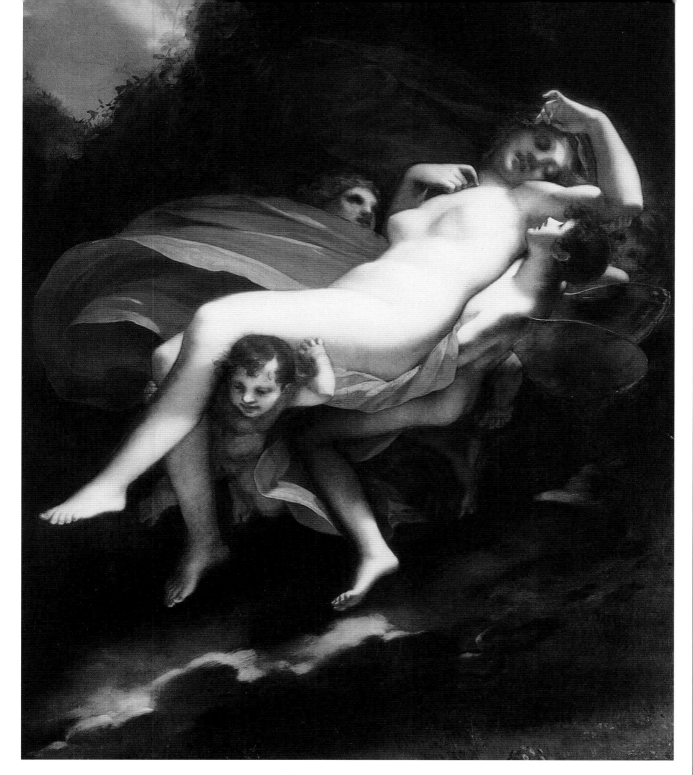

Pierre-Paul Prud'hon
The Abduction of Psyche by Zephyrus to the Palace of Eros
1808, oil on canvas.
Paris, Louvre.

This painting was exhibited next to *Justice and Divine Vengeance* (1804) at the 1808 Salon. The work provided proof of the artist's great skill, as he was capable of painting with equal talent severe, dramatic moral themes and agreeable subjects suffused with sensuality. The noble rendering of form, the mannerisms of the Enlightenment, and references to the art of the past (where the influences of Rosso Fiorentino and Correggio interweave with the ancient, endowing the scene with the pathos of "sublime" painting) were all adapted to the classical myth of Psyche and Cupid.

Marie-Louise-Elisabeth Vigée-Lebrun
(b. Paris 1755, d. 1842)

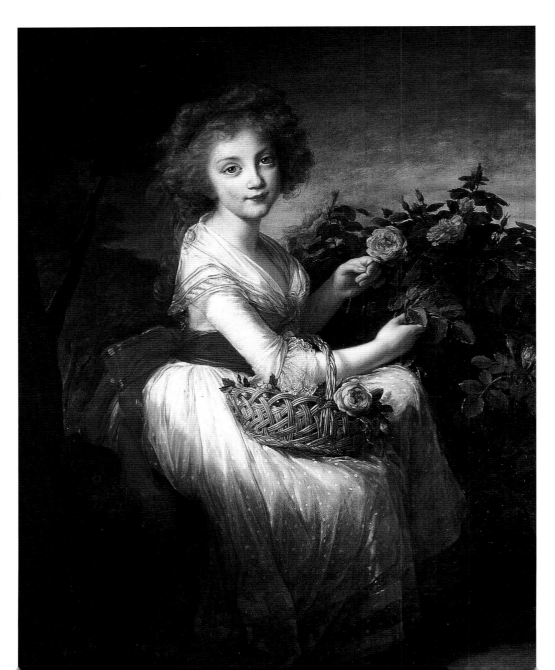

Marie-Louise-Elisabeth Vigée-Lebrun, *Self-portrait*, detail, 1789, oil on canvas. Florence, Uffizi Gallery.

An artist's daughter, Marie-Louis-Elisabeth Vigée began to work at a very young age. In 1776, she married art dealer Jean-Baptiste-Pierre Lebrun and devoted herself so successfully to portraiture that Queen Marie Antoinette called her to Versailles in 1779. Vigée-Lebrun worked for the royal family and the court for seven years. A trip to Flanders and Holland in 1781 was decisive for the development of her style. In 1783, Louis XVI ordered she be admitted to the Académie Royale de Peinture et de Sculpture. Given her court associations, she left France when the Revolution broke out, traveling around Europe for twelve years, from Rome to Naples, from Vienna to Moscow, receiving praise everywhere for her art. On returning to Paris in 1801, she received commissions from abroad and she left for England, where she painted Lord Byron, and then for Switzerland (1807). She published her memoirs in 1835.

Marie-Louise-Elisabeth Vigée-Lebrun
Portrait of Maria Cristina of Bourbon
1790, oil on canvas. Naples, National Museum and Galleries of Capodimonte.

As soon as she reached Naples, Vigée-Lebrun received a commission to paint portraits of the royal children. The youngest child, Maria Cristina, is portrayed in a garden, gathering roses. The white *plumetie* muslin dress, pulled in at the waist with a bright red band, accentuates the image's refreshing "rustic" grace. This painting was an ideal extension to the artist's portraits of the child's aunt, Marie Antoinette of France, which were quite different from conventional court portraits.

Louis Gauffier

(b. Poitiers 1762, d. Florence 1801)

A winner of the Prix de Rome, Gauffier arrived in Rome in 1784, where he remained at the French Academy for four years. In 1789 he returned to Paris, but the economic crisis caused by the Revolution persuaded him to settle in Italy, first in Rome, then in Florence (from 1793), where he gave up historical painting to devote himself to landscapes and portraiture, partly as a consequence of his monarchist political belief that precluded the protection of revolutionary France. The beautiful Vallombrosa landscapes date to 1796, as do the numerous portraits of the erudite, cosmopolitan society that gravitated around the circle of poet Vittorio Alfieri and the Countess of Albany, which Gauffier frequented with the painter François-Xavier Fabre. Gauffier's intimate portraits, set in the countryside, embodied the new sentimental view of nature; their innovative character typified the Restoration from that point on.

Louis Gauffier, *Self-portrait,* detail, 1800, oil on canvas. Florence, Uffizi Gallery (stored at Pitti Palace, Modern Art Gallery).

Louis Gauffier
Self-portrait with His Wife and Children
1800, oil on canvas.
Florence, Uffizi Gallery
(stored at Pitti Palace,
Modern Art Gallery).

The modest size of this family scene, set in a fictitious landscape appealing to the neoclassical imagination, accentuates its intimate character. The artist's wife, also a painter, leans with easygoing charm against an ancient altar and, setting aside her sketchbook, accepts her role as model; in the foreground, the children sit on the grass and participate with interest. Destiny soon destroyed this idyllic domestic situation—just a few months later the Gauffier couple died, and the artist's paintings and drawings were dispersed in a sale organized to benefit the two orphans, who then became wards of the painter Fréderic Desmarais.

Philipp Otto Runge

(b. Wolgast, Pomerania 1777, d. Hamburg 1810)

Philipp Otto Runge, *Self-portrait*, detail from *We Three*, 1805, pencil on white paper. Berlin, Old National Gallery, State Museum of Berlin.

Runge arrived in Hamburg in 1795 to devote himself to trade and mixed with the literary scene, also taking drawing lessons. In 1798, he became a pupil of Nicolai Abraham Abildgaard at Copenhagen Academy. From 1801 to 1803 he studied in Dresden, where he met Caspar David Friedrich. He developed a color theory, which he discussed with Goethe, whom he had met in Weimar in 1803, and who regarded him as the most important artist of the time. In 1804, he settled in Hamburg, where he dedicated himself to landscapes, which he deemed to be the greatest of the figurative genres, and which he interpreted applying a mystical idea of nature. Runge also produced portraiture, but this was expressed in turgid, compact shapes. In 1810, he published his treatise on colors, *Farbenkugel*, a work that had great influence on art in Germany and elsewhere, in the nineteenth and twentieth centuries.

Philipp Otto Runge
The Hülsenbeck Children
1805, oil on canvas. Hamburg, Kunsthalle.

This image of the three siblings playing in their garden is steeped with an abstracting quality by the clear rendering of the contours, influenced by German Renaissance art and apparent in the affectionate attention to details that so warmly evoke everyday life. Runge believed the world of childhood to be precious, identifying that period of life with superior creativity because of the innocence and imagination that characterize it.

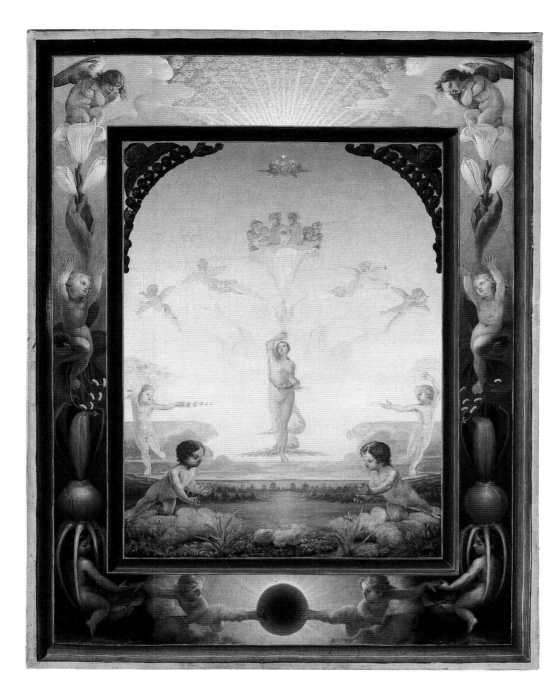

Philipp Otto Runge
Morning
1808, oil on canvas.
Hamburg, Kunsthalle.

Morning was inspired by
a series of engravings
depicting *The Times of
the Day*, completed in
1805. The painting
expresses, with its
obvious figurative
charm, the artist's
conception of the world
and art. Aurora,
illuminated by the rising
sun, symbolizes the
beginning of life; the
connection between
childhood and nature
alludes to a state of
innocence that is a
source of endless bliss.

Karl Friedrich Schinkel
(b. Neuruppin 1771, d. Berlin 1841)

Schinkel studied architecture in Berlin and in the meantime created designs for a pottery factory. From 1803 to 1805, Schinkel lived in Italy, where he completed landscape studies and also studied ancient art, which he then used to draw monumental dioramas. A similar exercise allowed him to work as a set designer, and he created forty-two designs between 1815 and 1832. He began to work as a state architect in 1815. His brilliant work gave a new structure to Berlin: official buildings and residences, churches, museums, theaters, and private homes all reflected his love for classical architecture. Nonetheless, plans that were never brought to fruition indicate his penchant for the Gothic style, linked to the events occurring in England, where he visited in 1826. The trip proved to be important for Schinkel's artistic development, as he was interested in industrial architecture.

Friedrich Tieck, *Bust of Karl Friedrich Schinkel*, detail, 1819, marble. Potsdam, Foundation of Prussian Palaces and Gardens Berlin-Brandenburg.

Karl Friedrich Schinkel
The Arrival of the Queen of the Night
1815, gouache.
Berlin, Old National Gallery, State Museum of Berlin.

The queen stands on a crescent moon immersed in the immensity of the starry sky. This set was designed for the January 1816 production of Wolfgang Amadeus Mozart's *Magic Flute* (Act I, Scene 6), in Berlin. The mysterious hallowed quality of the figure merges beautifully with the magical effect of the surrounding heavenly vault.

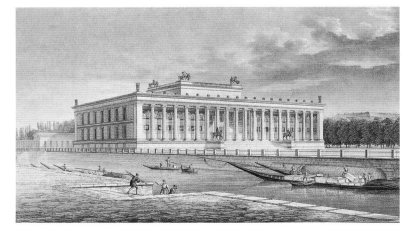

Friedrich Thiele, after **Karl Friedrich Schinkel**
The Altes Museum
1825, etching.
Berlin, Print Room, State Museum of Berlin.

Schinkel worked on the building of a new museum in the heart of Berlin between 1825 and 1830. The sobriety of the architectural volumes enhances the austere monumentality of the building, whose main façade is decorated with an imposing Ionic colonnade. The grand entrance hall, featuring a domed ceiling and completed with a velarium (called the "rotunda"), was the museum's key feature. The hall's impressive appearance evoked in visitors an appropriate spirit for appreciation of the museum's artworks.

John Nash

(b. London 1752, d. Isle of Wight 1835)

William Hoane, *Portrait of John Nash*, detail, 1826, oil on canvas.

As the apprentice of Robert Taylor, Nash had already shown himself to be a brilliant, innovative town planner in about 1780, building his first London houses with stucco façades. From 1783, he worked with the landscape gardener Humphrey Repton, developing numerous country homes that brought him great success. His open-minded eclecticism led him to make candid reference to various styles and models, from the Italian Renaissance to oriental exoticism. His most significant contribution was, nevertheless, the urban renewal of London. He worked on the layout of Regent's Park and Regent Street from 1811, creating an initial model of a garden city; from 1820 he planned Trafalgar Square, Suffolk Street, and Suffolk Place, and began work on Buckingham Palace. In 1830, the death of George IV brought his career to an abrupt end.

John Nash
The Royal Pavilion
1815–23.
Brighton.

The pavilion is a striking example of John Nash's talent for adopting the architectural styles of different eras and cultures to create buildings with surprisingly evocative forms, suited to their intended use. The exotic appeal of an imagined—rather than known—India befitted the levity of its illustrious guests' vacation lifestyle in England's most famous seaside town: Brighton.

Francisco Goya y Lucientes
(b. Fuendetodos 1746, d. Bordeaux 1828)

Goya was apprenticed in his hometown, and after a few vain attempts to enter Madrid Academy he left for Rome in 1770. On his return, in June 1771, he obtained various commissions in Saragossa. Thanks to his brother-in-law, the painter Francisco Bayeu, he received his first important engagement in Madrid (1774): a set of cartoons for the Real Fábrica de Tapices de Santa Barbara, a job that lasted until 1791. In the meantime, he became a member of the Royal Academy of San Fernando (1780), frescoed the dome of the Vergine del Pilar in Saragossa, painted high-society figures and, in 1789, was appointed painter for the King's chambers. In 1792, a serious illness left him deaf, and the ensuing depression developed into a spiritual crisis that tainted his art with pessimism, as can be seen in the *Caprichos*

Francisco Goya y Lucientes
Self-portrait, detail, 1795, charcoal.
New York, Metropolitan Museum of Art.

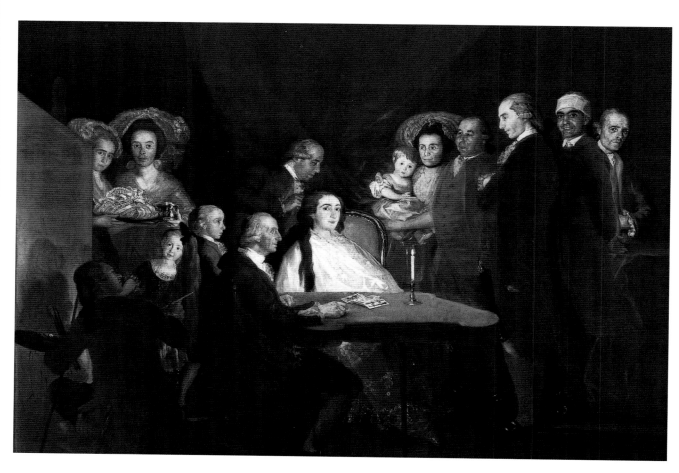

Francisco Goya y Lucientes
The Family of Infante Don Luis de Borbón
1783, oil on canvas.
Parma, Magnani Rocca Foundation.

This painting portrays the family of the brother of Carlos III of Spain in a scene from everyday domestic life. In the evening, Luis de Borbón finishes a game of solitaire, watched by his children and servants gathered around the table, while his wife prepares for the night; only a young girl shows interest in the artist, who is seated at his easel, preparing to paint the scene. The dim candlelight accentuates the intimate nature of the scene, whose charm lies in its inventiveness and narrative novelty.

series of etchings. From 1796 to 1797 he was a guest of the Duchess of Alba, whom he painted many times. *The Family of Charles IV*, an unconventional portrait of the Spanish royal family, dated 1800, marked the peak of his triumph. The 1808 Spanish crisis, followed by the French invasion, the rule of Joseph Bonaparte, and the repressions that ensued, inspired the painter to create (in 1814) *The Disasters of War* series, as well as two paintings of the May revolt. When Goya was accused by the Inquisition, in 1815, it marked the beginning of his decline and prompted him to retire to a house in the suburbs (1819), subsequently called "the house of the deaf man." The artist painted

dramatic scenes on its walls and these, together with the *Disparates/Los Proverbios* (*The Absurdities/The Proverbs*) (1820) engravings, document the most obsessive period of his art. Frightened by the king's repressive politics, Goya settled in Bordeaux in 1824, where he learned lithographic techniques, which he used for the *Bulls of Bordeaux* series. He also devoted himself to genre subjects like *The Milkmaid of Bordeaux*. In 1826 he made a final trip to Madrid before retiring for good to Bordeaux, where he died.

Francisco Goya y Lucientes
The Sleep of Reason Produces Monsters
c. 1799, preparatory drawing for an engraving in the *Caprichos* series. Madrid, Prado Museum.

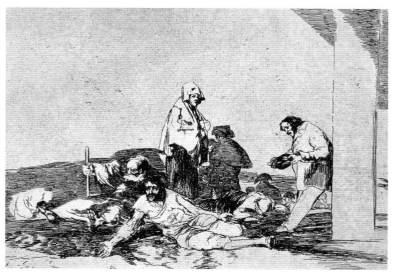

Francisco Goya y Lucientes
Misery and Elegance from
The Disasters of War
1811–20, engraving.

The artist's exuberant creativity, permeated with drama, irony, and visionary imagination, found its full expressive potential in the medium of engraving. Goya employed this technique with commanding confidence, bending the chisel to the whims of his imagination, seen clearly in these series: *Los Caprichos*, completed at the end of the seventeenth century, *The Disasters of War*, a tragic meditation on the political events in Spain during the French occupation, and the lithographic series *Toros de Burdeos*, realized between 1824 and 1825 during his voluntary exile in Bordeaux.

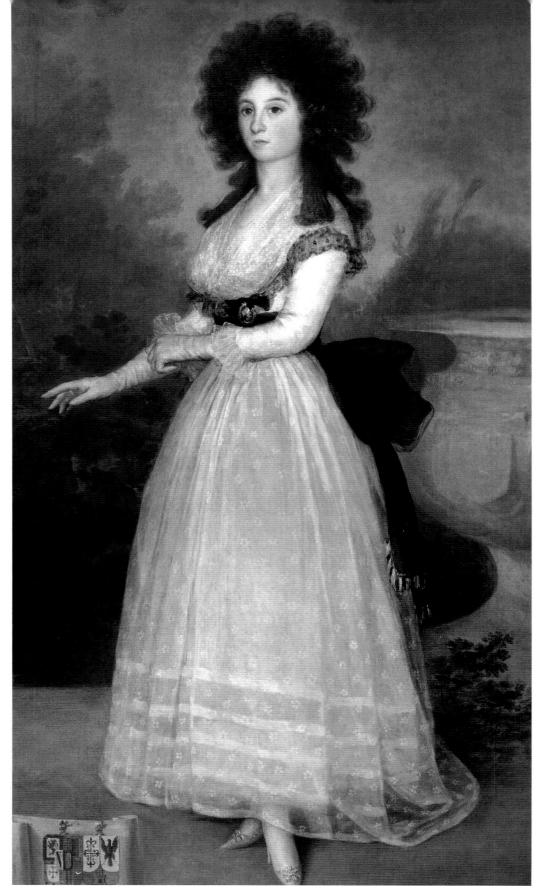

Francisco Goya y Lucientes
Dona Tadea Arias de Enríquez
c. 1790, oil on canvas. Madrid, Prado Museum.

The slender, modest figure of the young bride emerges with aristocratic detachment against a garden background depicted sketchily with rapid, "watery" brushstrokes. By lingering on the details of garments and hairstyle, Goya brought forth the character of the young woman and even suggested her state of mind.

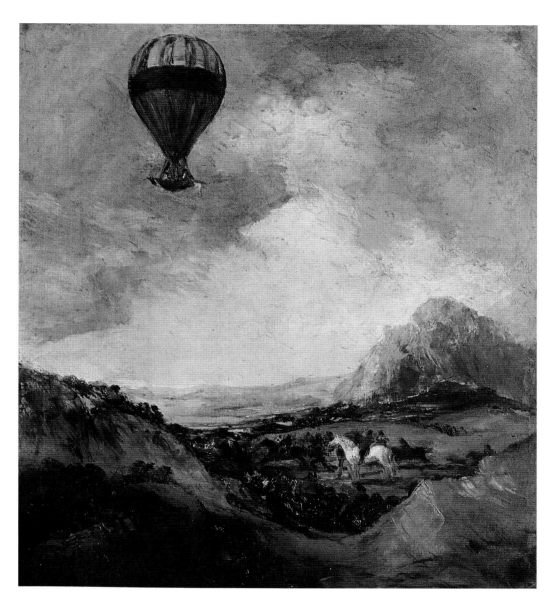

Francisco Goya y Lucientes
The Balloon
1813–16, oil on canvas.
Agen, Museum of Fine Arts.

In a valley encircled by hills, men and horsemen watch the ascent of a hot-air balloon in amazement as it rises delicately into a sky with ever fewer clouds. The apparently rapid brushwork producing patches of color aptly expresses the spectators' emotions, and simultaneously suggests the artist's disillusionment with progress, which he had previously welcomed with the enthusiasm typical of aficionados of the Enlightenment.

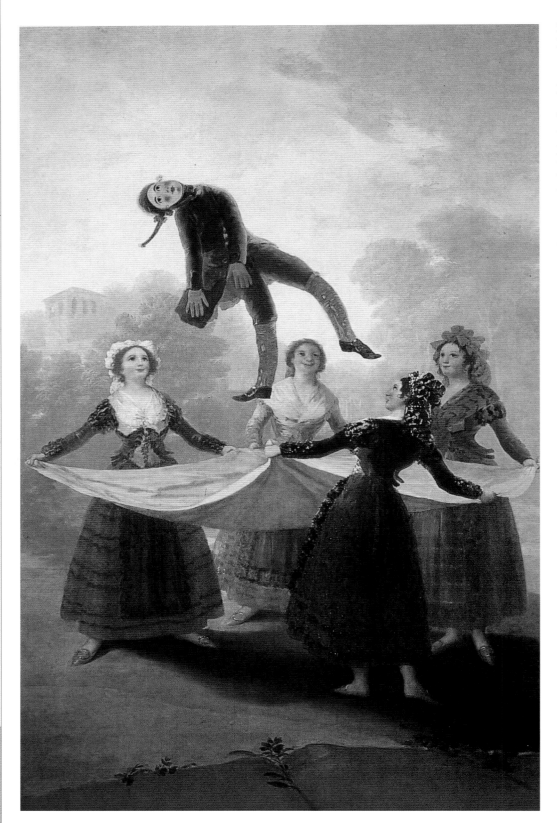

**Francisco Goya y
Lucientes**
The Puppet
1791–92, oil on canvas.
Madrid, Prado Museum.

This painting was part of
the final series of
patterns Goya produced
for the Real Fábrica de
Tapices (Royal Tapestry
Workshop) of Santa
Barbara. The very light
shades add an even more
pleasing, playful aspect
to the subject, which was
requested by the king.
Goya, who by that
time had built up great
experience with this
tapestry maker, simplified
the composition and
treated the human
figures as caricatures,
with puppet-like
features. The scene can
therefore be viewed as
an allegory of Humanity
at the mercy of Fate.

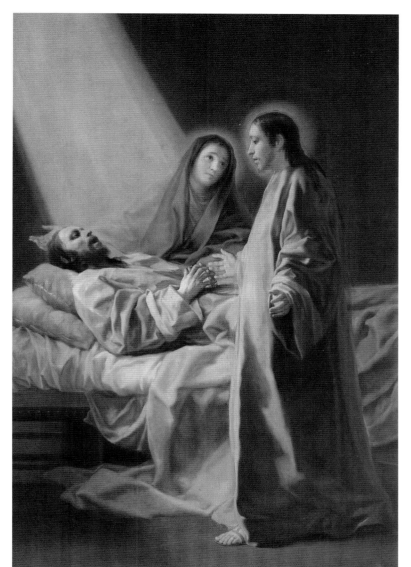

Francisco Goya y Lucientes
The Death of St. Joseph
1787, oil on canvas.
Valladolid, Monastery of
Saint Joachim and Saint Anne.

Goya painted this work for the medieval monastery
after its renovation in the neoclassical style by
Francesco Sabatini. The painting demonstrates that
Goya was *au fait* with the most recent styles in
European painting. The luminous radiance of the
colors, reminiscent of Tiepolo, emphasizes the serene
quality of this austerely simplified scene.

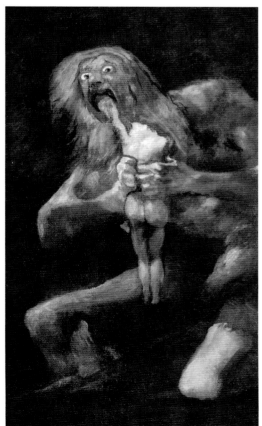

**Francisco Goya y
Lucientes**
*Saturn Devouring His
Children*
1820–23, oil on canvas.
Madrid, Prado Museum.

The monstrous, powerful figure of Saturn emerges
from the shadows, forcefully biting his own son's
bloody body. The painting, which before being
transferred to canvas decorated the walls of the
"house of the deaf man," is pared down to colors
applied with contorted strokes and enhanced by the
dramatic power of darkness. Nineteenth-century
artistic literature made an analogy between the figure
of Saturn—the allegorical representation of the
passing of time and the victory of night over the
sun—and the languishing old artist, weary of life.

Francisco Goya y Lucientes
Pedro Romero
1795–98, oil on canvas.
Forth Worth, Kimbell Art Museum.

The close perspective of this portrait accentuates the intense gaze of one of the most famous bullfighters of the time. The portrait was painted with a spontaneity that emphasized the mutual feelings of affinity and respect between the artist and the subject. The extraordinary whiteness of Romero's shirt contrasting with the black of his suit and headdress illuminates the painting, which was created in accordance with strict compositional divisions.

Francisco Goya y Lucientes
The Duke of Alba
1795, oil on canvas.
Madrid, Prado Museum.

The subject was the husband of one of Goya's most famous female patrons. The duke is dressed in riding clothes and portrayed in an informal pose, leaning against a pianoforte, as he looks through a Haydn score; there is a violin next to him, which he played with great skill. The carefully depicted setting enhances the man's character and culture, portraying him according to the international models seen in portraiture from Thomas Gainsborough to Jacques-Louis David.

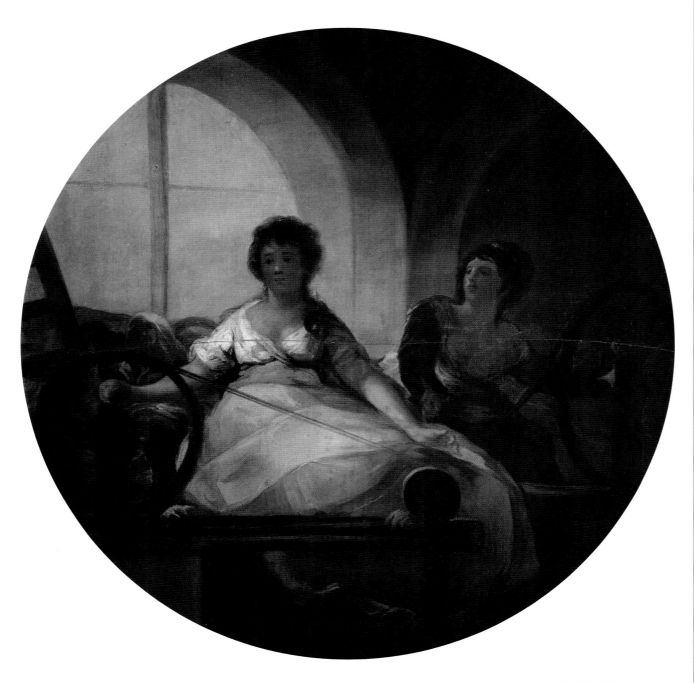

Francisco Goya y Lucientes
Allegory of Industry
1801–5, oil on canvas.
Madrid, Prado Museum.

The circular canvas dictates the figurative design of this composition. The work was commissioned by Manuel Godoy and formed part of a series of four round paintings depicting the pivotal economic and cultural aspects of progress: Commerce, Agriculture, Industry, and Science (now lost). Goya painted a spinning mill for the allegory of Industry, adopting Velázquez's *The Spinners* as a refined pictorial precedent.

On Page 90:
Jean-Baptiste Wicar
Portrait of Julie Clary, Wife of Joseph Bonaparte, with Her Daughters
1808, oil on canvas.
Caserta, Royal Palace of Caserta.

Lifestyles

in the Neoclassical Period

Lifestyles in the Neoclassical Period

An International Style

In the second half of the 1700s, a shared language of form, common to Europe and North America, involved all branches of artistic production, from architecture to decoration, furnishings to fashion and jewelry. Some highly fertile publishing activity contributed decisively to the widespread diffusion of the neoclassical style, with the intention of raising awareness of antiquities, antique collections; contemporary architects and decorators were inspired by ancient models and paintings that depicted Homer's subjects with historical accuracy. Albums, in-folio volumes, prints depicting the antiquities of Herculaneum, the vase collections of the count of Caylus and of D'Hancarville, Gavin Hamilton's Homeric paintings, Piranesi's *Diverse maniere d'adornare i camini*, to mention but a few of the iconographic and stylistic sources of European art in the closing decades of that century, worked together in decreeing a substantially uniform style that left its mark on everyday furnishings and objects, imbuing them with some historical memory. The innovative interest in the decorative arts was due to the discovery of Herculaneum and

Cristoph Heinrich Kniep
Sir William Hamilton and Emma Hamilton
Witness the Discovery of a Few Ancient Vases
in a Tomb in Nola
c. 1790, pen and ink on paper.

This is a preparatory drawing for the frontispiece of the first of four volumes of engravings edited by William Hamilton and Wilhelm Tischbein, entitled *Collection of Engravings from Ancient Vases Mostly of Pure Greek Workmanship Discovered in Sepulchres in the Kingdom of the Two Sicilies but Chiefly in the Neighbourhood of Naples . . .* Hamilton dedicated the work, published between 1791 and 1795, to Milord Leicester, president of the Society of Antiquarians of London. In Kniep's drawing, the couple admires a precious archeological discovery in the midst of the site's bustling activity.

Joseph Gandy
The Breakfast Parlour
dated November 1798, watercolor.
London, Sir John Soane's Museum.

This is a rare depiction of the scholarly antiquarian John Soane's first residence, located at 12 Lincoln's Inn Fields, London. The room served as both an informal dining room and a library, as can be seen from the faux bamboo chairs and the six mahogany cabinets along the walls. The ceiling is embellished with a Pompeii-inspired vault that simulates an arbor, painted by John Crace in 1793.

Pompeii. The objects recovered in the excavations, together with the mural paintings that recalled the daily life of the ancients with considerable impact, proved extremely useful in discovering more about the classical world. As Anna Ottani Cavina observed, "in the many daily objects that emerged, 1700s critics perceived not only the fact of their beauty, but also the rationalities and functionalities that were able to promote the social grading that Enlightenment philosophy contemplated" (Ottani Cavina 1982, 605). Understated lines, simplified forms, and solidity, inferred from the rationality and functionality of antique objects, became intrinsic qualities of the neoclassical style and allowed serial production of common objects and furnishings, which was certainly facilitated by scientific progress and deemed indispensable for civic and cultural social growth. One example is Englishman Josiah Wedgwood's pottery factory, which affirmed itself throughout Europe, manufacturing impeccable china, inspired by the ancient models but produced thanks to innovative technical processes. In 1768, Wedgwood began to produce his "Etruscan" china, with a faux bronze effect; in 1774, his "Jasper" imitated precisely that mineral.

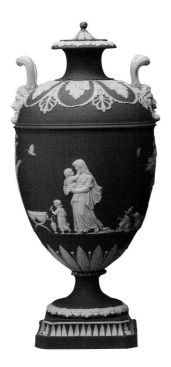

Josiah Wedgwood and John Flaxman
Vase
c. 1790, blue jasper.
New York, Metropolitan Museum of Art.

The vase was designed by John Flaxman for production by Josiah Wedgwood's Staffordshire factory. The figures are rendered in white relief on a blue background and represent a scene of motherhood and childhood, in accordance with a common tendency at the time to combine neoclassical style with sentimental or moral subjects.

Adam Weisweiler
Louis XVI secrétaire, full view, and detail of biscuit tondo
c. 1788, *bois-de-citron*, carved and painted, gilded bronze, marble, biscuit.

This bureau was sold at Sotheby's auction house in London on June 15, 1990. A similar piece was recognized in the Austrian Imperial Collection at Schönbrunn (Vienna). In fact, that object has biscuit decorations of the same kind, evidently inspired by Josiah Wedgwood's designs. The bureau's look of precious fragility is enhanced by the insertion of biscuit tondos depicting amorous scenes.

Restrained Elegance and Recherché Simplicity

The diffusion of the neoclassical style came about thanks to awareness of classical Roman antiques and the writings of Piranesi, as well as the development of European aesthetic taste in that direction. This was soon reflected in cabinetmaking, and late-1700s furniture designs often involved other artistic techniques: carving, goldsmithing, bronze smelting, mosaics, porcelain, and, above all, marquetry. This skill was perfect for the polished, refined decorations sought by patrons, and various workshops excelled in

it, including the Maggiolini family's, in Lombardy. The shapes and ornamental motifs of furniture and furnishings did not imitate the antique, but rather paid homage to it, with the intellectual freedom and subjectivity that distinguished the culture of the time. The works fitted perfectly into the neoclassical interiors furnished with the restrained elegance and studied simplicity of the linear style, which favored light or white painted wood and delicate gilding, called "Louis XVI" in France and "George III" in England. Interiors decorated with stuccowork of supreme refinement, whose subtle reliefs hinted at noble Roman architectures, included those created by Robert Adam for the homes of the English gentry, and the

Real Laboratorio de Piedras Duras del Buen Retiro
Table with Pelota Players
c. 1784–88 (mosaic), 1791–96 (base), table top in hard-stone mosaic, gilded bronze base with hardstone fruit.
Madrid, Prado Museum.

This, and another, similar table, were listed in the furniture inventory of the royal palace, in Madrid, when Carlos III of Bourbon died in 1788. The depictions inspired those created in Florence by Giuseppe Zocchi several decades later, for Grand Duke François of Lorraine.

Grato and Giocondo Albertolli
Decorations for the Niobe Room
1774–79, gilded and painted stucco.
Florence, Uffizi Gallery.

These stuccos, produced from designs by Zanobi del Rosso, completed the decoration for the room created in 1779 to house the statues of Niobe and her children, which originally came from Villa Medici, in Rome.

inventions of Giocondo and Grato Albertolli, who decorated court palaces and villas for Lombard and Tuscan nobility, with classical motifs borrowed from ancient and Renaissance sources. Adam did not limit himself to designing country homes and townhouses to gratify the passion of educated, freethinking English patrons for the ancient world. With his brother James, he also designed interiors, down to the last detail, creating exquisitely elegant pieces inspired by classical sources and the Italian Renaissance, interpreted with such sensitivity that a specific style was born, later continued by the cabinetmakers George Hepplewhite and Thomas Sheraton. The understated

décor and clean, functional shapes became distinctive motifs of European potteries, including those of Lorenzo Ginori and Manifattura Reale di Capodimonte; the latter was relocated to Madrid, to the Buen Retiro palace, by Charles III, duke of Bourbon, when he became king of Spain in 1759. In fact, it was thanks to Charles III that the working of hard stones flourished in Spain, where (as in Florence and Naples) highly trained craftsmen used designs by famous artists to make refined products that paid homage to antiquity.

Ginori Porcelain Factory
Teapot with spout
c. 1770, porcelain.
Sesto Fiorentino (Florence), Richard-Ginori Museum.

This teapot features *mazzetto* decoration. The piece was created while the factory was managed by Lorenzo Ginori, son of the founder of Manifattura di Doccia (1758–91), and is noteworthy for the elegant simplicity of its decorations, which by that time were very different from Rococo models.

Sèvres Porcelain Factory
Vase with gilded putti and royal medallions
c. 1778, porcelain and biscuit.
New York, Metropolitan Museum of Art.

This vase was designed by Jacques-François Deparis (or Paris), famous for having ingenious juxtapositions of various materials. The figures are the work of Jean-Louis Morin and Nicholas Petit the Elder.

Lucca Production
Footrest with Elisa Baciocchi's monogram
c. 1805–9, carved and gilded wood.
Florence, Pitti Palace, Palatina Gallery.

Lifestyles in the Neoclassical Period

The Stately, Compact "Empire Style"

At the turn of the nineteenth century, the birth of the Napoleonic Empire encouraged the development of a style inspired by a more austere, solemn perception of antiquity, in line with the work of David. Known as the "Empire style," it quickly spread throughout Europe, supplanting the restrained linearity of the Directoire look, and tended to statelier, more compact forms, accentuated by a lavish ornamentation of bronze that stood out on mahogany. The decorative motifs included the imperial symbols of ancient Rome: eagles, winged victories, lictor bands, laurel or oak leaf crowns.

Besides a repertory taken from Greek, Roman, and Etruscan art, Egyptian motifs also found great favor, emerging after Napoleon's campaign in Egypt, illustrated in accounts by Baron Dominique Vivant Denon. Bronzesmiths and furniture-makers active in the imperial court, like Pierre-Philippe Thomire and François-Honoré Jacob, were the creators of models soon imitated by European craftsmen, first and foremost by those active in the Empire's satellite courts, governed by Napoleon's family. Napoleonic policy's interest in the decorative arts also gave a new thrust to the Sèvres porcelain factory, involved in manufacturing goods and crockery appropriate for suggesting imperial authority through the purity of form and

Florentine Production
Small worktable
c. 1815, wood with mahogany veneer, carved, painted, and gilded. Florence, Pitti Palace, Winter Quarter.

The table has a triangular top and supports carved in the shape of swans, tinted black and gilded, creating a contrast of color and form with the distinct linearity of the mahogany surfaces.

Roman Production
Inkstand
early nineteenth century, lapis lazuli and gilded bronze, rectangular plaque with miniature mosaic on front.

The landscape with classical ruins depicted in the miniature mosaic plaque enhances the elegance of the inkstand and completes the allusion to the ancient.

precious colors, highlighted with gold. To make the china even more opulent, it was sometimes glazed in gilt bronze to imitate Roman hard-stone tableware.

Jewelry and Fashion

Jewelry and fashion adjusted to the new trends. The former proposed objects of refined workmanship that also referred to antiquity for their crafting, for instance detailed mosaics whose iconographic motifs were inspired by Roman culture. The extraordinary precision of the art of miniature mosaic ensured it the same success—if not more—as hard-stone cutting. The possibility of obtaining high standards of quality and decoration, even on a small scale, made it suitable for embellishing small objects and jewelry, much admired by an increasingly vast international public. In the meantime, women's fashions proceeded to replace the airy softness of à la grecque models (further enhanced by diaphanous fabrics like crêpe, chiffon, and muslin) by concentrating the compactness of strictly geometrical lines, and dresses cut high on the bust, with refined tiny puff sleeves becoming the rage.

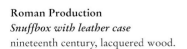

Roman Production
Snuffbox with leather case
nineteenth century, lacquered wood.

The small mosaic depicts the Pyramid
of Cestius in Rome.

François Gérard
Portrait of Queen Hortense
1805, oil on canvas.
Arenberg, Napoleon Museum.

The queen wears a typical neoclassical period dress, cut high at the bust and with short puff sleeves. The queen of Naples, Julie Clary, wore a similar dress for her portrait three years later, painted by Jean-Baptiste Wicar and illustrated on page 90.

Parks and Gardens

Neoclassical sensitivity took nature, in its good and its bad aspects, as its preferred and consummate point of reference, developing a new rapport with urban and rural landscapes. Towns were furnished with public gardens suitable for walking, festivals, and military parades. While the model of a park surrounded by houses prevailed in London, wide pathways were preferred in Paris, Madrid, Vienna, Berlin, Munich, Milan, and Florence, winding through meadows, copses, and tree-lined avenues, to hearten the soul of those who passed on foot or by carriage, as a traveler noted at the time (Zangheri 2003, 189). The differing awareness of nature meant that the aesthetic notion of the garden and its design were completely revised. The geometric layout of the Italianate garden, a clearly human design, gave way to the English model theorized by Horace Walpole: an image of dense, luxuriant greenery, furrowed with twisting paths—also of human planning, but intended to suggest visions of pastoral beauty, akin to those described in the ancient literature penned by Homer and Virgil. Thus, a journey parallel to that of coeval landscape painting, and with the same formal references: the classicist landscapes of Nicolas Poussin and Claude Lorrain.

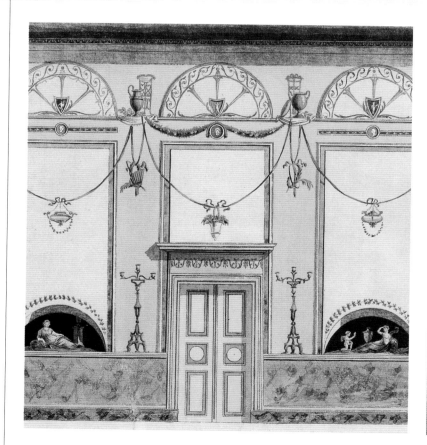

German Artist
Plans for the Decoration of a Garden Building
1796, engraving and etching, hand colored.

This is plate XII in the second volume of the German work entitled *Magazin für Freunde des guten Geschmacks der bildenden und mechanischen Künste, Manufakturen und Gewerbe*, which illustrates numerous examples of decorations inspired by the ancient world and offers recommendations "for friends with good taste."

The Park at Caserta Palace, in a view from above c. 1774.

Neoclassical parks were given the same "copses of a variety of trees, flowing streams, and small, ruined temples that reflect in still waters" that were found in these paintings. Water became a constant presence: ponds, streams, waterfalls, sometimes mirroring "ruins," sometimes of medieval rather than classical appearance, almost buried by vegetation. The aesthetic requirements of the eighteenth-century garden, which aspired to raze the distinction between the landscape and the closed, demurely cultivated space, ensured that it became a favorite place for reflecting on human rapport with nature. Europe soon mimicked the parks created in England, sometimes accentuating the literary echoes (as was the case of the dairy built in the Rambouillet jardin anglais, in 1785, for Marie Antoinette, who wished to create an Arcadia rich in bucolic sentiment accents), sometimes increasing the architectural magnificence (as in the Reggia di Caserta park, entrusted to the English gardener John Andrew Graefer), or even understanding and adhering totally to the original model, as occurred at Aranjuez, in Spain, thanks to the sensitivity of Juan de Villanueva.

The Temple of Apollo in the park at Stourhead, designed by Henry Flitcroft and Henry Hoare c. 1767.

Juan de Villanueva *Round Temple in the Palace Garden* 1784. Aranjuez.

Romanticism

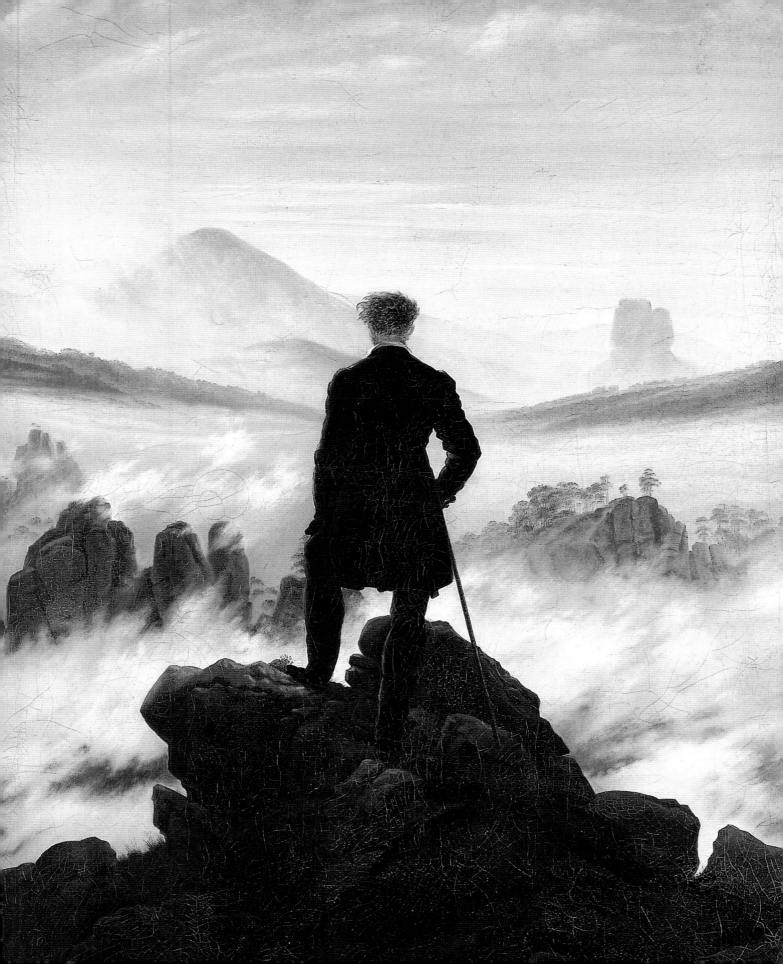

Previous page:
Caspar David Friedrich
Wanderer above the Sea of Fog
1818, oil on canvas.
Hamburg, Kunsthalle.

Johann Friedrich Overbeck
Joseph Being Sold by His Brothers
c. 1817, oil on canvas.
Berlin, Old National Gallery, State Museum of Berlin.

Nature as the Model of Truth

The enthusiasm stirred among contemporaries by the spontaneity and "truth" emanating from Bertel Thorvaldsen's frieze of the *Arrival of Alexander in Babylon* (painted, as mentioned earlier, in the early 1800s for Napoleon's Quirinal apartment, its composition adhering to the serene cadences of pure plastic linearity) was indicative of how quickly the widespread mind-set based on the ultimate truth of nature went on to influence aesthetic culture and taste, finally approving the decline of neoclassicism. Equally, the attitude to antiquity was also modified: the personal, free interpretation of the art of the past that might elicit private emotions or strict ethical lessons was replaced by a methodological recovery of these forms. Thus a form of art that aspired to true illusion was replaced by a model that expressed a misleading reality. A similar disparity in outlook is quite obvious in the different approaches taken by

Canova and Thorvaldsen with regard to archaeological restoration. The former categorically declared himself (London, 1816) to be against the period restoration of the Parthenon marbles, acquired by Lord Elgin and made known to the Western world for the first time; Thorvaldsen intervened—albeit on the wishes of the owner, later King Ludwig I of Bavaria—integrating, to the point of reinterpretation, fragments of statues from the pediment of the Temple of Aphaia at Aegina.

The Nazarenes

On the other hand, many of the young artists active in the early 1820s, above all the Nazarenes, were actually losing interest in the models of the ancient world. These German speakers first founded the Lukasbund (Brotherhood of Saint Luke, also known as the Nazarenes) in Vienna, under the guidance of

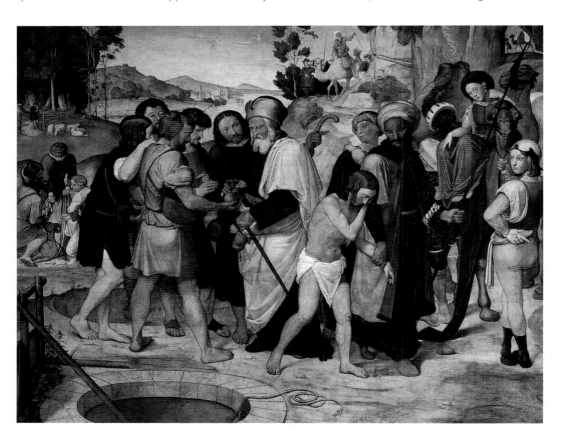

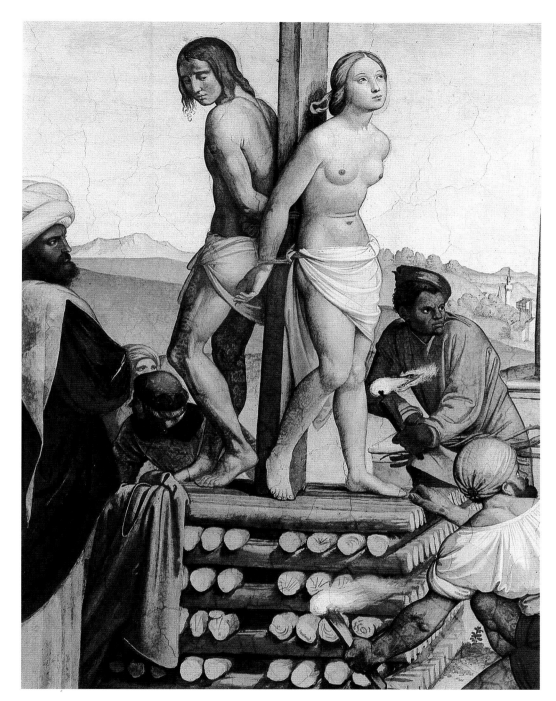

Franz Pforr and Johann Friedrich Overbeck, then in 1810 settled in Rome, in the old Sant'Isidoro monastery, where they became known for their community life, long hair, and old-fashioned garb. The Nazarene movement aimed to restore to art the ethical values associated with Christianity, and resolutely distanced itself from refined neoclassical beauty, whose sensual mythological themes it also censured, salvaging the style and subjects of German and Italian primitive painters, which were seen as exemplary in their purity and simplicity. It was no coincidence that the Nazarenes preferred

fresco technique, which they were able to try out in important decorative cycles executed in Rome after the fall of Napoleon: *The Story of Joseph* (1815–16) for Salomon Bartholdy (ambassador of Prussia), and the decoration of Prince Massimo's Lateran hunting lodge (1817–29), with subjects from Alighieri Dante's *Divine Comedy*, Ludovico Ariosto's *Orlando Furioso*, and Torquato Tasso's *Jerusalem Delivered*.

In Rome the Nazarenes found an important point of reference in their compatriot Josef Anton Koch, a follower of the style of Swedish painter Jacob A. Carstens, whom he had befriended on arriving in the city in 1795. Order, solemnity, and equilibrium, based on the austere, incisive draftsmanship of German primitive art, hallmarked Koch's paintings, inspired by dramatic subjects from "modern" literature, as in *Paolo and Francesca* or *Macbeth*.

The artist also painted urban scenes, however, and it was thanks to his assiduous visits that the Nazarenes turned to landscapes, adjusting to Italian landscapes the calm austerity of composition and the strict palette that had been developed for their figures.

Purism

The fresco technique, much admired by the Nazarene movement, "as it was congenial in expressing their interest in Italian primitive artists, together with the moral sense of the 'trade' of painter (instances of religious application to painting)" (Sisi 2003, 225), found favor in other Roman art spheres. The classical tradition was not entirely forsaken, however, nor were any historical subjects suitable for suggesting chosen moral values set aside, especially patriotic values dictated by nationalist aspirations at their height almost everywhere in Europe. This was the case of the young Palazzo Venezia *pensionnaires*, of whom Francesco Hayez was an outstanding figure and winner of the 1813 competition at the Accademia di San Luca, with his *Victorious Athlete*. It was mainly to these *pensionnaires* that Canova entrusted the fresco decoration of the new Chiaramonti Museum in the Vatican. Canova had his heart set on the cycle and paid generously for the fifteen lunettes celebrating Pius VII's policy of protecting the arts. Alongside Hayez and other young Italian painters, there were actually

Joseph Anton Koch *Dante Assailed by the Three Beasts*, full view and detail 1825–26, fresco. Rome, Casino Massimo, Dante room.

Philipp Veit
The Empyrean and the
Spheres of the Planets
1819–24, fresco.
Rome, Casino Massimo,
Dante room.

Left: **Josef Anton Koch**
Classical Landscape with
Rainbow
1802, oil on canvas.
Karlsruhe, Staatliche
Kunsthalle.

several Nazarenes who worked on the scheme, including Philipp Veit, who had returned from Casa Bartholdy, where he had frescoed two episodes of the *Stories of Joseph*. So Canova succeeded in harmonizing different formal styles in a single decorative context, including those of the Nazarenes and painters of the neoclassical tradition, foreseeing the theoretical foundations of purism. This aesthetic movement, which established itself in the 1820s, to be resumed in the 1840s, believed that art had reached its peak with the young Raphael, and had then fallen into irreparable decline. Purism actually proposed as key models for restoring modern art both the figurative "chastity" of the Nazarene move-

ment, modeled on the primitive artists, and the lofty stylistic qualities of Ingres and Thorvaldsen, instilling them with moral and educational values that were expressed by austere formal rendering.

The School of David

José de Madrazo, a Spanish pupil of Jacques-Louis David, also obeyed the rules of neoclassical culture. He lived in Rome from 1803, and in 1807 he painted *The Death of Veriato*—a subject taken from Spain's history—which was much admired by critics and immediately interpreted as a reference to the

José de Madrazo
Death of Viriatus
1807, oil on canvas.
Madrid, Prado Museum.

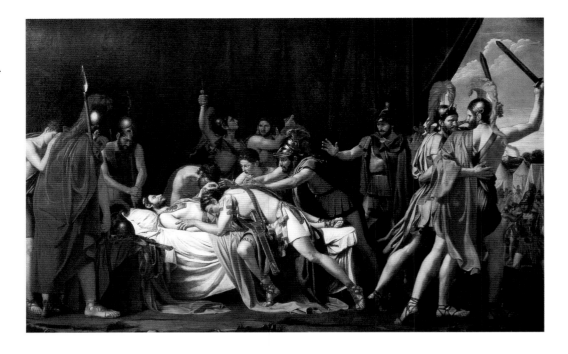

French occupation of Spain. Nonetheless, of David's pupils, it was Ingres above all who gave new lifeblood to the neoclassical idiom, articulating it with an unusual purity of line and color, which he soon adopted for subjects no longer taken from antiquity, but from the medieval and Renaissance world and literature, which were far dearer to the romantic attitude.

The Restoration

Following the fall of Napoleon Bonaparte, a need for social order and stability arose as a reaction to the overwhelming excitement of cultural and political events that had occurred in Europe over the last few decades, and were achieved when the 1815 Congress of Vienna sanctioned the Restoration.

**Jean-Auguste-
Dominique Ingres**
La Grande Odalisque
1814, oil on canvas.
Paris, Louvre.

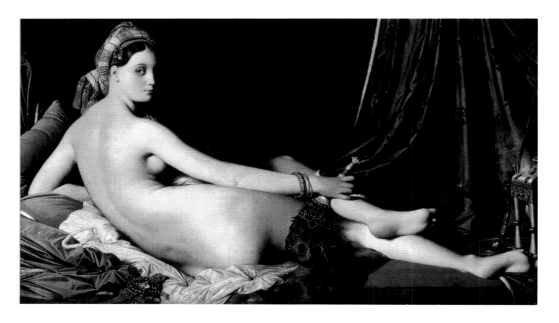

Thomas Cole
The Giant's Chalice
1833, oil on canvas.
New York, Metropolitan
Museum of Art.

107

Thus the aesthetic criteria established by neoclassicism were overturned and the movement's typical subjectivity was replaced by an objective outlook, based on the reality of nature, adopted as a model for its wise balance of contrasting elements regulating the universe and assuring its harmony. In art, the quest for spontaneity brought the development of a widely understood language of the sentiments, intending a steady communication of contents and the teaching of useful truths, by speaking to the heart of the observer. Nature, therefore, was not represented as fortuitous but rather enfolded in an aesthetic and moral precept that ensured its beauty and also comprehension. From this point, the concept of "united" or "relative" beauty governed artistic creation and rejected any strong expressions, ugliness, fortuitousness, atrocity, or exuberant emotions that rocked the harmony of the eminently conservative Restoration world. As part of a similarly stable hierarchy of values, historical and literary inspired themes retained their supremacy over other figurative genres, although the aspiration to quiet, reassuring stillness, typical of the age, fostered the spread of domestic scenes, views, landscapes, and still lifes, all characterized by an additional narrative theme that was sufficient to

Carl Blechen
Interior of the Palm House
c. 1833, oil on paper on canvas.
Hamburg, Kunsthalle.

Peter Fendi
Girl in Front of Lottery Shop, detail
1829, oil on canvas.
Vienna, Historical Museum of Vienna.

Augustus von der Embde
The Young Louise Reichenbach
1820, oil on canvas. Kassel, Kassel State Art Collection.

Giuseppe Tominz
The Moscon Family
1829, oil on canvas. Ljubljana, Narodna Gallery.

suggest the reassuring serenity required of art. Understated, quiet ambients were preferred for interiors, which reflected with sheer exquisite relevance the immobility expressed by the time, rendered with neo-fifteenth-century perspectives, in the manner of Marius Granet. Even when depicting the exotic variegated vegetation of a winter garden, as was the case of the Palm House, a residence built by Karl Friedrich Schinkel for Crown Prince Frederick William IV of Prussia, using orientalizing set designs, there was an aura of domestic affability. Portraits were interwoven with sentiments akin to simplicity and composure, which were often set in the welcoming, comfortable elegance of drawing rooms and gardens, mainly of contemporary bourgeoisie, especially when several family members were shown, in a Biedermeier-type evolution of the unconventional "conversation piece" typical of the English 1700s.

Biedermeier

The movement known as Biedermeier personified the social aspirations of Austria, northern Germany, and Denmark to a retiring, peaceful existence, spent with family and friends, in quiet, comfortable rooms, savoring simple pleasures, enjoying domestic peace, day after day, and oblivious to the outside world and its dangers. Scenes of everyday life, still lifes, landscapes, moments of seeming banality—a woman combing her hair, a man at his desk, children playing—are shown with affectionate attention to detail, carefully lingering brushstrokes, which suggest the attitude of serene retreat by a society that preferred to live sheltered from passion. It is no coincidence that a recurring Biedermeier motif is a window open onto a road or the countryside, simultaneously excluding and taking refuge from the cares of the world.

Samuel Palmer
In a Shoreham Garden
1829, ink, watercolor,
and gouache mixed with
gum.
London, Victoria and
Albert Museum.

Antoine-Louis Barye
A Python Killing a Tiger
post 1825 watercolor and
gouache on paper.
Bayonne, Bonnat
Museum.

Historical Painting

At the turn of the 1820s, a prevailing interest became increasingly evident in specific cultural areas for historical scenes painted against a landscape, or vice versa. In France, Spain, and Italy, historical subjects from the medieval or Renaissance world, dense in patriotic meanings on a par with the celebration of national illustrious figures, were the most important examples, with the consequent caveat; in Great Britain, landscapes were preferred for personifying the moral and civic aspirations of contemporary society in the most communicative and touching way.

In Paris Jean-Louis-Théodore Géricault finished *The Raft of the Medusa*, instilling the coeval theme with the values of a metahistorical allegory, and Eugène Delacroix evoked the drama of Greece enslaved to the Turks, while Ingres settled in Florence thanks to his friend Lorenzo Bartolini (an old companion from David's atelier), and worked on the *Vow of Louis XIII*, an example of his methodological recovery of Raphael. Meanwhile, in Milan, Francesco

Hayez and Pelagio Palagi abandoned mythology and classical history in favor of medieval and Renaissance subjects. They were soon followed by

the Tuscan Giuseppe Bezzuoli, who was also involved in developing the poetics of historical romanticism, an aesthetic expression that grew out of purism, cleverly interwoven with historical, ideological, and ethical allusions, associating the figurative arts, music, and literature. Over time, a similar solid equilibrium between concept and form began to disintegrate, and historical subjects were presented in a setting that gave dramatic emphasis to emotions in a more direct, realistic fashion. This is the quality that distinguished the paintings of Paul Delaroche, an artist adored by collectors and colleagues alike, and who had sought a narrative style that was distinct from both the emphasis of Delacroix and the severe imprint of Ingres. Moreover, in about 1840 Ingres had mellowed the solemn Raphaelesque equilibrium of his painting, and was expressing a wistful yearning for the ancient world in works suffused with sentimental evocations, including *Antioch and Stratonice* (Chantilly, Musée Condé).

A pulse of emotion also pervaded French sculpture at that time, far more inclined to naturalist

Edouard Cibot
*Anne Boleyn in the
Tower of London in the
First Moments after Her
Arrest,* detail
1835, oil on cavas.
Autun, Rolin Museum.

Romanticism

Leo von Klenze
Plan for the decoration
for the ceiling of
Ludwig I's study in his
Munich residence
c. 1835.
Private collection.

expression than the rest of Europe, thanks to the route forged by Jean-Antoine Houdon from the late eighteenth century. So the irresistible, energetic impetus found in François Rude's friezes for the Parisian Arc de Triomphe, and the aesthetic poses of sensuality in James Pradier's sculptures, offset the expressions of wonderful *terribilita*—intense grandeur—produced by Antoine-Louis Barye, famous for his groups of warring animals. The diffusion of purist tenets, which proposed a moral conception of art, standardized to the integration of concepts of beauty, goodness, and truth, had caused admiration for the work of Canova to wane, if not actually to vanish, replaced by Thorvaldsen's "modern classicism," which meant expressions filled with a more composed aura of beauty, based on the imitation of nature conveniently adjusted to the artist's communication needs. Lorenzo Bartolini is a good example of this, as he spread new styles of purist sculpture all over Europe from Florence; Johann Gottfried Schadow, Pietro Tenerani, Christian Daniel Rauch, Carl Wichmann, and Caspar Wolf are just a few others whose works are in the collection of the New Hermitage. The palace in Saint Petersburg had been built for Tsar Nicholas I by Leo von Klenze, who designed a refined interpretation of Tuscan Renaissance architecture, which he had already applied to the palaces, temples, gates, and museums built in Munich for Ludwig I, including the Residenz (Residence) palace. The latter was later frescoed by Schnorr von Carolsfeld, the Nazarene painter of the Casino Massimo Stanza dell'Ariosto (1821–27) in Rome.

The Gothic Revival

French and British architecture was also affected by the general interest in primitive art, with a preference for medieval art, which had already woven fantasies for eighteenth-century English culture—the engine of the Gothic Revival. What was, however, simply fantasy in the neoclassical world, a dream of the past whose charm or greatness was evoked, emphasizing the picturesque or the sublime, now became material for philological recoveries and "period restoration." Clear proof of this can be seen

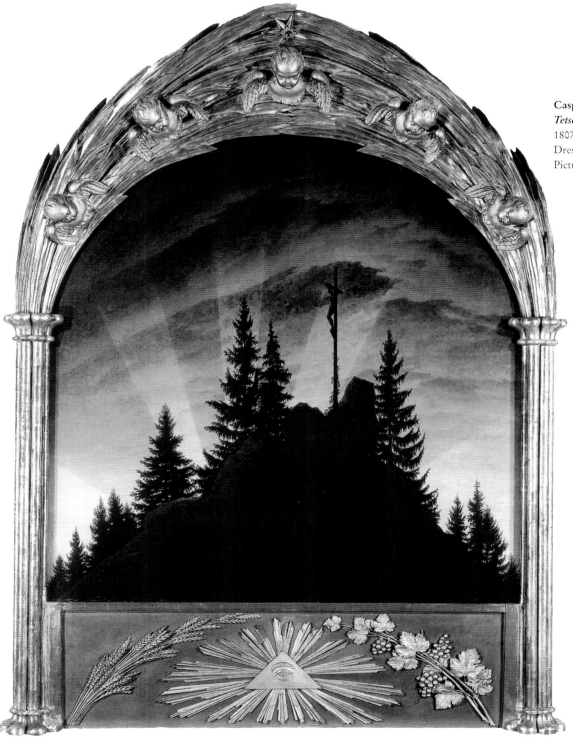

Caspar David Friedrich
Tetschen Altar
1807–8, oil on canvas.
Dresden, Old Masters
Picture Gallery.

Caspar David Friedrich
*View from the Artist's
Studio, Window on
the Left*
c. 1805–6, pen and sepia
on paper.
Vienna, Vienna Art
History Museum.

Caspar David Friedrich
*View from the Artist's
Studio, Window on
the Right*
c. 1805–6, pen and sepia
on paper.
Vienna, Art History
Museum.

Anton Sminck Pitloo
*Francavilla Grove and
Palazzo Cellamare*
c. 1824, oil on canvas.
Naples, National
Museum and Galleries of
Capodimonte.

in the intense activity of Augustus Welby N. Pugin, the architect of many works, including the Houses of Parliament in London (whose Gothic style reflected England's national and Christian spirit), as well as in the work of architect and restorer Eugène-Emmanuel Viollet-le-Duc, meant to valorize medieval architecture's decorative and rational features, so eloquent in the understanding of history.

New Landscapes

The importance of the role played by British and Scandinavian landscape painting in the renewal of figurative language has already been mentioned. Art criticism in recent times has expressed the conviction that the Italian landscape, with its Mediterranean light and scented air, steeped in millennia of history and culture, generated a new manner of interpreting this genre of painting by many foreign landscapists, who turned views of rural and urban Italy into images that enchanted with their fresh approach and new features of composition. The practice of working from life, *en plein air*, allowed a more familiar, intimate relationship with nature, and artists thus discovered its endless nuances, participating with increasing conviction in the romantic idea of an animated, organic universe that defied scientific classification. Moreover, the increasing use of the oil-on-paper technique allowed a fast rendering of surroundings, using color as a medium of synthesis to suggest visual perceptions rather than make accurate descriptions. Country and city views "served as a window" and somehow hinted at spontaneity and naturalness, bringing a definitive change to the

Jean-François Millet
Peasant Women
Carrying Firewood
c. 1858, oil on canvas.
Saint Petersburg,
Hermitage.

Théodore Rousseau
The Avenue in the Forest
of L'Isle-Adam
c. 1858, oil on canvas.
Paris, Musée d'Orsay.

meaning of the term "landscape painting," eventually considering it a projection of a state of mind. It was mainly German romantic culture that gave the landscape its key role in the creation of art. This intellectual circle was the birthplace of the idea of nature as a creative force; only the artists, in turn creators, knew how to decipher the mysterious language. German painter Philipp Otto Runge regarded landscape painting as the art of the future, while Caspar David Friedrich, for whom it had never been interpreted in a worthy manner, extended its meaning, considering it both a subject of contemplation and a tool for introspection. Thanks to Friedrich, the landscape acquired innovative aesthetic values and content; *The Tetschen Altar* (1807–8), an enchanting mountain view, conceived as a religious painting, shows this very well, emphasizing the "sanctity" of nature, and announcing equality among painting genres.

Nineteenth-century art literature selected William Turner and John Constable from the serried ranks of artists who devoted themselves to landscape painting in the early 1800s (now enjoying a critical reconsideration overall), chiefly for the influence of their style on modern—especially French—painting. Turner and Constable both made their debut at the end of the eighteenth century, and they both played active roles in the lively London art scene at the turn of the century. They studied many examples of ancient and contemporary art—from Claude Lorrain to Meindert Hobbema, the Ruysdaels, Alexander and John Robert Cozens, as well as contemporaries like Thomas Girtin and John Linnell—successfully imbuing strikingly natural light and atmosphere into their untamed landscapes. Turner, a master of watercolor, evolved extraordinary evanescent effects that conjured up the perception of color and light emanating from the views he painted. A precious sensation of light, transfused through the particles of dust in the atmosphere, fills the Neapolitan landscapes painted by Dutchman Anton Sminck Pitloo from the 1720s on, when he settled in the city and opened an art school there that would prove to be essential in spreading new landscape painting principles, based on real-life study of nature. At this time, the beauty of Naples exercised strong attraction for Nordic artists, and facilitated meetings and profitable exchanges among landscapists. Abraham Alexander Teerlink, Christian Dahl, Franz Ludwig Catel, and Sil'vestr Shchedrin were in Naples then and certainly played quite a decisive role in the development of the School of Pitloo (known as the School of Posillipo) painting. The Russian Shchedrin, who had resided at length in the city, was a close friend of Giacinto Gigante, one of the first artists to apply Pitloo's teachings, and the only one of the pupils to experiment enthusiastically and passionately in watercolors, with which he obtained extraordinary effects of light and transparency.

Alexandre Gabriel
Decamps
*Farmyard at
Fontainebleau*
1848–50, oil on panel.
Paris, Musée d'Orsay.

The Barbizon School

Around 1830 the fortuitous aspects of the beauty of nature became the preferred motif of French painters who gathered in the Fontainebleau forest, near Paris, to paint landscape views from life, which was also innovative in terms of setting. In their works, the atmospheric notations and varying light and shade, rendered in bold, feverish compositions, with brief strokes, rich in texture and applied with vigor, are certainly owed to John Constable and his formal references. These painters gave life to a current known as the "Barbizon school" (whose leading artists were Théodore Rousseau, Jules Dupré, Rosa Bonheur, and Charles Troyon, as well as Alexandre Decamps, Camille Corot, and François Millet), and they refined this new figurative style with the intention of emphasizing "reality," insofar as it was a trait that withstood the conventional precepts of the romantic depiction of nature.

Adolph von Menzel
Emilie Menzel, Sleeping
c. 1848, oil on paper.
Hamburg, Kunsthalle.

John Everett Millais
Ferdinand Lured by Ariel
c. 1849, oil on panel.
Makins Collection.

A New Generation of Artists

A few years later, while the European political stability endorsed by the Restoration was sorely tested by the conservatism of governments, by increasingly pressing nationalist unrest in the Hapsburg Empire and the Italian peninsula states, and by objective difficulties in facing new economic structures caused by industrialization, the loyalty to "realism," already formulated by the Barbizon painters, had become the shared expression of a young generation of artists, intolerant of social conformity and academic education. "Realism" was then perceived as an expression of starkness, of

Hippolyte Flandrin
Nude Youth Sitting by the Sea
c. 1835–36, oil on canvas.
Paris, Louvre.

unpredictability, of the shattering of the universe's harmony as imagined by the Restoration. In contemporary literature, a perfect example of this zeitgeist can be found in *The Lady of the Camellias* published in Paris, in 1848, by Alexandre Dumas fils. The title of this famous novel, with a disconcerting desecration of taboos associated with female physiology, alludes to the leading character's system for informing probable clients of her occasional unavailability. The need to break the expressive conformity imposed by Restoration culture, and therefore the ensuing passive communication, in favor of individualism, from then on would mark many European art events, even those that differed significantly from one another in terms of their format and subject choices. Even if it is actually possible to identify associations between the

images of Adolph von Menzel (in the painting *Emilie Menzel*, the artist's sister reposes deep in sleep, and is rendered with a downstated arrangement of chiaroscuros) and the expressive, emotional power of *Spartacus* by Vincenzo Vela (sculpted in 1848), or the moving depictions of Christian martyrs, from the fervid imagination of Domenico Morelli, it is harder to recognize similar traits of provocative autonomy in the work of the Pre-Raphaelites, the English art movement that established itself in the early years of Queen Victoria's reign. Pre-Raphaelite paintings may depict medieval and Shakespearian subjects appropriate to the romantic tradition, but the rendering is achieved with unexpectedly rigorous draftsmanship and vivid color schemes, emphasizing the rift occurring between nature and modern institutions, between reason and emotion.

Gustave Courbet
Self-portrait with Black Dog
1842, oil on canvas. Paris, Musée du Petit Palais.

L'Art pour l'art and Artistic Individualism

Even the lofty, rigorous nature of the form sought by *L'Art pour l'art* painters (including Hippolyte Flandrin, one of the most admired pupils of Ingres), who were uninterested in the didactic values of content, emphasized only the style of representation, and was dismissive of a collective agreement, favoring utterly individualistic expression. The same desire for drastic individualism—but expressed with authority, using heavy clay-like impastos, and deep lunging shadows—distinguishes the work of Gustave Courbet, whose greatness lay in his conviction that art is a solitary adventure, free of the limitations imposed by moral and social convention. The bold image that a barely twenty-year-old Courbet gives of himself, sitting solitary in the countryside with his dog, his eyes proud and probing, proves how deeply a generation desired freedom, experimentation, and knowledge, even risking happiness, seeing the way of "realism" as the path to the independence of art.

Page 120:
Horace Vernet
Bertel Thorvaldsen with the Bust of Horace Vernet, detail
1833, oil on canvas. New York, Metropolitan Museum of Art.

Romanticism

Leading Figures

Artists and Works of the Romantic Period

Artists and Works of the Romantic Period

Jean-Auguste-Dominique Ingres
(b. Montauban 1780, d. Paris 1867)

Jean-Auguste-Dominique Ingres
Self-portrait, detail, 1858, oil on canvas. Florence, Uffizi Gallery.

Initially taught by his father, in 1791 Ingres enrolled at the Academy of Toulouse. From 1797, he attended David's Paris atelier and made his debut at the 1802 Salon. Ingres won the Prix de Rome and arrived in Rome in 1806, remaining there until 1819. He produced works that expressed his personal vision of Italian Renaissance art, including *The Valpinçon Bathe*r (1808) and *Raphael and La Fornarina* (1814). Ingres was an excellent portrait painter who sketched pencil portraits to make a living, even while living in Florence, from 1819 to 1824, in the coterie of Lorenzo Bartolini and the Swiss artists. On his return to Paris, he was applauded by critics. From 1835 to 1841, he was the director of the French Academy in Rome. When he returned to his homeland, he enjoyed supreme success. In 1851 Paris municipal authority commissioned his *Apotheosis of Napoleon*. His creativity never waned and this can be seen in *The Turkish Bath* (1863).

Jean-Auguste-Dominique Ingres
Joseph-Antoine Moltedo
c. 1810, oil on canvas.
New York, Metropolitan
Museum of Art.

Jean-Auguste-Dominique Ingres
Madame Paul-Sigisbert Moitessier
1856, oil on canvas.
London Trustees of the
National Gallery.

Facing page:
Jean-Auguste-Dominique Ingres
Nikolai Dmitrievich Gouriev
1821, oil on canvas.
Saint Petersburg,
Hermitage.

These three portraits, painted over the span of many years, show Ingres's extraordinary talent for portraiture. In addition to capturing the physical likeness of the subjects and rendering their clothing in meticulous detail, Ingres was able to suggest the personality, education, social status, and spirit of the people he portrayed. In these examples, the subjects were an official in the Napoleonic empire, a lady of Parisian upper-middle-class society during the Second Empire, and a Russian count residing in Florence, where he also had portraits of his wife and himself painted by Lorenzo Bartolini.

Jean-Auguste-Dominique Ingres
Oedipus and the Sphinx
signed and dated 1808 (with changes made in 1827),
oil on canvas.
Paris, Louvre.

Having arrived within sight of Thebes, Oedipus is forced to solve the riddle of the Sphinx in order to escape death. His thoughtful face and powerful nude body stand out against the cavern of dark rock, the monstrous being's shelter. The light in the painting originates from the base, leaving the upper portion in darkness and thereby accentuating the scene's mood of tragic suspense. Ingres painted this work during the first years of his stay in Rome, when his intellectual curiosity was continually inspired by the ancient world, Renaissance art, and the art of his contemporaries. *Oedipus and the Sphinx* resulted from his interest in Guercino's paintings, perhaps filtered through Poussin's work. In 1827, Ingres made the scene more disturbing, but also more narrative, by adding the human remains and the man fleeing in the background.

Jean-Auguste-Dominique Ingres
The Valpinçon Bather
1808, oil on canvas.
Paris, Louvre.

This work, depicting a female nude from behind in a domestic setting, successfully combines influences from the art of the past with the naturalism dictated by modern sensibilities. Ingres's ability to take inspiration from ancient models without imitating them was precisely the reason that this painting, along with *Oedipus and the Sphinx*, did not receive favorable reviews from critics when it was sent to Paris.

Jean-Auguste-Dominique Ingres
The Martyrdom of Saint Symphorien
1834, oil on canvas.
Autun, Saint-Lazare.

This painting depicts the most dramatic moment in the life of Saint Symphorien, the first Gallic Christian martyr killed by the Romans; it focuses on the scene of the route to the gallows, with his mother exhorting him to die rather than forswear his God by worshiping pagan idols. After working on the painting for a decade, Ingres exhibited it at the 1834 Salon. The work caused such an uproar that the painter left Paris to become director of the French Academy in Rome; he never exhibited in public again. Nevertheless, Ingres's admirers and students realized even at the time that the painting was a superb expression of the master's aesthetic conception, creating a fine balance between beauty of form and expression of content.

Bertel Thorvaldsen
(b. Copenhagen 1770, d. 1844)

A student of the Royal Danish Academy, in 1797 Thorvaldsen won an art scholarship to reside in Rome, where he remained until 1838, becoming a leading figure on the city's art scene and the main reference for Nordic artists. He came to the public eye in 1803, when he presented *Jason*, a statue that expressed his austere, solemn idea of antiquity, aligned with the ideas of Carl Ludwig Fernow. In 1812, he worked on the decoration of the Quirinal, with his *Triumph of Alexander the Great*. In 1816, Ludwig I of Bavaria entrusted him with the restoration of sculptures from the temple of Aphaia at Aegina. The Restoration climate affected the sculptor's poetics, and the long series of mythological topics was replaced by one of devotional and historical subjects, his formal quality shifting towards

Bertel Thorvaldsen, *Self-portrait,* detail, 1810, black crayon on white paper. Copenhagen, Ny Carlsberg Glyptotek.

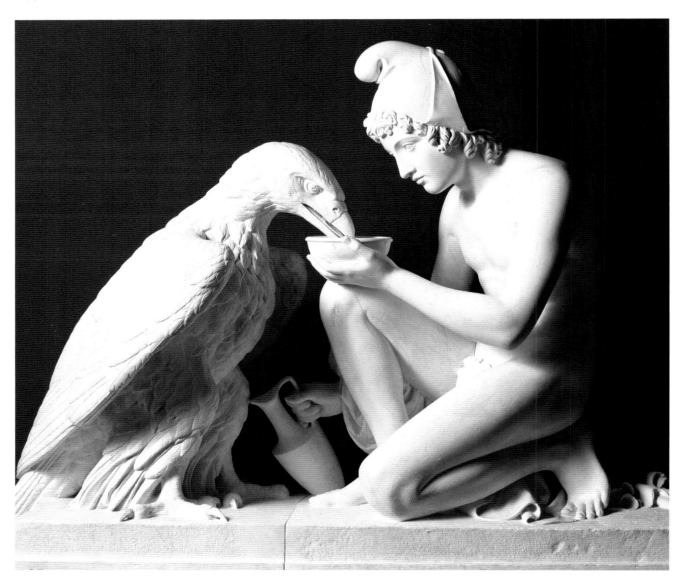

purism, making a crucial contribution to the renewal of sculpture in the romantic circle. Thorvaldsen returned to Copenhagen in 1819, to decorate public buildings, including Vor Frue Kirke, where he painted the *Twelve Apostles and Christ*. In 1823, he was commissioned to erect the Monument to Pius VII (1830) in Saint Peter's, while the Monument to Andrea Appiani, for Brera Academy, dates to 1826. Much admired for his portraiture, Thorvaldsen depicted not only Napoleon, but also Lord Byron (both in 1830), and produced many ecclesiastical busts. In 1830 he went to Munich, where he was offered a commission to make the equestrian monument to Maximilian I (1839). In the meantime, he acquired a collection of ancient Greek, Etruscan, Egyptian, and Roman objets d'art, which he extended during his time in Italy (1841–42). Thorvaldsen donated vases, bronzes, coins, jewelry, his own works, and a collection of ancient and modern paintings and drawings to his birthplace, Copenhagen, on the condition that they be housed in a museum named after him. The architect Michael G. Bindesbøll designed the museum, and it was decorated by the most famous Danish romantic artists, including Jorge Sonne (painter of a celebratory frieze for Thorvaldsen's homecoming), and opened to the public in September 1848, the day after the artist's body was moved from Copenhagen cathedral.

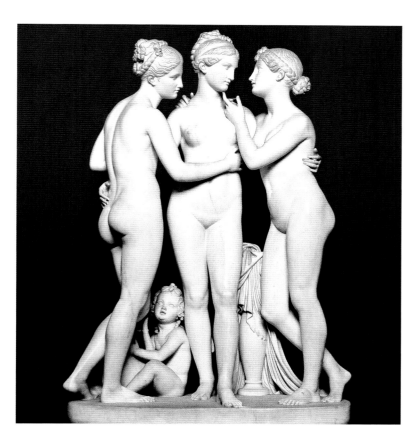

Bertel Thorvaldsen
The Three Graces
1817–19, marble.
Copenhagen, Thorvaldsen Museum.

The three female figures harmoniously united in a delicate embrace were identified by a friend of Thorvaldsen as Beauty, Grace, and Timidity. The elegant modeling and references to ancient works, combined with a great naturalism, means that this interpretation of one of the most common subjects of neoclassical "ideal beauty" (Canova had already produced an excellent example) is absolutely in keeping with romantic culture.

Facing page:
Bertel Thorvaldsen
Ganymede and the Eagle
1817, plaster.
Rome, National
Academy of Saint Luca.

A marble version of this sculpture was produced in 1815 for Count Paolo Tosio Martinengo of Brescia, who considered the work to be a true "jewel of modern sculpture." Numerous replicas were later made, all of which were based on this plaster, donated to the Roman Academy by Thorvaldsen in 1831. While the marble sculpture maintains a lofty neoclassical abstraction, the plaster version displays a naturalism and tenderness in the modeling that indicate the sculptor's evolution towards purism. The Austrian playwright Franz Grillparzer admired the contrast between the "heavenly purity" of the youth loved by Jupiter and the avid gaze of the god in the shape of an eagle, who seems to want to "swallow in a single gulp, both the youth and the cup."

Hans Ditlev Christian
Martens
*Leo XII Visits
Thorvaldsen's Atelier in
Piazza Barberini on St.
Luke's Day, October 18,
1826*, oil on canvas.
Copenhagen, National
Gallery of Art (on loan
to the Thorvaldsen
Museum).

Bertel Thorvaldsen
Cupid and Psyche
1810, marble.
Copenhagen,
Thorvaldsen Museum.

Placed in a semicircular niche, Cupid and Psyche express the feeling of profound tenderness that unites two lovers. The god's open wings define the space and simultaneously suggest a sense of protection and intimacy, in keeping with the sentiments of affectionate spouses like Baron Herman and Baroness Jacoba Schubart, who commissioned the sculpture. The Schubarts were also close friends of Thorvaldsen. In fact, he was a frequent guest at their home in Montenero, near Livorno, where the work was originally located.

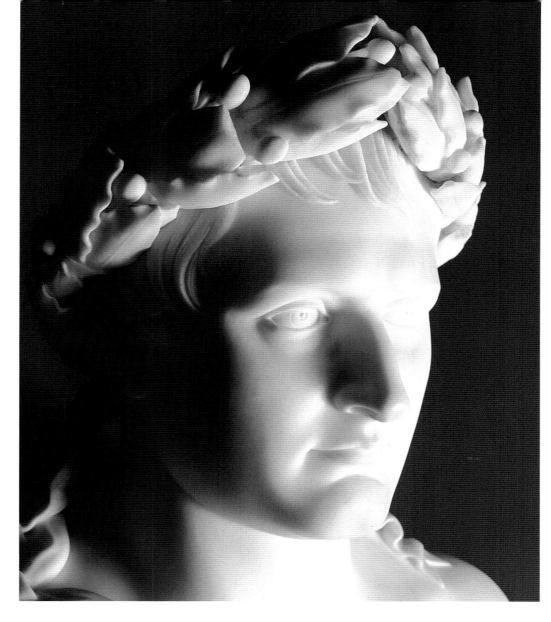

Bertel Thorvaldsen
Napoleon, full view and
detail
1830, marble.
Copenhagen,
Thorvaldsen Museum.

Thorvaldsen sculpted
this bust of a triumphant
Napoleon for Alexander
Murray, a Scottish client.
While the eagle, the aegis
with the head of Medusa,
and the crown of laurel
allude to the emperor's
military glory and
political power, the
intentional reference to
Roman imperial
portraiture further
ennobles Bonaparte's
image. The ribbon
binding the crown falls
in soft folds to his
shoulders and imbues
the sculpture with a
feeling of contrasting
human fortuitousness.

Bertel Thorvaldsen
Day
1815, marble.
Brescia, Pinacoteca Tosio Martinengo.

Day, represented by the figure of Aurora, flies upward
scattering roses, alluding to the first glimmer of dawn.
A biographer discussing the creation of this round
plaque and its complement, depicting *Night*, sculpted
in Rome in 1815, stated: "Early one morning, before
the house had awoken and come to life," Thorvaldsen
"abandoned his bed and went to a blackboard on an
easel to sketch the image that seemed to have been
revealed to him during the night."

Lorenzo Bartolini

(b. Savignano, Prato 1777, d. Florence 1850)

Bartolini was apprenticed to marble and alabaster cutters, then went to Paris and attended David's studio, where he befriended Ingres. In 1807, perhaps thanks to Dominique Vivant Denon, he was appointed director of the school of sculpture in Carrara, which was governed by Elisa Baciocchi—an admirer of the artist—and she commissioned various portraits of herself and her relatives. In 1815, he settled in Florence and soon began to establish himself as a portrait sculptor in a circle of sophisticated international patrons, especially the Bonaparte family. In 1820, the arrival of Ingres in Florence marked a turning point for Bartolini's art, tending towards a purist appreciation of the Tuscan 1400s. In 1824, he sculpted his *Charity*. *Trust in God* is dated 1834. In the meantime, he worked on the *Demidoff Table*. Italian and foreign commissions multiplied; in 1840, he added teaching to his busy schedule, dedicating himself to it with passion.

Jean-Auguste-Dominique Ingres
Portrait of Lorenzo Bartolini, detail
1820, oil on canvas. Paris, Louvre.

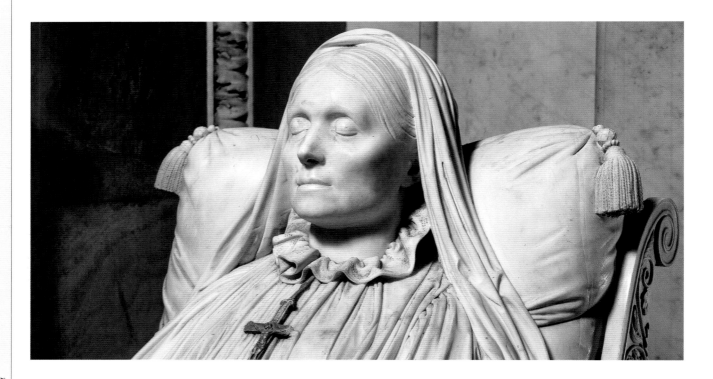

Lorenzo Bartolini
Tomb of Sofia Zamoyska, full view and detail
1837–44, marble.
Florence, Basilica of the Holy Cross (Santa Croce),
Salviati Chapel.

After the torments of agony have passed, the woman's face appears tranquil in death. The tomb's austere neo-fifteenth-century design is pervaded by a sense of spiritual transcendence. Bartolini received the commission for the monument to the Polish aristocrat in 1837, but the work was placed in Santa Croce in 1844.

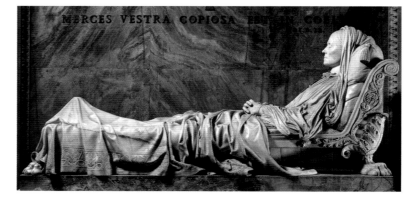

Lorenzo Bartolini
Charity, full view and detail
1820–35, marble.
Florence, Pitti Palace, Palatina Gallery.

The sculpture depicts a mother, beautiful but indifferent to her own beauty, occupied with the task of raising her children, nourishing their bodies and educating their minds. As the sculptor explained to the grand duke of Tuscany, who commissioned the work, the sculpture group reinterprets the traditional iconography of Charity. Bartolini created the work for the Villa del Poggio Imperiale chapel, but it was later placed in Pitti Palace. The work is an expression of the "natural beauty" that Bartolini conceived as a means of overcoming the constraints of neoclassical "ideal beauty."

Johann Friedrich Overbeck
(b. Lübeck 1789, d. Rome 1869)

In 1806, Overbeck enrolled at the Vienna Academy. He soon became interested in the work of German and Italian primitives, admiring the chaste form and religious themes. In 1810 he went to Rome with Franz Pforr and other companions, settling at the Sant'Isidoro monastery with them, adopting the conduct that earned them the name "Nazarenes." From 1816 to 1817 Overbeck worked with Peter Cornelius, Philipp Veit, and Wilhelm von Schadow to decorate Casa Bartholdy. In 1818 he was employed to decorate a room in the Casino Massimo with scenes from *Jerusalem Delivered*, a job that he did not complete, preferring to devote himself to religious subjects. He then painted *The Miracle of the Roses*. In 1831 he returned to Germany, where he worked essentially on *The Seven Sacraments*, a monumental opus consisting of a series of tapestries, whose cartoons are kept in the Vatican.

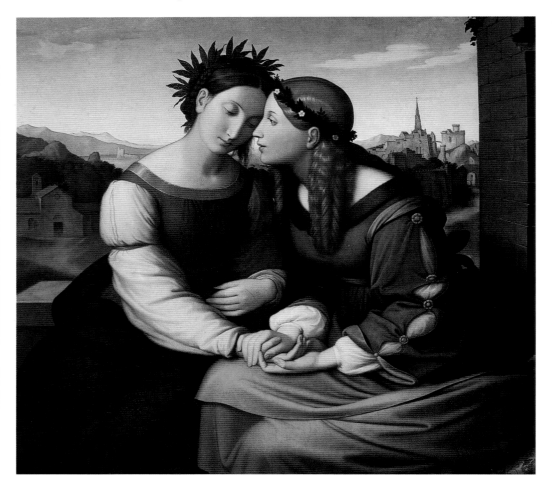

Johann Friedrich Overbeck
Self-portrait with a Bible, detail
1809, engraving. Lubeck, Museum
of Hanseaic Art and Cultural History.

Johann Friedrich Overbeck
Italy and Germany
1811–28, oil on canvas.
Munich, New
Pinacotheca.

The painting depicts two girls, crowned with laurel and with myrtle, united in an embrace. There is a composite landscape behind them, with a view that is vaguely Italian to the left, and German to the right. The artist justified this invention by his experience as a "German in Italy." He said it was true that "they are two opposing entities, but my mission is [...] to fuse them at least in the form of my creation," driven "by a yearning that attracts the North towards the South, for its art, Nature, and poetry" (Metken 1981, 202–203).

Friedrich Wilhelm von Schadow

(b. Berlin 1788, d. Düsseldorf 1862)

Born into the profession, the young Schadow learned drawing from his father, the sculptor Johann Gottfried; in 1808, at the age of twenty, he enrolled at Berlin Academy, which he attended for about two years. By 1810 he was in Rome with his brother Rudolf, both in the care of Bertel Thorvaldsen, whom they regarded as their mentor. During his time in Rome, Schadow associated with the Nazarenes, and in 1813 he was accepted into the prestigious Accademia di San Luca. His conversion to Catholicism dates to this period. In 1816–17, the Berlin-born artist was still in Rome and decorated Casa Bartholdy with his compatriots Peter von Cornelius, Johann Friedrich Overbeck, and Philipp Veit. On his return to Berlin in 1819, he took on the direction of a studio financed by the Prussian state. He devoted himself to religious painting and portraiture. In 1826, he was appointed director of Düsseldorf Academy; from 1830 to 1840, he returned to Italy four times.

Friedrich Wilhelm von Schadow
Self-portrait with Bertel Thorvaldsen and Rudolf Schadow, detail, 1815, oil on canvas. Berlin, Old National Gallery, State Museum of Berlin.

Friedrich Wilhelm von Schadow
Portrait of Felix Schadow
c. 1830, oil on canvas.
Munich, private collection.

Italian Renaissance models influenced the portrait of Schadow's half brother. The outline of the youth against the background of the sky is defined with delicate precision, reflecting the purist elegance of the design. The white starched collar accentuates the childlike grace of his face and the intense gaze of his deep, dark eyes.

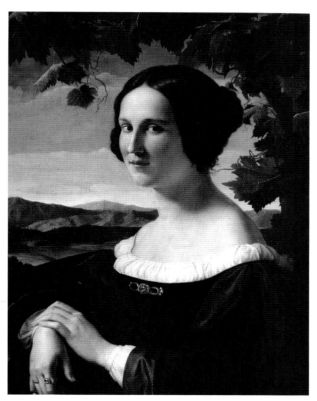

Friedrich Wilhelm von Schadow
Portrait of a Young Woman
1832, oil on canvas.
Berlin, Old National Gallery, State Museum of Berlin.

The young woman smiles with enigmatic grace as she rests her right arm against the sill of a window overlooking a wide valley, framed by a spray of vine. The portrait reflects the aesthetic conceptions that the artist solidified in Rome with the Nazarenes, and that were supported by Thorvaldsen's work. The painting is a re-interpretation of the style and compositional plan of Italian Renaissance portraits, in particular the early work of Raphael.

Peter von Cornelius
Double Portrait with Friedrich Overbeck, detail, signed and dated 1812, pencil. Munich, private collection.

Peter von Cornelius
(b. Düsseldorf 1783, d. Berlin 1867)

Introduced to art by his father, Cornelius enrolled at Düsseldorf Academy in 1795. In 1807 he received his first public commission and in 1811 he went to Rome, where he joined the Nazarene movement, illustrating Goethe's *Faust*, the *Nibelungenlied*, and *Romeo and Juliet*. In 1816, with Johann Friedrich Overbeck, Philipp Veit, and Friedrich Wilhelm von Schadow, he began painting a fresco cycle on Joseph for Casa Bartholdy. Then he embarked on a project to decorate the Dante room in Rome's Casino Massimo, but he did not complete the project. In 1819 Cornelius was in Munich to fresco Leo von Klenze's Glyptothek. In 1825 he was appointed director of Munich Academy, and in 1839 he frescoed the Ludwigskirche, but left Bavaria for Prussia following disagreements with Ludwig I. His trips to Paris and London and long periods in Rome (where he lived from 1853 to 1861) allowed him to foster worthwhile relationships with his colleagues.

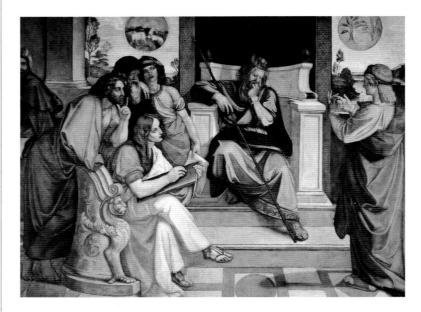

Peter von Cornelius
Joseph Interprets the Dream of the Pharaoh, detail
1816–17, fresco detached from wall.
Berlin, Old National Gallery, State Museum of Berlin.

This fresco once decorated the salon in the residence of Jacob Bartholdy, Prussian consul to Rome. Cornelius suggested to Bartholdy that this biblical theme was most in keeping with the Nazarenes' ethical and artistic ideas. The obvious influences of primitive Tuscan painters and Raphael's early works, combined with the devout subject, confirm that the chasteness of the painting's contents and figurative simplicity for this artist and his colleagues were synonymous with moral values and an opposition to neoclassicism's pagan beauty.

Peter von Cornelius
Portrait of Franz Pforr
c. 1810, oil on canvas.
Berlin, Old National Gallery, State Museum of Berlin.

Even the familiar presence of the cat, purring next to the subject in the foreground, contributes to the evocation of late-fifteenth-century art that distinguishes this portrait.

Julius Schnorr von Carolsfeld
(b. Leipzig 1794, d. Dresden 1872)

This pupil of a portrait-painter father went to Vienna in 1811, where he became interested in the Nazarene movement, founded by a group of artists with whom he would associate closely when he arrived in Rome, in 1817. Von Carolsfeld lived in Palazzo Caffarelli, where a major German exhibit was held in 1819. Friedrich Wilhelm von Schadow, Johann Friedrich Overbeck, and art historian Johann David Passavant were some of his closest friends. Like them, he devoted himself to portraiture, religious art, landscapes, and fresco decoration. From 1821 to 1827, he decorated the Stanza di Ariosto in Rome's Casino Massimo. In 1826, he went to Sicily and then to Munich, called to court by Ludwig I to decorate his residence; the work was completed in 1867 and was inspired by the *Nibelungenleid*. In 1851, he was in London for the World Exhibition. In 1846, von Carolsfeld had been appointed director of Dresden Academy and Gallery, a position he filled until 1871.

Julius Schnorr von Carolsfeld,
contemporary engraving.

Julius Schnorr von Carolsfeld
Annunciation
1820, oil on canvas.
Berlin, Old National Gallery, State Museum of Berlin.

A stone arch frames the scene that unfolds with measured cadence as far as the distant horizon, delicately outlined against the sky. The artist interwove German and Italian Renaissance influences to create a simple, solemn image that invites contemplation. The apparent artlessness of the form and religious content contribute to the affirmation of an ethical conception of art based on the inseparable values of beauty, goodness, and truth.

Julius Schnorr von Carolsfeld
Charlemagne and the French Army in Paris
1826, fresco.
Rome, Casino Massimo, Ariosto room.

Detail of the frescos on the wall opposite the entrance to the Ariosto room.

Leo von Klenze
(b. Bockelah, Harz 1784, d. Munich 1864)

Leo von Klenze, period photograph.

Klenze enrolled in business studies at Berlin University, but at the same time studied at the city's Academy of Art. On a trip to Paris, he studied with Charles Percier and Pierre-François-Léonard Fontaine, and then went to Italy. From 1804 to 1813, he was court architect in Kassel. In 1816, after a period in Vienna and a return to Paris, Klenze was appointed architect to the Bavarian court and settled in Munich. He designed the new Munich, obeying the wishes of King Ludwig I, and his works include the Glyptothek, the Pinakothek (picture gallery), the Residenz, and the Propylaea. From 1823 to 1824 Klenze went to Sicily. In 1834, he was called upon to build a royal palace for Athens, freed from the Turks, and here he committed himself to the preservation of ancient Greek constructions. From 1839 on he made many trips to Russia, commissioned by Tsar Nicholas I to design a new museum building for Saint Petersburg. Klenze may be thanked for the New Hermitage and most of its lavish decoration (1840–51).

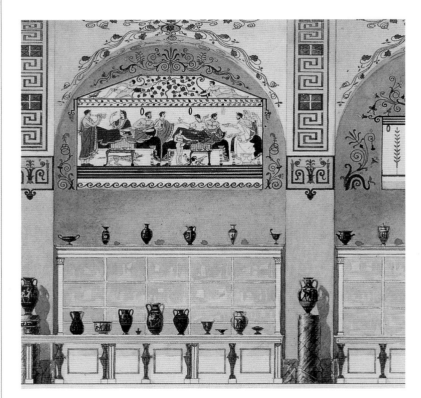

Leo von Klenze
Design for the decorations in the Glyptothek Vase room
c. 1816–30.
Munich, State Graphic Collection.

The Glyptothek was built by Ludwig I of Bavaria to house classical works of art, primarily the statues from the Temple of Aphaia at Aegina restored by Thorvaldsen. This was the first monumental building that Klenze erected on Königsplatz. Klenze's project for the square was conceived as a monumental repertory of ancient Greek architecture and assumes the appearance of an organic urban space filled with enough evocative charm for the romantic imagination to relive the magnificence of Athens.

Leo von Klenze
Propylaea
1831–42.
Munich, Königsplatz Museum.

The Propylaea, modeled after the Propylaea of the Athens Acropolis, was designed as a majestic entrance to Ludwig I of Bavaria's new Munich, completing the Königsplatz layout. Flanked by two imposing quadrangular buildings, the central block has the appearance of a Doric temple with pediments decorated by sculptures of the war for the liberation of Greece from the Turks and a tribute to King Otto I (son of Ludwig I of Bavaria), who ascended to the Greek throne in 1832.

Johan Christian Dahl

(b. Bergen, Norway 1788, d. Dresden 1857)

Dahl was apprenticed as a decorator, then in 1811 he enrolled at Copenhagen Academy, where he studied the seventeenth-century Dutch landscape painting of Meindert Hobbema and the Ruysdaels. In 1816 he became a student of Christoffer Wilhelm Eckersberg, who introduced him to painting *en plein air*. He moved to Dresden in 1818 and went to Italy from 1820 to 1821, a decisive period for his career as a landscape painter. In 1823, he returned to Dresden, where he and Caspar David Friedrich shared a studio and house—Friedrich influenced Dahl's work significantly. In 1826, he returned home to Norway (going back also in 1834, 1839, and 1844), where as a nature scientist he painted studies of "realistic definition." In time he went on to establish the Norwegian Art Society and the National Gallery. He went to Paris in 1847. Dahl's teaching at Dresden Academy, where he had worked since 1824, spurred the renewal of imagery in a realist direction.

Johann Carl Rössler
Portrait of Johan Christian Dahl,
detail 1819, oil on canvas. Oslo,
National Gallery.

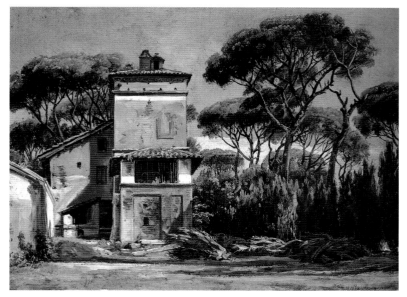

Johan Christian Dahl
The Caretaker's House at Villa Borghese
1821, oil on canvas.
Bergen, Bergen Art Museum, Rasmus Meyers
Samlinger Collection.

At the beginning of the nineteenth century, it was believed that when Raphael lived in Rome, his studio had been in the solitary house depicted by Dahl. The modest building, surrounded by pines and awash with sunlight, stands out in all its poetic antiquity against a pure blue sky, barely touched by cloud. The view, faithful in the formal rendering of detail and sentiment to the models conceived by his teacher Christoffer Eckersberg, acquires new vitality from the skillful use of color.

Johan Christian Dahl
Study of Clouds: Storm Clouds over the Tower at Dresden Castle
c. 1825, paper glued to board.
Berlin, Old National Gallery, State Museum of Berlin.

The paint, applied with rapid, light brushstrokes, depicts an area of sky where clouds blown by the wind create striking plays of light on the roofs of Dresden.

Caspar David Friedrich

(b. Greifswald, Germany 1774, d. Dresden 1840)

Caspar David Friedrich
Self-portrait, detail, c. 1810,
charcoal. Berlin, Print Room,
State Museum of Berlin.

A student of Nicolai Abildgaard at Copenhagen Academy, Friedrich settled in Dresden in 1798, devoting himself to landscape study. He stayed in Dresden for a long time, in 1802 meeting Philipp Otto Runge, who introduced him in turn to the city's intellectuals. He became acquainted with writers Heinrich von Kleist and Novalis, the painters Carl Gustav Carus and Georg Friedrich Kersting, and Johan Dahl, who became his friend. In 1808, he exhibited the *Tetschen Altar*, a painting that provoked a debate on figurative genres. He went to Bohemia in the same year and returned there in 1809. He then traveled through Germany (1810–13), drawing inspiration from the country. In 1823 he shared a studio with Dahl and began teaching at the Academy in 1824, but he was not awarded the landscape painting professorship. The melancholy he suffered from his youth intensified, and he became mentally detached. His illness and quick death cast his art into oblivion until the twentieth century.

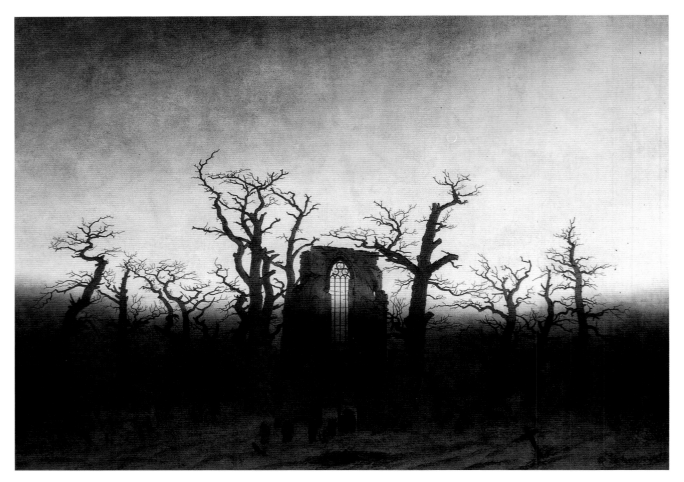

Caspar David Friedrich
Abbey in the Oakwood
1810, oil on canvas.
Berlin, Old National
Gallery, State Museum
of Berlin.

The gnarled, contorted branches of the age-old trees create, as the moon fades, nervous arabesques against the pale early morning sky. The mood of mysterious holiness pervading the scene emanates more from the dawn light that enshrouds the desolate winter landscape, frozen in time, than from the ruined Gothic abbey surrounded by bare oak trees. The success Friedrich obtained with this painting, exhibited in 1810 and purchased, along with *Monk on the Seashore*, by the crown prince of Prussia, Frederick William IV, led to the artist's membership in the Berlin Academy.

Caspar David Friedrich
Picture in Remembrance of Johann Emanuel Bremer
1817, oil on canvas. Berlin, Old National Gallery, State Museum of Berlin.

The profile of a port city and the masts of docked boats emerge from the fog in the pale moonlight. With a vibrant silhouetted effect, the moon also illuminates the arbor and fence of a garden that is relentlessly closed. The painting is an enchanting, poetic meditation on death, inspired by the memory of the Berlin doctor who died in 1816 and whose name is written on the gate.

Caspar David Friedrich
Moonrise Over the Sea
1822, oil on canvas. Berlin, Old National Gallery, State Museum of Berlin.

The painting depicts three figures absorbed in contemplation of the seascape that begins to turn to silver as the moon appears through the dispersing evening clouds. During this tranquil moment, two ships return to shore, accentuating a mood of profound involvement in the greatness of nature as a comfort for the spirit.

Leading Figures | *Caspar David Friedrich*

Caspar David Friedrich
Woman at a Window
1822, oil on canvas.
Berlin, Old National
Gallery, State Museum
of Berlin.

A young woman
observes the movement
of boats along the Elbe,
looking out of the
window of a somber,
shadowy room that
contrasts with the airy
limpid atmosphere of the
day. Although the image,
for which the painter's
wife posed, appears to
have an everyday
casualness, it is actually
full of existential
connotations regarding
humankind's destiny
and consolatory faith
in the afterlife.

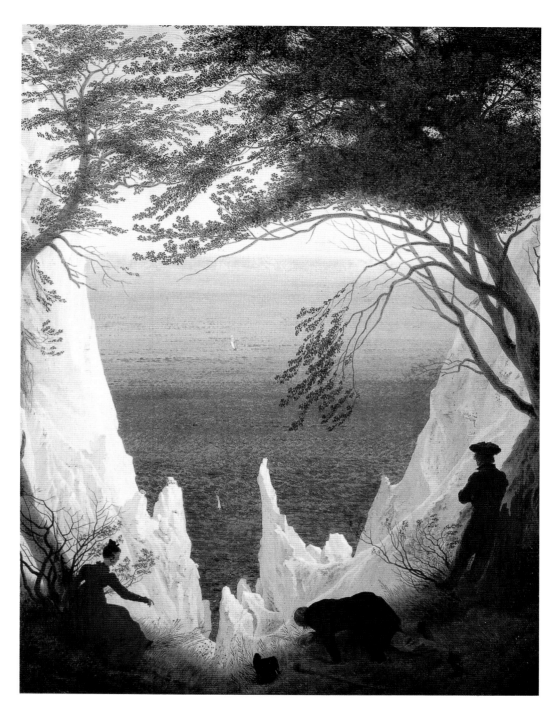

Caspar David Friedrich
The Chalk Cliffs of Rügen
1825–26, oil on canvas.
Leipzig, Museum of Visual Arts.

The tree limbs frame the landscape and limit the range of vision, focusing attention on |the human figures in the foreground. Two of these figures appear to be vainly searching for something on the ground. Their precarious situation introduces a sense of unease to this contemplation of nature in its majestic beauty. Rügen Island was a place the artist loved and it inspired many studies and drawings.

Christoffer Wilhelm Eckersberg
(b. Blaakrog, Denmark 1783, d. Copenhagen 1853)

In 1803, Eckersberg became a pupil of Abildgaard at the Copenhagen Academy. His interests soon turned to landscape painting. In 1809 he moved to Paris and stayed there until 1813, attending David's atelier. He then lived in Rome for three years, frequenting Thorvaldsen's circle of artists and painting cityscapes, preferring the less picturesque aspects, where the sense of passing time is evoked with subtle, yearning poetry. He returned to Copenhagen and began to teach at the Academy in 1818, contributing to the revival of Danish art in a decisive manner. His Roman experience led him to encourage students to study landscape painting *en plein air*. In 1833, he published papers on perspective, for use by young painters, establishing new rules for spatial composition and light interaction.

Christoffer Wilhelm Eckersberg
Self-portrait, detail, c. 1803, oil on canvas. Copenhagen, National Gallery of Art.

Christoffer Wilhelm Eckersberg
In the Gardens at the Villa Albani
c. 1814, oil on canvas.
Copenhagen, National Gallery of Art.

The gleaming light of the beautiful day infuses the view of the villa and its large gardens with a sense of serenity. As was his custom, the artist chose an unusual perspective that emphasizes the everyday nature of the building rather than its nobility. The height of the three full cypresses standing in the foreground defines the spatial depth of the view and relegates the image of the majestic villa to the background. This sensation is accentuated by the delicate silhouette of the chipped balustrade and the depiction of the lemon houses open to the warm Roman spring sunshine.

Christoffer Wilhelm Eckersberg
Porta Angelica and the Vatican Palaces
1814, oil on canvas.
Copenhagen, National Gallery of Art.

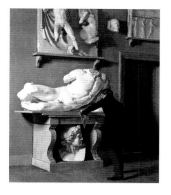

Christen Købke
(b. Copenhagen 1810, d. 1848)

Købke was a student of Copenhagen Academy and, from 1828, a pupil of Christoffer Eckersberg, who influenced his style. From 1834, his landscapes acquired a more solemn and emotional quality, inspired by his interest in Caspar Friedrich's painting. He left for Rome in the summer of 1838; during the journey, he visited Dresden and Munich. In May 1839 he arrived in Naples, and he stayed there until August 1840, copying the Pompeian frescoes in the National Museum. He lived on Capri with his compatriot painter Constantin Hansen. When he returned home, he turned his Italian life studies into large-scale paintings. He worked on the interiors of the Thorvaldsen Museum. In 1845 he moved back to Copenhagen, in the (vain) hope of being called to the arts academy. Financial problems forced him to start working as a decorator.

Christen Købke, *Visit to the Plaster Models Collection at Charlottenborg,* detail. 1830, oil on canvas. Copenhagen, The Hirschsprung Collection.

Christen Købke
A View of One of the Lakes in Copenhagen
1838, oil on canvas. Copenhagen, National Gallery of Art.

Two women stand on a short wooden pier in the tranquility of the summer twilight, watching a boat move away towards the far lake shore. The delicate silhouette effect accentuates the slightly melancholy mood of the scene and the hour, and simultaneously suggests the artist's sensitivity in communicating the naturalness of the scene. The Danish painter acquired this ability during his long apprenticeship to his compatriot Eckersberg; during this time the two men traveled together, sketching the Danish countryside from life. Before deciding on the definitive layout for this painting, Købke executed various sketches of this view that he knew and loved. In fact, the painter lived right on the lakeshore.

Ferdinand Georg Waldmüller
(b. Vienna 1793, d. Helmstreitmühle bei Mödling 1865)

Waldmüller attended the Vienna Fine Arts Academy irregularly and copied from the old masters. His early work was faithful to the classicism of Giovan Battista Lampi. Waldmüller established himself as an elegant portrait painter. The lucidity of his renderings was such that it aroused a subtle uneasiness in the apparently serene images of the Viennese bourgeoisie. An equally meticulous quality distinguishes his landscapes and still lifes. He went to Italy in 1828 and then to Paris in 1830. He was appointed curator of Vienna Fine Arts Academy Gallery in 1829, a position he filled until 1857. In the meantime, he ran a private art school. After 1848 he devoted himself to delicate life scenes of fields and the farming world, inspired by sentiments similar to those expressed by Adalbert Stifter. At this time, his brushwork forsook its former pearly compactness, the light was mellowed, and colors became more subtle.

Ferdinand Georg Waldmüller
Self-portrait at Age 35, detail, 1828, oil on panel. Vienna, Belvedere, Austrian Gallery of the 19th and 20th centuries.

Ferdinand Georg Waldmüller
The Family of the Viennese Notary Joseph Eltz
1827, oil on panel. Vienna, Historical Museum of Vienna.

Following a popular romantic tradition, this family portrait is set in an easily identifiable location, the thermal baths at Ischl, near Salzburg. The father is greeted affectionately by the younger children and his wife, as he returns from a walk with his older children. The compact brushwork, which adds touches of brilliance to the features and apparel of the subjects, separates into delicate filaments in the depiction of the landscape, enveloped in a soft shadow, almost suggesting the memory rather than the reality of a favorite place.

Peter Fendi
(b. Vienna 1796, d. 1842)

Friedrich von Amerling
Portrait of Peter Fendi, detail,
1833, oil on panel. Vienna,
Lichtenstein Museum.

Fendi was a pupil of Giovan Battista Lampi at Vienna Fine Arts Academy, but he was forced to interrupt his artistic studies when he was orphaned in 1814. To help his family, he copied old works, in considerable public demand at the time, acquiring such skill that he was appointed artist for the Imperial Cabinet of Medals and Antiques in 1818. Fendi went to Venice in 1821, and studied Venetian sixteenth-century masters. Devoting himself to genre painting, he achieved remarkable success in the early 1830s, also thanks to his exquisite draftsmanship, which allowed him to draw scenes in captivating detail. His paintings, which narrate touching human situations in great detail or illustrate delightful scenes of popular life, typical of Biedermeier culture, were also popular with the royal family. In the last few years of his life, he ran a highly rated art school.

Peter Fendi
The Officer's Widow
1836, oil on panel.
Vienna, Historical Museum
of Vienna.

A young mother sits on a makeshift bed on the floor with a sleeping child by her side, sewing by the light of a dormer window, while she cradles a newborn and an image of her lost husband on her lap. The small family uses the deceased man's coat as a blanket. The meticulous depiction of the many objects stored haphazardly in the room focuses attention on the details and softens the scene's poignant atmosphere to a subtle sentiment of compassion.

Peter Fendi
Evening Prayer, detail
1839, watercolor.
Vienna, Albertina
Museum, Collection of
Graphic Arts.

The painting depicts the family of future Emperor Franz Joseph gathered in prayer.

Alexandre-Marie Colin
Jean-Louis-Théodore Géricault,
detail, 1824, lithograph. Rouen,
Museum of Fine Arts.

Jean-Louis-Théodore Géricault
(b. Rouen 1791, d. Paris 1824)

In Paris Géricault attended the ateliers of Charles Vernet (1808–10) and Pierre Guérin. He made his debut at the 1812 Salon with *The Charging Chasseur*. He spent time in Rome (1816–17), where he admired Michelangelo and Caravaggio in particular, and it was here that he prepared a set of studies for *The Race of the Barbari Horses* (unfinished), which interpreted the ancient world in an innovative and dramatic manner. On his return to Paris, he worked on *The Raft of the Medusa*, which caused a sensation and provoked bitter criticism on its showing at the 1819 Salon. Disheartened by such a reaction, he went to London where he took an interest in the work of John Constable and painted the *Epsom Derby* (1821). On his return, he visited Jacques-Louis David in Brussels. His physical and mental health deteriorated rapidly and shades of this were soon captured in his paintings: faces of desperate men rendered with intense brushwork, highlighted by contrasts of color and light.

Jean-Louis-Théodore Géricault
The Raft of the Medusa
1819, oil on canvas.
Paris, Louvre.

The lofty quality of the rendering of form and the noble influences from the art of antiquity endow this contemporary account with the importance of an epic event and lend it the same moral value. The subject of this monumental painting is the dramatic rescue of a tiny number of French survivors of a shipwreck that occurred in July 1816. It was exhibited at the 1819 Salon, where it elicited varied reactions, not for its pictorial qualities, but rather for its innovative significance in the role of historical paintings in romantic culture.

Jean-Louis-Théodore Géricault
The Capture of a Wild Horse
1817, oil on canvas.
Rouen, Museum of Fine Arts.

The apparent rapidity of the "erratic" brushwork that summarily fills in the restless silhouettes introduces a vitality to the severe classical rhythm of the composition, which derives from ancient bas-reliefs. Equestrian subjects are a recurring theme in the artist's work, ranging from similar interpretations paying homage to antiquity to compositions of absolute modernity, like *The Epsom Derby*, a painting of this horse race dated 1821.

Jean-Louis-Théodore Géricault
Portrait of a Kleptomaniac
1822, oil on panel.
Ghent, Museum of Fine Arts.

This painting's close perspective imposes a tragic perception of the man committed to Salpêtrière for his mental illness. Against the dark tones of the palette, the white of the collar and tie emphasizes the man's emaciated face and frightened gaze; the artist captures, with human pathos, his desperate, brutalized state. The painting is one of a series produced for his friend, the physician Etienne Georget.

Eugène Delacroix
(b. Charenton-Saint-Maurice 1798, d. Paris 1864)

Delacroix attended the atelier of Pierre Guérin, where he befriended Théodore Géricault (posing for *The Raft of the Medusa*), and the atelier of Antoine Gros. He made his debut in 1822, with *The Barque of Dante*, but he became famous with *The Massacre of Chios* (1824). His interest in John Constable led him to London in 1825. The Revolution, in July 1830, inspired him to paint *Liberty Leading the People*, which is perhaps his most famous canvas. He mixed with some of the best-known literati: Merimée, Dumas, Hugo, George Sand, and Baudelaire were his friends. In 1832, he traveled around Spain and Morocco, recording ideas in quick sketches. He received many commissions for decoration of public buildings and churches, including the Palais du Luxembourg (1840–46), the Louvre (1850–51), and Saint-Sulpice (1849–61). He went to Belgium and Germany in 1850. Delacroix kept a diary, which is an invaluable record of his thoughts and art.

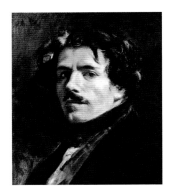

Eugène Delacroix, *Self-portrait*, detail, c. 1839, oil on panel. Paris, Louvre.

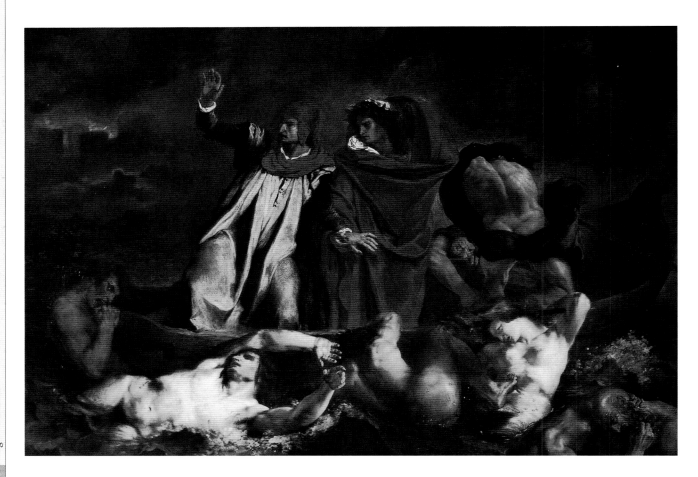

Eugène Delacroix
Dante and Virgil in Hell
1822, oil on canvas.
Paris, Louvre.

Dante, shaken by the horrifying vision of the damned clutching at the boat, asks Virgil for support. In the livid light, the bodies of the dead appear in a dramatic monumentality bereft of strength. Michelangelo and Rubens, together with Géricault, inspired the painting's force and expressive zeal. The work was unreservedly admired by Baudelaire, who deemed Delacroix among the greatest artists because of his talent for suggesting "the invisible, the intangible, dreams, energy, and *soul*" (Baudelaire 1981, 331).

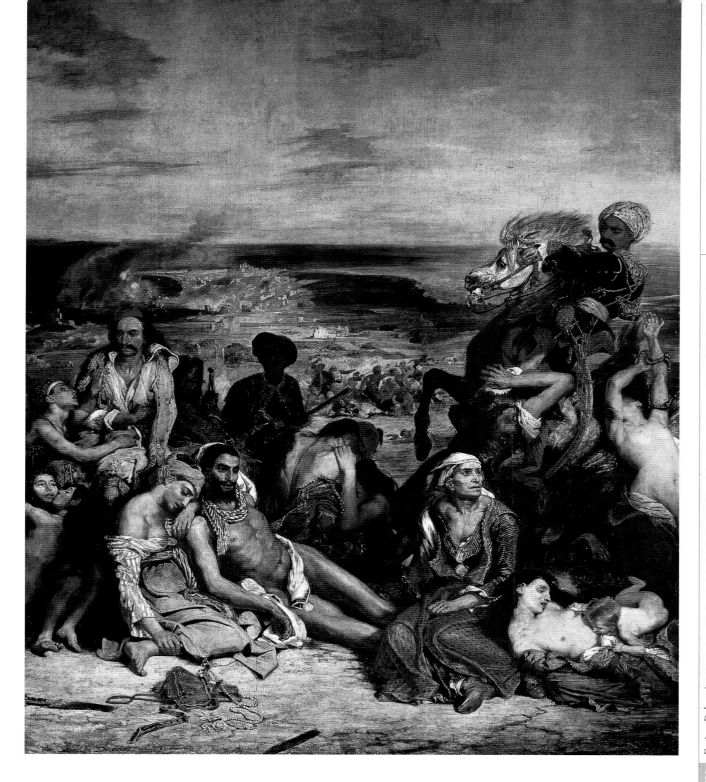

Eugène Delacroix
The Massacre at Chios
1824, oil on canvas.
Paris, Louvre.

On January 12, 1824, Delacroix noted in his diary: "Massacre at Chios, duration one month." The tragic event occurred in 1822, during the Greek war of independence from Turkey. European artists and intellectuals participated, and not just emotionally, in this dramatic war perceived as the rescue of the cradle of Western civilization from the Islamic world and an affirmation of nationalism, a sentiment that became increasingly heartfelt and widespread during the romantic era.

Eugène Delacroix
Moroccan Notebook
1832, oil on canvas.
Paris, Louvre, Drawing
Collection.

During Delacroix's
voyage to the Orient,
between January and
July of 1832, he kept a
diary where he made
notes, writings, and
watercolor sketches, in a
seamless continuum.

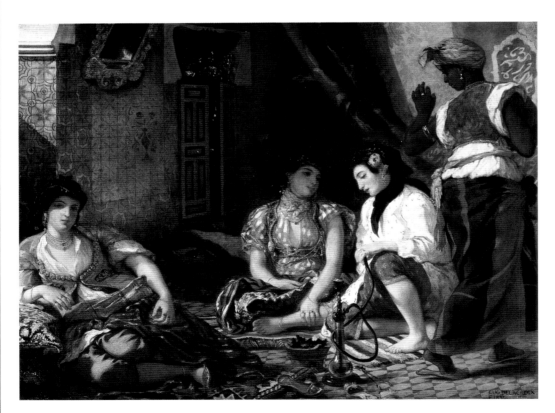

Eugène Delacroix
*Algerian Women in
Their Apartments*
1834, oil on canvas.
Paris, Louvre.

Delacroix's voyage to Morocco, where the "beauty that walks the streets"
continually inspired "the frenzy to paint," was a fervid source of inspiration for
exotic subjects. He rendered these paintings with such evocative intensity that they
became a model for rendering a theme that was of great interest to the romantic
imagination. In any case, Delacroix was well aware of his own creative energy and
he even declared: "What are most real to me are the illusions that I create with my
paintings. The rest is shifting sand."

Eugène Delacroix
Study of Trees in the Park at Nohant
1843, watercolor.
Private collection.

Delacroix depicts this corner of the park with masterly confidence, suggesting a complexity of perceptible sensations with his brushwork, which deepens or dilates to create the density of the woods, the air of dampness, and the faint shadows of the sparse trees, projected into the foreground.

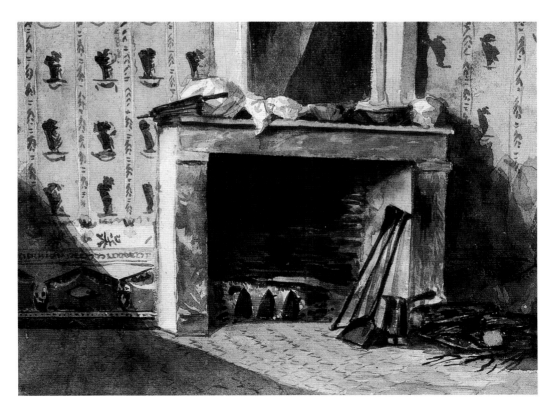

Eugène Delacroix
The Fireplace
1824, watercolor.
Philadelphia, Museum of Art.

The painting's perspective reveals an unconventional view of the wall, focusing on the fireplace and the various tools required: tongs, shovel, and bellows. The presence of three irons on the hearth, standing in a row, evokes a sense of domestic familiarity and, at the same time, suggests the creative spirit of the painter who was able to capture the poetry of such an everyday subject.

Karl Pavlovič Briullov

(b. Saint Petersburg 1799, d. Manziana, Rome 1852)

Raised in a family of artists, from 1809 to 1822 Briullov attended Saint Petersburg Academy. In 1823 he went on a study trip to Germany and Italy, settling in Rome, where he stayed until 1835, playing an active role in the city's art scene. He then painted subjects of typical Mediterranean charm, including *Italian Morning* (1823) and *Young Girl Gathering Grapes in the Neighborhood of Naples* (1827). The work that ensured his fame, however, was *The Last Day of Pompeii* (1830–33). When he returned to Russia, he received many honors. In 1835 he went to Greece and Turkey, entrusted with the task of sketching the countries. He lived in Saint Petersburg, where he taught at the Academy, and he established himself as a portrait painter. Between 1843 and 1847 he worked on sketches for the decoration of the city's cathedral, a project he never completed because his poor health forced him back to Rome.

Karl Pavlovič Briullov
Self-portrait, detail, c. 1849, oil on board. Saint Petersburg, Russian State Museum.

Karl Pavlovič Briullov
The Last Day of Pompeii
1833, oil on canvas. Saint Petersburg, Russian State Museum.

This painting was presented to the public at the artist's Roman studio and immediately aroused enthusiastic admiration from the international artistic and literary communities. Overwhelmed by the blanket of ashes revealed by the glow from the red-hot lava, people and animals vainly attempt to escape devastation and death. The artist succeeded in infusing the composition with panic without sacrificing the noble quality of form and cultivated references to the art of the past. The long and demanding evolution of the painting exhausted Briullov who, aware of the importance of his work to the future of art, portrayed himself in the scene as the figure of a young man fleeing and carrying a box with paints and paintbrushes on his head.

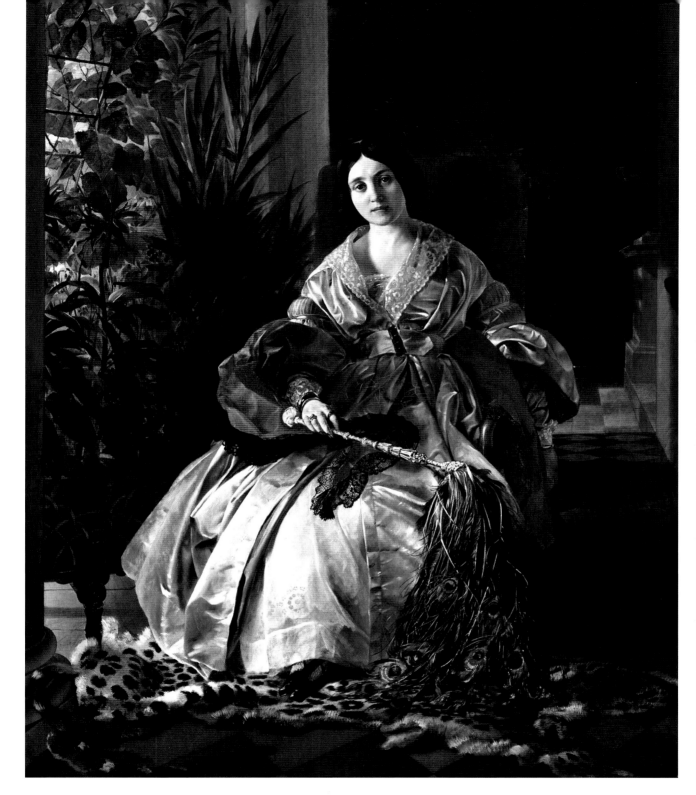

Karl Pavlovič Briullov
Princess Yelizaveta
Pavlovna Saltykova
1841, oil on canvas.
Saint Petersburg, Russian
State Museum.

The sumptuous use of colors, including the princess's blue dress with a white skirt and her red mantle trimmed with precious black lace, enhances the aristocratic image of the woman sitting in a winter garden luxuriant with splendid exotic flowers. She poses on a wide red velvet armchair in a tranquil, almost pensive manner, among the symbols of her beauty and opulence: the fan with colored peacock feathers, with which she wearily shoos away flies, and a disheveled leopard skin below her small feet, shod in elegant black slippers.

Francesco Hayez
(b. Venice 1791, d. Milan 1882)

Hayez studied at the Venice Academy and was in Rome from 1809 to 1813, thanks to his mentor, Antonio Canova, who also found him work in the Chiaramonti Museum. On his return to Venice, in 1817, Hayez worked on the decoration of the royal palace. In 1820 he painted *Pietro Rossi*, marking the birth of historic romanticism. The painting's success opened the doors to Milan's Brera Academy, where he became president in 1860, after a lengthy teaching career. His fame as a historical painter matched that of his portrait skills, and his patrons were some of Milanese society's most fashionable figures. In 1837 he went to Vienna to present the Hall of the Caryatids decoration project. In 1855 and 1867 he took part in the Paris Universal Exposition and then the 1873 Expo in Vienna. In 1869 he wrote his *Memoirs*. He continued to paint with surprising creative force until the end of his life, as can be seen in his *Vase of Flowers on the Window of a Harem* (1881).

Francesco Hayez
Self-portrait with Friends, detail
1827, oil on canvas. Milan, Poldi
Pezzoli Museum.

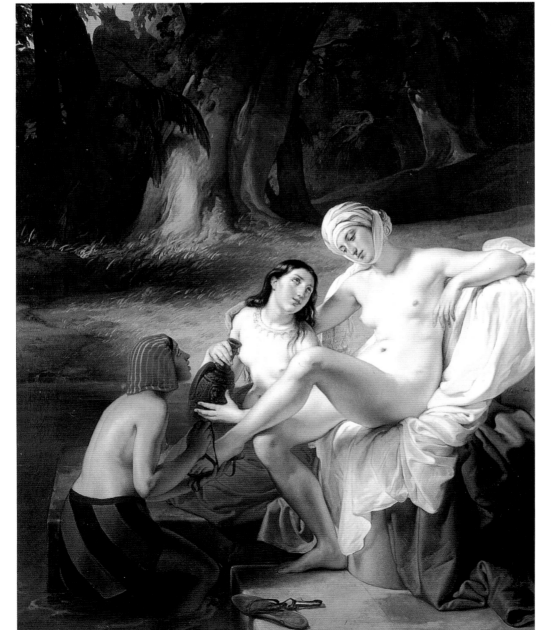

Francesco Hayez
Bathsheba at Her Bath
1834, oil on canvas.
Private collection.

Light molds the female nude and her devoted handmaidens, lingering in the description of their features and the infinite gentleness that unites the three figures in silent conversation. Pure ivory skin is enhanced by the red garments worn by the handmaidens and the whiteness of the sheet. The sensuality that underpins the scene, set on the bank of a stream, is rendered even more intense by the figure of David, glimpsed amid the thick fronds of an age-old wood.

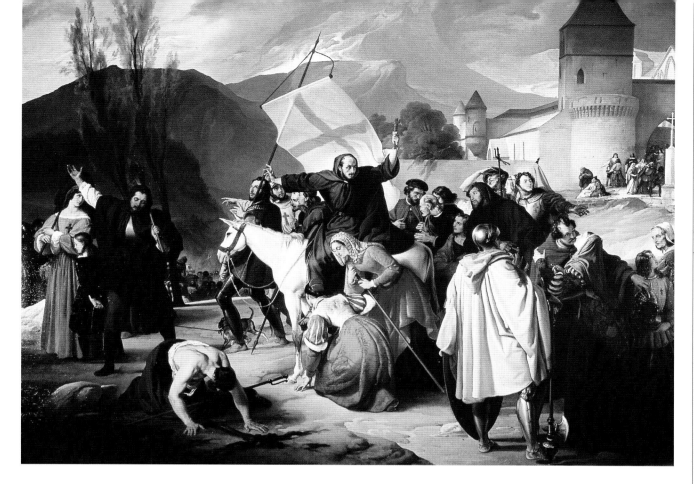

Francesco Hayez
Accusa Segreta
1847–48, oil on canvas.
Pavia, Malaspina
Museum.

The sole female figure is
sufficient to achieve a
masterly rendition of
this captivating story,
where the woman's
jealousy is so
overwhelming that she
accuses her treacherous
lover. The shadowy
eroticism that pervades
the scene, set on the
loggia of Palazzo
Ducale in Venice, is a
counterpoint to the view
of the city, seen in the
sunshine of a fine day.

Francesco Hayez
Peter the Hermit Preaches the Crusade
1827–29, oil on canvas.
Private collection.

This artwork was shown at the Accademia di Brera
(Milan) in 1829, and was admired by Stendhal for the
credibility of the ardent expressions. There was
general enthusiasm for the beauty of the painting, but
also for the openly patriotic expression, aligned with
the tenets typical of romanticism. It was no
coincidence that Giuseppe Mazzini indicated it as an
exemplary opus of nationalist ideals, thanks to the
ability of Hayez, who endowed the figures of Peter
the Hermit and his disciples with such emotional
impetus that the subject acquired the significance of a
great page from history.

Hippolyte (Paul) Delaroche
(b. Paris 1797, d. 1856)

Delaroche studied landscape at the École des Beaux-Arts, then devoted himself to historical painting, becoming a pupil of Antoine-Jean Gros in 1818. Delaroche's sentimental scenes are rendered with very dramatic technique and achieve great emotional effect, but are also known for the expressive plausibility of the characters depicted. In 1831 he exhibited *Children of Edward*, a painting that marked the peak of his success, even inspiring Casimir Delavigne to paint a tragedy on the same theme (1833), dedicated to Delaroche. In 1833, after being appointed lecturer at the École des Beaux-Arts, he was commissioned to paint the *Stories of Mary* for the church of La Madeleine, in Paris. In 1834 he went to Italy on a study trip. From 1837 to 1841 he worked on the École des Beaux-Arts fresco hemicycle, which depicts the glory of the artists from the Renaissance to the modern day. His demise was mourned by artists all over Europe.

Hippolyte (Paul) Delaroche
Self-portrait, detail, 1838, charcoal on paper. Private collection.

Hippolyte (Paul) Delaroche
The Princes in the Tower
1830, oil on canvas.
Paris, Louvre.

The artist was determined to render the subject as emotionally convincing as possible so he resorted to a direct, gripping presentation of the players, with a close-up depiction of their human pathos. The little dog emphasizes the fearful suspense of the scene.

Hippolyte (Paul) Delaroche
The Childhood of Pico della Mirandola
1842, oil on canvas.
Nantes, Museum of Fine Arts.

Pico della Mirandola, the great Renaissance scholar held in esteem by the court of Lorenzo the Magnificent, is shown as a child, in an image of a neo-1500s flavor that pays homage to the portraiture of Andrea del Sarto in the charming, affectionate feel of the genre scene. The painting expresses the artist's aspiration to render the historical event he is narrating as realistic as possible, and it describes family life, spotlighting the meditative pose of the child prodigy intent on his spelling, his mother looking on tenderly as she teaches him to read.

Théodore Chassériau

(b. Sainte Barbe de Samana, Santo Domingo 1819, d. Paris 1856)

Chassériau became a pupil of Ingres in 1833 at the École des Beaux-Arts. In 1836 he made his debut at the Salon, establishing himself as a portrait painter. *Ruth and Boaz*, his first biblical subject, dates to 1837, and was followed by *Suzanne Bathing* and *The Toilet of Esther*, imbued with as touching a sensuality as that found in mythological subjects. He visited Naples and Rome in 1840; he met Ingres, but had already distanced himself from the style of the master, accentuating the latter's simplification of form to the point that the harmony of the image—based on Mannerist painting filtered through the "sublime"—was shattered. On his return, he was commissioned to decorate a chapel in the church of Saint-Merry, which was completed in December 1842. From 1844 to 1848 he decorated the staircase of the Cours des Comptes, but he interrupted the work for a trip to Algeria in 1846, a chance to study and sketch, later using the results for the orientalist scenes that brought him the most success.

Théodore Chassériau, *Self-portrait*, detail, 1835, oil on canvas. Paris, Louvre.

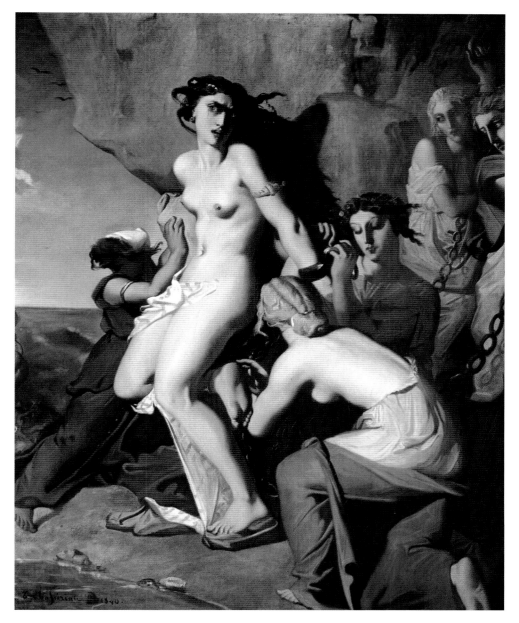

Théodore Chassériau
Andromeda Chained to the Rock by the Nereids
1840, oil on canvas.
Paris, Louvre.

This painting was exhibited at the 1841 Salon and was the artist's outright declaration of his emancipation from the master's purism. If Chassériau perceived beauty of form and references to figurative tradition as indispensable elements for the realization of an artwork, the emotional intensity and sheer creativity prove just how innovative his painting was, of a strength sufficient to pour new vitality and remarkable meaning into the mythological theme. Dramatic force springs from the contrast between the victim's desperation and the impassive calm of the Nereids in the face of fate, making the subject topical, while the background and the happy ending are deliberately ignored.

Joseph Mallord William Turner
(b. London 1775, d. Chelsea 1851)

Turner began his studies at the Royal Academy, in 1789, and was already exhibiting in 1790. He was inspired by Thomas Girtin and John Robert Cozens, and painted his first landscape in 1796. He visited Switzerland and France in 1802. From then on, he frequently traveled around Europe, especially in France. In 1807, he was appointed as professor of perspective at the Royal Academy. In 1819 he produced watercolor illustrations for James Hakewill's Picturesque Tour of Italy and went to Italy for the first time. He visited the Lakes, Venice, Rome (where he met Antonio Canova), Naples, and Paestum. In January 1820 he returned with nineteen full sketchbooks, sources of inspiration for his future paintings. From 1830, he was often a guest of Count Egremont at Petworth, where his paintings included lush floral compositions. He returned to Venice in 1833, during a trip around central Europe, and again in 1840. At that time he painted a lavish series of watercolors of the city and the lagoon.

Joseph Mallord William Turner
Self-portrait, detail, c. 1799, oil on canvas. London, Tate Britain.

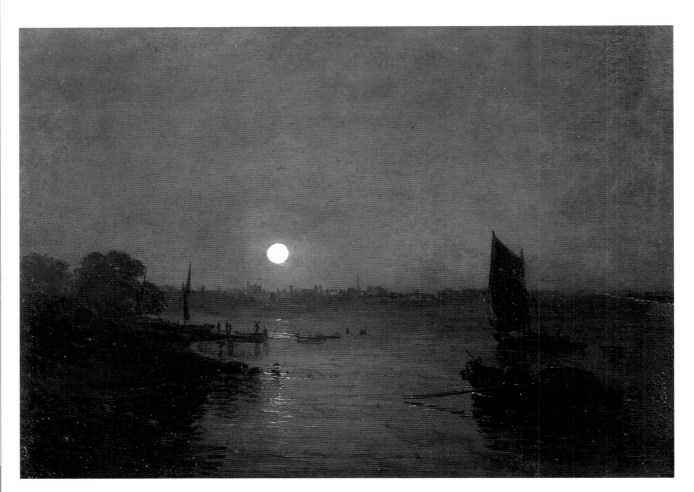

Joseph Mallord William Turner
Moonlight, a Study at Millbank
1797, oil on canvas.
London, Tate Britain.

The pale, shadowy light of the full moon and blue reflections on the surface of the Thames enhance the space of the night scene, casting a veil of mystery that is even more tangible thanks to the silhouetted boats appearing in the hazy backlight.

Joseph Mallord William Turner
London Seen from a Distance
1796–97, watercolor, colored paper.
London, Tate Britain.

From the 1790s, the artist acquired the habit of using a sketchbook to preserve the memory of a detail of light or mood. In this case, Turner noted the effect produced by the sun's rays through the rain-soaked clouds; the towers and domes of London are glimpsed as light shadows in the sky through the fleeting shafts of light.

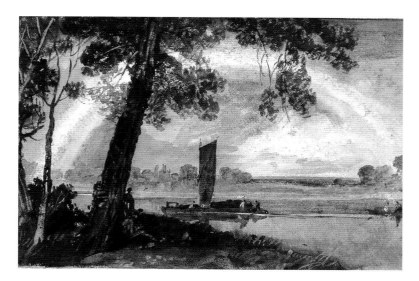

Joseph Mallord William Turner
Thames with Rainbow
c. 1805 watercolor, colored paper.
London, Tate Britain.

Another sheet from the sketchbook, but here the landscape shown already reveals the traits of skillfully calculated and composed arrangement, evocative of the great works left by 1600s Dutch landscapists like Meindert Hobbema and the Ruysdaels.

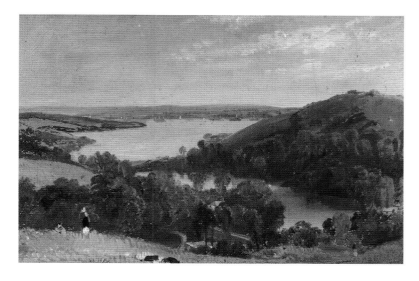

Joseph Mallord William Turner
Hamoaze from Saint John (Cornwall)
1813, oil on paper.
London, Tate Britain.

A view from above of the Cornish coast, where the blue of the distant sea is instilled with the color of the sky. This work was painted in the studio from pencil sketches executed *sur le motif*, and is typical of Turner's exquisite sensitivity in the pictorial transposition of natural light and atmosphere.

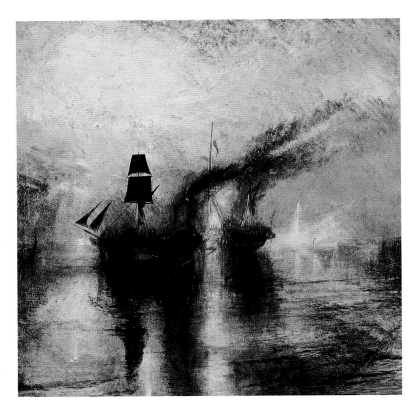

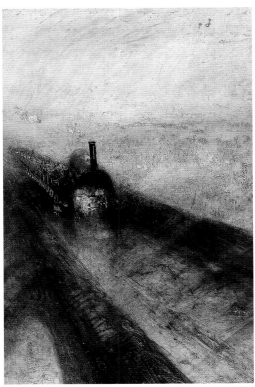

Joseph Mallord William Turner
Burial at Sea of the Body of Sir David Wilkie
1842, oil on canvas. London, Tate Britain.

This piece, shown in 1844 at the Royal Academy, commemorated Turner's friend David Wilkie, the Scot painter who died off Gibraltar while returning from the Holy Land. The powerful backlighting effect creates a leaden contrast for the ships and sails, creating a metaphor for grief with the dramatic atmosphere and gloom of a stormy day.

Joseph Mallord William Turner
Rain, Steam and Speed—The Great Western Railway, detail
1844, oil on canvas. London, National Gallery.

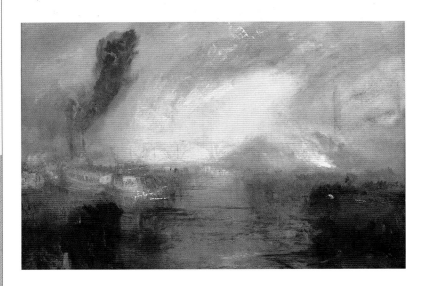

Joseph Mallord William Turner
The Thames above Waterloo Bridge
1830–35, oil on canvas.
London, Tate Britain.

The thread-like brushwork, thickening to create the black smoke from the chimney stacks, the unruly vegetation along the banks of the Thames, and the low cloud heavy with rain, then yields into precious pearly light effects that suggest, rather than depict, the view of London. The reminiscence of Claude Lorrain's painting enlivens the image of a city imprinted with the advance of progress, not unlike the descriptions Charles Dickens was soon to create for his novels.

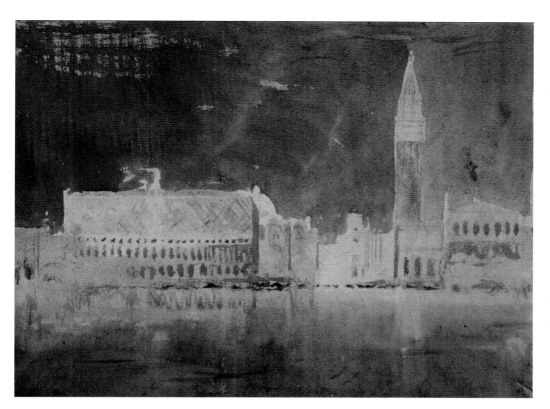

Joseph Mallord William Turner
The Campanile of Saint Mark's and the Doge's Palace
1819, watercolor and pencil, white paper. London, Tate Britain.

This watercolor dates to the artist's short 1819 stay in Venice. Although the pencil has outlined the contours of the buildings, it is the color that depicts the city's luminous beauty, appearing with the evanescence of a vision between the blue of the sky and that of the lagoon.

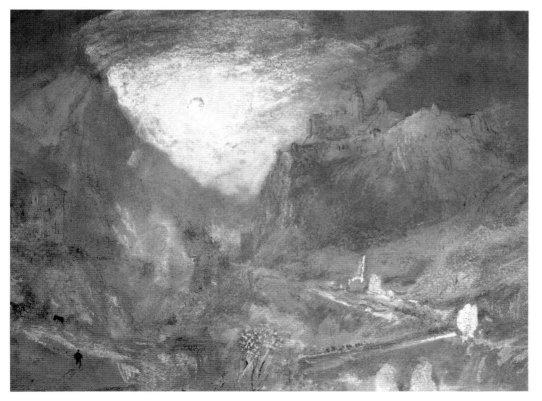

Joseph Mallord William Turner
View of Sisteron
1832, watercolor and pencil, pale blue paper. Krugier-Poniatowski Collection.

The brushstroke almost dissolves as it composes the majestic French landscape, which appears like the reflection of an allusion, of a fantasy, rather than a real observation, thanks to the skilled study of the effect of light and transparency of the air.

Leading Figures *Joseph Mallord William Turner*

John Constable

(b. East Bergholt, Suffolk 1776, d. London 1837)

Constable went to London in 1799 to enroll as a student at the Royal Academy. He admired Thomas Girtin and John Robert Cozens, and the seventeenth-century landscape painting of Claude Lorrain, Meindert Hobbema, and the Ruysdaels. In 1802 he began to exhibit at the Royal Academy with landscapes of the English countryside: places he loved and often depicted, under different lighting and weather conditions, paying careful attention to render the changing atmosphere. He went to Salisbury for the first time in 1811, and to Dorset in 1816, where he painted his first sea studies, including Weymouth Bay. In 1824, a number of his paintings were awarded a gold medal at the Paris Salon. The death of his wife, in 1828, plunged him into a state of deep depression that was reflected in his art: the compositions became more restless and emotion increased in the rapport of light and color. In 1832 he published a mezzotint collection of his paintings, produced by David Lucas.

Ramsay Richard Reinagle
Portrait of John Constable, detail
c. 1799, oil on canvas. London,
National Portrait Gallery.

John Constable
Study of Clouds at Hampstead
1821, oil on paper laid on board.
London, Royal Academy of Art.

The sky is the key feature in Constable's open-air studies; it is the sky that determines the light effects that distinguish the painting's extensive range of weather conditions, from the luminous freshness of a spring day to the looming grayness of rain-laden clouds. Sometimes, imitating a habit of Cozens and Girtin, his attention lingers just on the sky, which becomes the sole motif of the life study.

John Constable
Wivenhoe Park
1816, oil on canvas.
Washington National
Gallery, Widener
Collection.

John Constable
Brighton Beach
1824, oil on paper.
London, Victoria and
Albert Museum.

The artist's habit of making oil studies *en plein air* allowed him a freedom of expression that was unhindered by convention. With pure color, laid in brisk, confident strokes, or shattered in a kaleidoscope of myriad dabs or filaments, Constable composed his landscapes, suggesting both a spatial depth and the light and weather conditions.

John Constable
Water Meadows near Salisbury
c. 1820, oil on canvas.
London, Victoria and
Albert Museum.

In an early summer day without sun, the sky is traversed by light clouds and reflected in the still water meadows, creating a precious play of light and color, ranging from the palest green to silver. In 1830, after the painting was remodeled to the style of 1600s Dutch landscapes, it was rejected for exhibition by the Royal Academy, causing Constable to resign from his post on the academic jury.

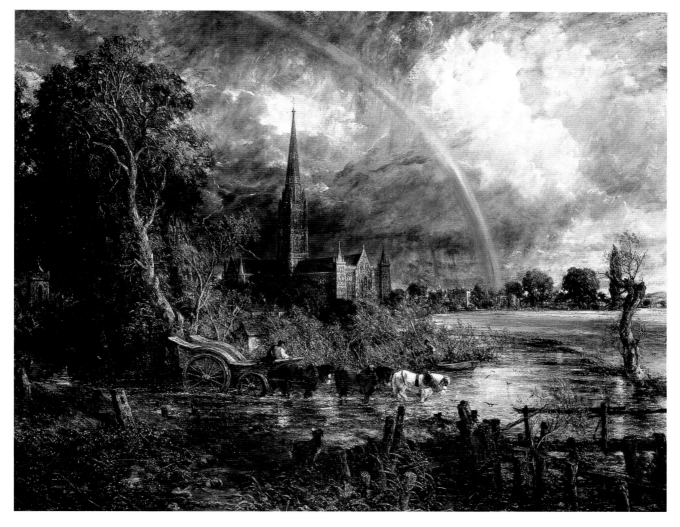

John Constable
Salisbury Cathedral from the Meadows
1831, oil on canvas. London, National Gallery.

A vivid light penetrates the blanket of gray cloud to cast a rainbow that seems to frame the view of the ancient cathedral beyond the torrent. The cart drawn by three horses, with the boatman and dog in the foreground, suggest that a daily routine is being carried on and thus casts a veil of pleasing poetry over the scene. The painting was based on life notes made in 1829, when Constable stayed in Salisbury for the last time, and was shown by the Royal Academy in 1831.

Jules Dupré, period photograph.

Jules Dupré
(b. Nantes 1811, d. L'Isle-Adam 1889)

Dupré began as a porcelain decorator in his father's factory at L'Isle-Adam. In 1831 he traveled to England, where he encountered, and was deeply impressed by, John Constable's landscape painting. At the Paris Salon of that year he exhibited six landscapes, a genre that he never abandoned. In 1834 he met Jean-Jacques Rousseau, becoming both his friend and financial supporter. They painted together at Fontainebleau and traveled around the unblemished French countryside in search of inspiration. Berry and Limousin were his favorite places. In 1839 he showed his work in Nantes, at a memorable exhibition that established the young French landscape painter. In 1848 he participated at the controversial Bazar Bonne-Nouvelle landscapist show, but in 1850 he retired to L'Isle-Adam, where he gradually abandoned *plein air* painting.

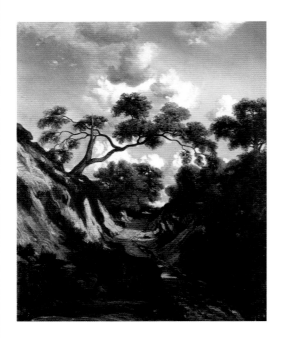

Jules Dupré
Path through the Rocks
c. 1835, oil on canvas.
Paris, Brame and Lorenceau Gallery.

In the crystal-clear atmosphere, the deep chiaroscuro contrasts and the nonchalant paint application that creates the steep slope of the path suggest that reality is certainly being depicted in every detail, taken as the start of a figurative revival by the artist and the painters who frequented the Barbizon countryside in the 1830s.

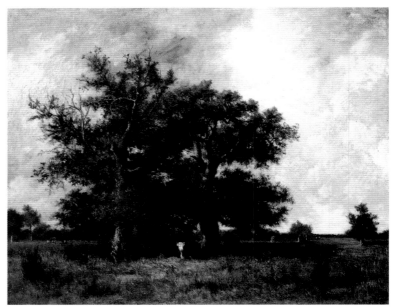

Jules Dupré
Fontainebleau Oaks
c. 1840, oil on canvas.
Minneapolis, The Minneapolis Institute of Arts, The William Hood Dunwoody Fund.

Using a rich impasto with a thready stroke, the artist renders on canvas the sensations aroused in him by Fontainebleau's untamed nature. Knotty, age-old trees break into the endless flow of fields, where wild animals would pasture. The composition, with its central group of mighty oaks soaring towards the cloudy sky barely tinged with blue, speaks of the painter's admiration for the Dutch landscapists Ruysdael and Hobbema.

Théodore Rousseau
(b. Paris 1812, d. Barbizon 1867)

Théodore Rousseau, period photograph.

Rousseau was apprenticed to a landscape painter who taught him how to copy seventeenth-century Dutch landscape painting. He started to work in the Fontainebleau forest in 1827. In 1830, he went to the Auvergne and found inspiration for his paintings. In 1831, he exhibited at the Salon for the first time. He then left Paris and settled in Chailly (1833), then in Barbizon (1836). In the meantime, he met Jules Dupré, who introduced him to English landscape painting. He lived between Barbizon and Paris from 1837 on. His painting, which depicts nature in its randomness, did not garner the favor of the most conservative critics, and his paintings were actually rejected by Salons until 1849, the year he met Jean-François Millet and became a close friend. His first important commissions date to 1850, but it was the 1855 Universal Exposition that confirmed the triumph of his art.

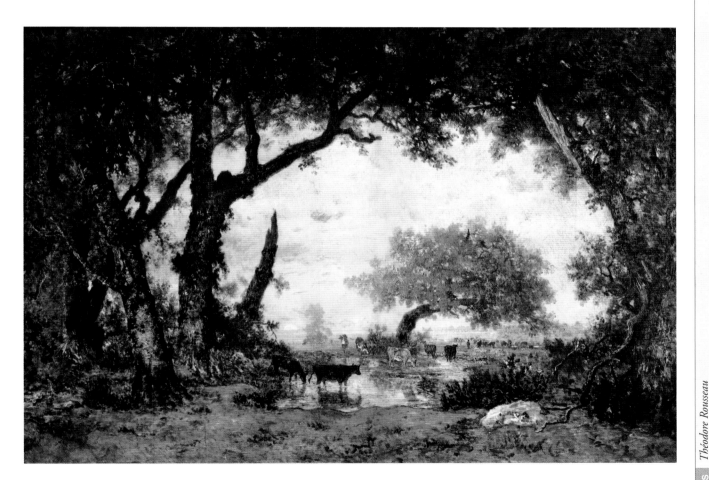

Théodore Rousseau
The Edge of the Forest at Fontainebleau: Setting Sun
1848, oil on canvas.
Paris, Louvre.

Oak branches entwine to create a leafy curtain that frames the ample view of a sky soaked in golden sunlight, just visible on the edge of the horizon. The painting was shown at the 1848 Salon, the first to include Barbizon painters, and was purchased there by the French politician Alexandre Auguste Ledru-Rollin. The opus is indicative of how, in the mid-1800s, the importance played by light effects in rendering the spontaneity of the landscape and the apparent speed of brushstroke to evoke the complexity of perceptions initiated a new way of creating art, intended in the modern sense as an expression of individual thought and sentiment.

Jean-Baptiste-Camille Corot
Self-portrait, Sitting next to an Easel, detail, 1825, oil on paper mounted on canvas. Paris, Louvre.

Jean-Baptiste-Camille Corot
(b. Paris 1796, d. 1875)

Corot studied landscape painting privately and began to work in the Fontainebleau forest and Normandy in 1822. He lived in Italy from 1825 to 1828 and painted many life studies of Rome and the Latium countryside, bearing a strong resemblance to neoclassical landscape painters like Pierre-Henri de Valenciennes in terms of style and sentiment. Corot returned to France and began showing his work at Salons. His second trip to Italy was in 1834 (Volterra, Florence, Venice), and he returned once more in 1843. During that period he was also focusing on figures, and he painted enchanting female images, as well as "animated" landscapes. He continued to paint in harmony with the Barbizon painters, especially Charles-François Daubigny, with whom he traveled throughout France. Corot was fond of photography and engravings, and used the *cliché-verre* technique. The 1855 Universal Exposition established his success.

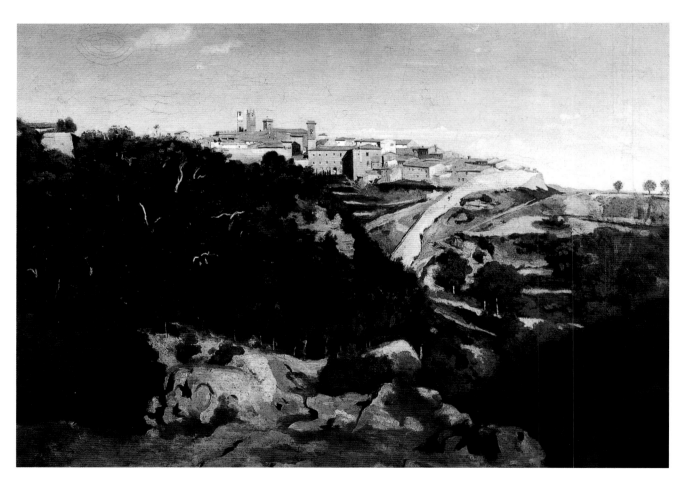

Jean-Baptiste-Camille Corot
Volterra
1834, oil on canvas. Paris, Louvre.

Beyond the shadowy thicket of cypresses and ilex, the towers and roofs of the Tuscan town stand delicately against the pale blue sky. The calm, muted light evokes calm contemplation for this view of Volterra and its verdant surroundings, considered "magnificent" by the painter, who stayed there briefly during his second trip to Italy, in 1834.

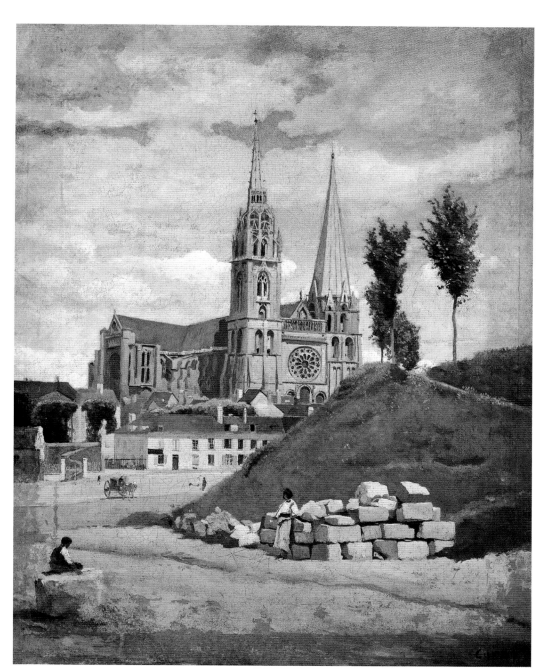

Jean-Baptiste-Camille Corot
Chartres Cathedral
1830, 1872, oil on canvas.
Paris, Louvre.

The start of the Revolution, in July 1830, made the artist leave Paris—where he could no longer work—and begin a journey across France. In Chartres, attracted by the Gothic architecture, he painted this view of the cathedral, adding the men in the foreground many years later. A pale light, reminiscent of painting from a Nordic country, settles gently on the cathedral, on the modest houses around it, and on the grassy slope where a few slender trees seem to balance out the massive belfries, thus ensuring a poised harmony to the composition.

Jean-François Millet
(b. Gruchy 1814, d. Barbizon 1875)

Jean-François Millet
Self-portrait, charcoal sketch
c. 1837.

When he was awarded a scholarship, Millet settled in Paris in 1837, and studied with Paul Delaroche. After producing Watteau-style genre paintings and portraits to support himself, he focused on humble peasant scenes, which established him at the 1848 Salon, when his *Winnower* was bought by Minister of the Interior Ledru-Rollin. Thanks to the engraver Charles Jacque, Millet began to spend time at Barbizon, where he took refuge with his family in 1849, forsaking Paris after the Revolution began. He spent the rest of his life in Barbizon, never ceasing to find sources of inspiration for his paintings of life in the fields, created in absolute adherence to figurative tradition. Nonetheless, the critics were indifferent to his work and he relied on the encouragement and financial support of his colleagues, until some success finally arrived, after 1860.

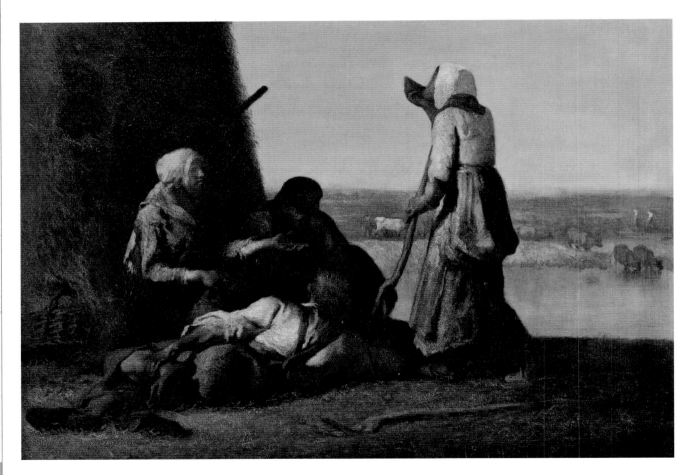

Jean-François Millet
Haymakers at Rest
1848, oil on canvas.
Paris, Musée d'Orsay.

The group of peasants, resting in the shade of the haystack as they consume their meager rations, looms disturbingly close because of their placement directly in the foreground. Beyond the pond where the herd slakes its thirst, the sun-drenched countryside rolls out of view. The artist's severe synthesist forms are further simplified by a fine, thready application of paint that seems to trap the light and transfuse it into particles, thus giving the figures and landscape the blurred appearance of a vision. It was precisely in 1848 that Millet began to propose the themes of humble peasants, casting on these images of ordinary existence an epic intention that pays homage to the leading figures in the history of great painting.

Augustus Welby Northmore Pugin, period photograph.

Augustus Welby Northmore Pugin

(b. London 1812, d. 1851)

Pugin studied with his father Auguste Charles, and then trained in the studio of John Nash; he received important commissions for interior decoration and furnishings of important buildings and homes from a young age. By 1832, he had furnished Windsor Castle and produced various set designs for Covent Garden. He was a staunch supporter of the Gothic Revival, theorizing about aesthetic and functional values in several essays, of which *Contrasts* was the most successful. In 1839 he started working with Charles Barry on the construction of the Houses of Parliament, in London, managing interiors and furnishings down to the last detail. Design of the church at Cheadle (Staffordshire) dates to 1841, and was completed in 1846; two years later he was involved in designing Nottingham Cathedral (1842–44), and he began work on the church of Saint Augustine, in Ramsgate, in 1846, which he financed after his conversion to Catholicism.

Augustus Welby Northmore Pugin
House of Lords (above)
Staircase in the House of Lords (right)
c. 1847.
London, Houses of Parliament.

The architectural finishes, decorations, and furnishings for the Houses of Parliament were designed in pure neo-Gothic style, and the obvious political function aligned the resulting models with ancient cathedrals intended to glorify God, with the celebration of earthly majesty. The rich materials, the refined working of the carved, gilded wood, gold, bronze, and stuccoes, the statues in niches, and the frescoes portraying aristocrats, as well as the stained-glass windows complete with armorial bearings, all contribute to emphasizing the power of the British monarchy and its system of government.

Eugène-Emmanuel Viollet-le-Duc, period photograph.

Eugène-Emmanuel Viollet-le-Duc
(b. Paris 1814, d. Lausanne 1879)

Viollet-le-Duc was a member of a cultured family, and was encouraged to turn to art by Prosper Merimée. The playwright entrusted Viollet-le-Duc with the restoration of the La Madeleine church in Vézelay, in 1840, followed by Sainte-Chapelle and Notre-Dame in Paris. He undertook many restoration projects, all for refurbishment of Gothic buildings that he regarded as an expression of a secular culture and, aligned with nationalist concepts, absolutely French. His theoretical writings emphasized the rationality, and function of Gothic architecture's bearing elements (groins, buttresses, rampant arches), which he felt were comparably modern as well as applicable to the iron structures of his day. He was appointed general inspector of diocesan monuments in 1853, and devoted himself to writing the *Dictionnaire Raisonné de l'Architecture Française du XIe au XVIe Siècle* (Paris, 1854–68), while also managing restoration of the town of Carcassonne.

Eugène-Emmanuel Viollet-le-Duc *Gargoyle* 1844–64. Paris, Notre-Dame.

The monstrous animals with their fantastic or diabolical features, set into the top of the cathedral's western tower to serve as gutters, were all designed by Viollet-le-Duc during a lengthy restoration of the building.

**Eugène-Emmanuel
Viollet-le-Duc**
View of the Cathedral
Carcassonne.

The refurbishment of the bastions, fortifications, and cathedral of the ancient military presidium of Carcassonne, in Languedoc, whose strategic role declined after the Pyrenees Treaty (1659), represents one of the most important—and most successfully resolved commitments—in the career of Viollet-le-Duc, who worked there from 1849, even dedicating an essay to the subject, published in 1878. Thanks to the restoration, the citadel, which dominates the residential area that developed on the River Aude, assumed the appearance of medieval architecture dictated by the parameters of nineteenth-century fantasies. Bastions, towers, turrets, merlons, lancet arches, and slate roofs contribute to this "period" scenery that has lost none of its charm.

Lifestyles
in the Romantic Period

Lifestyles in the Romantic Period

Restoration Society: A Quiet Life

The period covering the end of the Napoleonic Empire to 1848 reveals social, cultural, and aesthetic traits that were common to all of Europe: resignation, quiet temperance, and sacrifice of every dynamic ideal of renewal were recurring aspects of each country's sensitivity as well as its literary and artistic culture. The same aspiration to social stability gave rise to an idea of the world as a harmonic entity capable of integrating, as nature does, totally diverse or even completely contrasting aspects, such as life and death, in the hope of achieving immobile, reassuring quiet. Inevitably, a similar mentality was soon reflected in everyday life, flying the flag of "serene resignation" so dear to Restoration society. Rooms were designed in the perspective of "filling life" and not "using existence," in which living was easy, satisfaction came from simple pleasures, comfort from the gentle grace of genre paintings, still lifes, artificial flowers in bell jars, and the presence of a pet, perhaps just a goldfish darting around in a glass bowl.

Danhauser Furniture Factory
Table design
c. 1825, ink, watercolor. Vienna, Museum of Applied Arts.

The table designed by one of the most famous Viennese furniture factories of the time includes an aquarium and a bird cage, reflecting the Restoration's typical concept of "tamed nature."

Page 174:
Georg Friedrich Kersting
Young Woman Sewing by the Light of a Lamp, 1828, oil on canvas.
Munich, New Pinacotheca, The Bavarian State Picture Collections.

Emilius Ditlev Baerentzen
The Winther Family
1827, oil on canvas.
Edinburgh, National Galleries of Scotland.

The Winthers are shown in the quiet domestic intimacy of their drawing room, in this classic period painting.

Danhauser Furniture Factory
Selection of chairs
c. 1820–30, ink, watercolor, white paper. Vienna, Museum of Applied Arts.

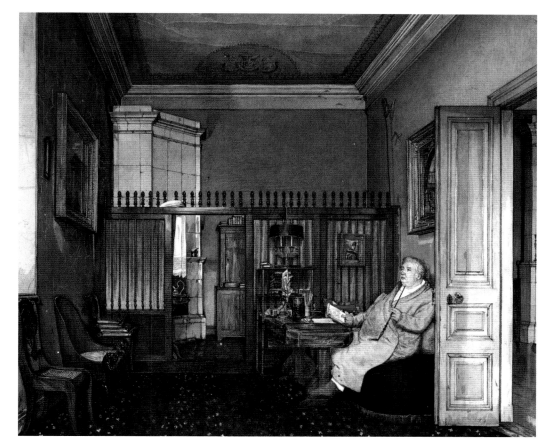

Carl Wilhelm Gropius
The Smoker in His Study, full view and details 1835, watercolor. Private collection.

In the cozy room, comforted by the huge ceramic stove, a middle-aged man smokes his pipe. The image is a visual transposition of the meaning of "Biedermeier": unpretentious Mr. Meier, intending a person who likes a quiet life and is content with a few, simple things.

Biedermeier Interiors

The furnishings and objects that were created at the time of the Biedermeier cultural context complied totally with this sort of domestic idyll that centered around a circular table laden with books, maps, needlework, the odd pastime, surrounded by comfortable cushioned sofas, a glass cabinet, or better still a butler's table overflowing with countless glasses, plates, and cups.

In stylistic terms, Biedermeier furniture—Restoration furniture in general—preserved the aesthetic line of the Empire style, but the structures were reinforced and the proportions enlarged to meet requirements for more practicality and comfort. The preferred woods were light—lemon, cherry, and maple, with intarsia of different-colored woods embellishing the furniture, replacing lavish bronze decorations. A bourgeois approach to the economy not only led to production of cheaper "substitutes," but also cozier, more practical domesticity. Veneer replaced hardwood, alabaster took the place of marble, and molten iron and zinc substituted bronze.

The friendly, pleasing, and more modern livability of Biedermeier interiors was also reflected in daily life at cafés and

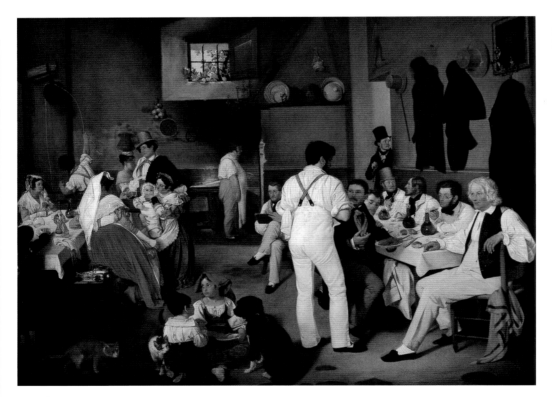

Detlef Conrad Blunck
Danish Artists at Osteria La Gonsola, Rome, full view and detail
signed and dated 1837,
oil on canvas.
Copenhagen,
Thorvaldsen Museum.

The popular tavern scene, where patrons, children, and pets mingle in a situation of routine cordiality, must have satisfied the fascination the colony of Nordic artists felt for Roman exoticism, mesmerized by the pace of life and "soft" south. At the same time, the scene proposes an adapted version of the 1600s tradition initiated by the Bamboccianti (seventeenth-century Dutch and Flemish painters in Rome). A previous version of this canvas, datable to about 1836, appears simplified but substantially similar, and is now in the Nationalhistoriske Museum på Frederiksborg, at Hillerod.

restaurants, which many Nordic painters depicted during trips to Italy, illustrating not only a pleasant pastime but a new way of favoring meetings and cultural exchanges among artists, rather than the traditional venues of academies and studios.

In Conrad Blunck's painting of a Trastevere restaurant, in Rome, Bertel Thorvaldsen (the oldest member of the group and certainly the mentor of these Danish artists) is shown listening attentively to the waiter, while all around women, children, and youths contribute "color" to the convivial scene. The *Danish Artists in Rome* are also the theme of a painting by Constantin Hansen, who, conversely, imbued a studio scene with a subtle melancholic aura. The artists gather in random poses in front of the large window overlooking the city rooftops; the long thin pipes they smoke are typical of Denmark and perhaps symbolize a yearning for their homeland, as would seem to be the case from their thoughtful, serious faces. It should be remembered that patriotism spread widely in the romantic era, finally resulting in the 1848 conflicts.

Eugène Delacroix
The Tented Room in the Apartment of Charles Demorny
1833, oil on canvas.
Paris, Louvre.

The large upholstered sofa fills the count's bedroom and suggests the decidedly masculine character of the chamber, echoing a vaguely oriental feel, underscored by the leopard skin thrown across the carpet.

Augustus Welby Northmore Pugin
Eastnor Castle drawing room
c. 1845–50.
Eastnor Castle, Hereford and Worcester, UK.

Sofas, settees, and armchairs with soft cushions, smoking tables, and small bookcases all suggest a level of warm comfort restored to this formal drawing room with its meticulous imitation of Gothic models down to the last detail: the chandelier, for instance, was copied from one in Nurnberg Cathedral.

New Forms, New Techniques

The spring cushion, the device that best expressed Restoration society's aspirations to domestic comfort, had already been invented in 1837. The system had come into use in Regency England, in the early 1830s, after it had been patented in 1828 by London upholsterer Samuel Pratt, a manufacturer of field supplies. Armchairs, divans, and sofas then took on a more corpulent look, almost suggesting their comfortableness and the invitation to settle into a relaxed pose, which society had previously frowned upon.

The considerable boost given by Hapsburg economic policy to the Bohemian glass industry from the 1700s had encouraged development of technical research and style. The same qualities distinguished Prussian glass in the Biedermeier period. In Berlin, as in Prague, the refinement of workmanship was testified to by the purity of the crystal glass, the glowing colors, and the tricks of light that rendered the material transparent, translucent, semi-opaque, and opaque. An enormous variety of forms and a multitude of colors were available: delicate floral decoration, glass with geometric patterns, sumptuously cut tableware, valuable goblets

**Vienna Furniture
Factory**
Sofa
c. 1825, mahogany,
maple, beech frame.
Private collection.

**Neue Augsburger
Kattunfabrik**
*Sample of printed
fabrics*
1831–34.
Private collection.

This German cotton
factory was one of the
first, and most famous,
European manufacturers
of fabric printed with
different colored
patterns.

and carafes evoking the precious, glowing compactness of jewels, and vases and bowls of understated linear purity.

Humankind's attitude of affectionate enthusiasm for well-ordered nature, obvious in the passing of the seasons, also suggested new decorative motifs: butterflies, garlands of precious flowers, and tiny wild blossoms appeared increasingly to enhance fabrics, china, jewelry, glassware, and silverware, expressing a familiarity with that much-loved universe, albeit with some preconceptions. From 1815, the potteries of Berlin, Meissen, Nymphenburg, and Vienna used motifs inspired by nature: roses, geraniums, violets, vine leaves, strawberries, ears of corn, carnations, campanulas, and even elaborately structured exotic flowers and carnivorous plants. The range of decoration was thus enriched for cups, ice buckets, coolers, flower vases, and sometimes used as "natural" frames for urban and landscape views, as well as for portraits.

Friedrich Egermann
Glass with lid
1830, marbled glass, gilded bronze. Vienna, Museum of Applied Arts.

The Bohemian Egermann can be thanked for the invention of this type of marbled glass, imitating hardstone; in this case, the violet nuances of the outer surfaces are offset by the deep red interior. The maker was aware of the fabulous quality of the artifact and he donated it to the Vienna Fabriksproduktenkabinet.

Berlin Potteries
Tray, teapot, milk jug
1817–23, porcelain. Berlin, Foundation of Prussian Palaces and Gardens Berlin-Brandenburg.

Items from a tea and coffee service decorated with naturalistic themes by Gottfried Wilhelm Völker.

The Romantic Garden

The design of the romantic garden was influenced by the same empathy with nature. The garden was to be a lovingly conceived place for walking along meandering paths, stumbling on architecture with an ancient feel, statues of more or less integral beauty, and nooks for refuge concealed by dense vegetation. The layout of such parks had not changed since the mid-eighteenth century in England, where the landscape flowed, seemed spontaneous, and cleverly deceptive designs tended to conceal real boundaries. In recent times, however, unexpected meanders led off into winding paths through nature rather than to static contemplation of its beauty. The lawn, once a seamless margin along farmed and wild land, became a place where exotic or native plants and multicolored flowers were grown in regular or even geometric beds, breaking up the carpet of grass, in harmony with a concept of unity conveyed by the variety typical of that time. Hedges formed by different species were left to grow in spontaneously, contributing to the atmosphere of a natural scenario, changing with each season. At times the hedges fenced out areas dedicated to one type of cultivation or another, allowing a fleeting glimpse of the garden, where beds of different flowers

Iᵃ Veduta del Giardino del Cavᵉ Torrigiani, presa dal suo Casino dalla parte di tramontana

Louis Cambray Digny
View of Marquis Torrigiani's Garden from the North Side of His Hunting Lodge
c. 1813, pencil, colored pencil, white paper.
Florence, private collection.

Louis Cambray Digny was the architect of the Regie Fabbriche e Giardini, the Grand Duchy of Tuscany's department of buildings and gardens. For Marquis Pietro Torrigiani he designed a garden set against the city walls of Florence, with naturalistic and architectural elements contributing to the creation of a harmonious environment, in which the spaces for cultivation of rare plants alternate with those set aside for strolling and recreation (as can be seen in the drawing), where the proprietors and the guests gaze in astonished admiration at a rising hot-air balloon.

unfolded, in an ongoing sequence of additions, cadenced as decided by the trends of the day.

Lithographic Printing

By the nineteenth century, artists had attained new levels of knowledge and skill that enabled them to masterfully filter original concepts through secondary techniques—one of the key reasons for the success of lithography during the Restoration period.

Lithographic printing was invented in Munich, in 1796, and became the most popular medium of reproduction, not only because it was relatively simple to achieve, but also because it allowed a revision of an initial idea, adding, correcting, and changing without compromising the final outcome.

The process, which is founded on the incompatibility of water and oily substances, was quite similar to the process used for drawing on paper, but the artist obviously worked on stone. The relative ease of the process made lithography the most suitable means for reproducing art images and illustrations for books, journals, and satirical newspapers, published in increasing

Jean-Baptiste-Adolphe Lafosse
Little Girl
c. 1840, etching with watercolor.
Florence, Pitti Palace.

Gaetano Baccani
Torrino
1821.
Florence, Torrigiani
Garden.

Baccani took over from Cambray Digny in the design of the Torrigiani gardens and he added this small tower, brimming with the evocative feel of a bygone era, simultaneously an emblem of the family and a turreted belvedere over Florence.

numbers during the nineteenth century. It was thanks to this technique that periodicals like *Punch* and *Charivari* achieved their fame. After 1815, when the first printers appeared in France, so many lithographers opened shop that the business was regulated by specific laws. For example, when an artist's work was reproduced as a lithograph, the name of the artist had to be stated, as did that of the draftsman who had transposed the image onto the stone. This added further value to the lithograph, which soon became a work of art in itself, able to replace the real artwork. While the lithograph was seen as a pleasing change from an oil painting in the bourgeois home and was perhaps used to decorate private areas (but not reception rooms, because of its relatively low cost), it became an ornament in less wealthy, less fashionable households, sometimes reproducing religious subjects or touching genre scenes. So the lithographic album was invented, with a set of images and short captions, offering information, or the chance to dream about exotic destinations, the world's remotest places, and animals unknown to most folk. These fascinating volumes were "dreams of escape" that could be enjoyed in the quiet of the fireside, while one leafed through the pages, often rendered even more attractive and striking by color illustrations (Mosco 1989, 15).

Charles Burton Barber
Bird's-eye View of the Palace of Industry of All Nations
Etching with watercolor, printed in London, 1851 by
Ackerman, published in the volume *The Kensington Gardens*.
London, Guildhall Library, Corporation of London.

The 1851 Expo

In 1851, one of the best-known European lithographic printers, Frenchman Rose-Joseph Lemercier, who produced the illustrations used for leading magazines like *L'Artiste* and *La Gazette des Beaux-Arts*, was awarded a gold medal at the London World Exhibition. This was the first European event to represent the myriad industrial products and artistic items from manufacturers worldwide. To allow the best possible arrangement of such a large quantity of machinery and applied art objects, a monumental cast iron and glass building, the Crystal Palace, was erected, expressing early nineteenth-century society's immense confidence in the industrial and scientific world. The expression of modernity voiced by Joseph Paxton's creation was such that at the end of the event it was dismantled and rebuilt at Sydenham Hill, installed in a park, and opened to the public in 1854 by Queen Victoria in person.

Alexandre-Marie Colin
(engraver Emilien
Desmaisons)
Tendre Amitié
1846, etching with
watercolor, printed in
Paris by Lemercier.
Florence, Pitti Palace.

Philipp Henry
Delamotte
*Tropical Plants in
Crystal Palace Egyptian
Pavilion*
1854, photograph.
Stapleton Collection.

Lifestyles *in the Romantic Period*

Bibliography

Antonio Canova. Venice: Marsilio, 1992. An exhibition catalog (Museo Correr, Venice, Mar.–Sept. 1992).

APOLLONI, MARCO FABIO. "Canova." Dossier in *Art e Dossier*, no. 68 (May 1992).

———. "Ingres." Dossier in *Art e Dossier*, 86 (Jan. 1994).

Bard Graduate Center for Studies in the Decorative Arts and Metropolitan Museum of Art, ed. *Vasemania. Neoclassical Form and Ornament in Europe, Selections from the Metropolitan Museum.* New Haven and London: Yale University Press, 2004. An exhibition catalog (Bard Graduate Center for Studies in the Decorative Arts, New York, Jul.–Oct. 2004).

BAUDELAIRE, CHARLES. *L'opera e la vita da Eugène Delacroix*. Torino: Einaudi, 1981.

BIETOLETTI, SILVESTRA, AND MICHELE DANTINI. *Ottocento italiano*. Florence: Giunti, 2002.

BOSSI, MAURIZIO, AND GIANCARLO GENTILINI, eds. *La Grande Storia dell'Artigianato: L'Ottocento*. Florence: Giunti, 2001.

BRIGANTI, GIULIANO, ed. *Romanticismo. Il nuovo sentimento della natura*. Milan: Electa, 1993. An exhibition catalog (Palazzo delle Albere, Trento, May–Aug. 1993).

Carl Blechen. Zwischen Romantik und Realismus. Munich: Prestel, 1990. An exhibition catalog (Nationalgalerie, Berlin, Aug.–Nov. 1990).

CASTELNUOVO, ENRICO, AND GIUSEPPI SERGI, eds. *Il Medioevo al Passato e al Presente, Arti e Storia nel Medioevo, IV*. Torino: Einaudi, 2004.

CAVINA, ANNA OTTANI, ed. *Un paese incantato. Italia dipinta da Thomas Jones a Corot*. Milan: Electa, 2002. An exhibition catalog (Mantua, Paris).

CHIARINI, PAOLO, ed. *Il paesaggio secondo natura. Jacob Philipp Hackert e la Sua Cerchia*. Rome: Artemide Edizioni, 1994. An exhibition catalog (Palazzo delle Esposizioni, Rome, Jul.–Sept. 1994).

CISERI, ILARIA. *Il Romanticismo: 1780–1860. La nascita di una nuova sensibilità*. Milan: Mondadori, 2003.

DELLA PERUTA, FRANCO, AND FERNANDO MAZZOCCA, eds. *Napoleone e la Repubblica italiana*. Milan: Skira, 2002. An exhibition catalog (Tonda della Bovisa, Milan, Nov. 2002–Feb. 2003).

DI MAJO, ELENA, BJARNE JØRNAES, AND STEFANO SUSINNO, eds. *Bertel Thorvaldsen 1770–1844: Scultore Danese a Roma*. Rome: De Luca, 1989. An exhibition catalog (Galleria Nazionale d'Arte Moderna, Rome, Nov. 1989–Jan. 1990).

GABETTI, ROBERTO. "L'Architettura Italiana del Settecento," in *Storia dell'arte italiana* vol. VI, second part. 1982.

GIZZI, CORRADO, ed. *Flaxman e Dante*. Milan: Mazzotta, 1986. An exhibition catalog (Torre de' Passeri, Castello Gizzi, Sept.–Oct. 1986).

GODI, GIOVANNI, AND CARLO SISI, eds. *La tempesta del mio cor. Il gesto nel melodramma dale arti figurative al cinema*. Milan: Mazzotta, 2001. An exhibition catalog (Voltoni del Guazzatoio, Parma, May–Jun. 2001).

HEILMANN, CHRISTOPH, ed. *Johan Christian Dahl 1788–1857: Ein Malerfreund Caspar Dad Friedrichs*. Munich: Lipp, 1988. An exhibition catalog (Neue Pinakothek, Munich, Nov. 1988–Jan. 1989).

HIMMELHEBER, GEORG. *Biedermeier 1815–1835*. Munich: Prestel, 1989.

HOFFMANN, WERNER. *Dal Neoclassicismo al Romanticismo 1750–1830*. Italian ed. Milan: Rizzoli, 1996.

HONOUR, HUGH. *Neo-classicism*. Harmondsworth: Penguin, 1968.

Important French Furniture and Clocks. Catalog from Sotheby's Auction, London, June 15, 1990.

KOERNER, JOSEPH LEO. *Caspar David Friedrich and the Subject of Landscape*. London: Reaktion Books, 1990.

LEYMARIE, JEAN, ed. *David e Roma*. Rome: De Luca, 1981. An exhibition catalog (Accademia di Francia, Rome, Dec. 1981–Feb. 1982).

LISTER, RAYMOND. *The Paintings of Samuel Palmer*. Cambridge: Cambridge University Press, 1985.

LOMBARDI, LAURA. *I Macchiaioli prima dell'impressionismo*. Eds. Fernando Mazzocca and Carlo Sisi. Venice: Marsilio, 2003. An exhibition catalog (Palazzo Zabarella, Padua, Sept. 2003–Mar. 2004).

LUNA, JUAN JOSÉ, AND MARGARITA MORENO DE LAS HERAS, eds. *Goya: 250 Aniversario*. Madrid, 1996. An exhibition catalog (Prado, Madrid, Mar.–Jun. 1996).

Maestà di Roma. Universale ed Eternal Capitale delle Arti: Da Ingres a Degas. Milan: Electa, 2003. An exhibition catalog (Accademia di Francia, Rome, Mar.–Jun. 2003).

Maestà di Roma. Universale ed Eternal Capitale delle Arti: Da Napoleone all'Unità d'Italia. Milan: Electa, 2003. An exhibition catalog (Galleria Nazionale d'Arte Moderna, Rome, Mar.–Jun. 2003).

MARCENARO, GIUSEPPE, AND PIERO BORAGINA, eds. *Viaggio in Italia: Un corteo magico dal Cinquecento al Novecento.* Milan: Electa, 2001. An exhibition catalog (Palazzo Ducale, Genoa, Mar.–Jun. 2001).

MATTEUCCI, GIULIANO, ed. *Aria di Parigi nella pittura italiana del secondo Ottocento.* Torino: Allemandi, 1998. An exhibition catalog (Villa Mimbelli, Livorno, Dec. 1998–Mar. 1999).

MAZZOCCA, FERNANDO. *Francesco Hayez.* Milan: Electa, 1994.

———. "Neoclassicismo." Dossier in *Arte e Dossier* 178 (May 2002).

MAZZOCCA, FERNANDO, ENRICO COLLE, ALESSANDRO MORANDOTTI, AND STEFANO SUSINNO, eds. *Il Neoclassicismo in Italia da Tiepolo a Canova.* Milan: Skira, 2002. An exhibition catalog (Palazzo Reale, Milan, Mar.–Jul. 2002).

METKEN, GÜNTER. *I Nazareni a Roma.* Eds. Gianna Piantoni and Stefano Susinno. Rome: De Luca, 1981. An exhibition catalog (Galleria Nazionale d'Arte Moderna, Rome, Jan.–Mar. 1981).

MOSCO, MARILENA, ed. *Carte Dipinte. Esotismo e Intimismo nell'Ottocento Francese.* Milan: ArtWorldMedia, 1989. An exhibition catalog (Andito degli Angiolini, Florence, Dec. 1989–Mar. 1990).

NORMAN, GERALDINE. *Biedermeier Painting 1815–1848.* London: Thames and Hudson, 1987.

OTTANI CAVINA, ANNA. "Il Settecento e l'Antico," in *Storia dell'arte italiana* vol. VI, second part. 1982.

PARINAUD, ANDRÉ. *Barbizon: Les Origines de l'Impressionisme.* Vaduz: Bonfini, 1994.

PETRUSA, MARIANTONIETTA PICONE, ed. *Dal Vero. Il paesaggio napoletano da Gigante a De Nittis.* Torino: Allemandi, 2002. An exhibition catalog (Palazzo Cavour, Turin, Apr.–Jul. 2002).

PIANTONI, GIANNA, AND STEFANO SUSINNO, eds. *I Nazareni a Roma.* Rome: De Luca, 1981. An exhibition catalog (Galleria Nazionale d'Arte Moderna, Rome, Jan.–Mar. 1981).

POULET, ANNE. *Jean-Antoine Houdon (1741–1828): Sculptor of the Enlightenment.* Washington, D.C., Chicago, and London: University of Chicago Press, 2003. An exhibition catalog (National Gallery, Washington, D.C., May–Sept. 2003).

ROPELLE, CHRISTOPHER, et al., eds. *Portraits by Ingres. Image of an Epoch.* New York: Metropolitan Museum of Art, 1999. An exhibition catalog (National Gallery, London; National Gallery of Art, Washington, D.C.; Metropolitan Museum of Art, New York, Jan. 1999–Jan. 2000).

ROSSI PINELLI, ORIETTA. *Il secolo della ragione e delle rivoluzioni.* Torino: UTET, 2000.

———. "Piranesi." Dossier in *Art e Dossier* 186 (Feb. 2003).

SISI, CARLO. "Temi Anacreontici," in *Maestà di Roma: Universale ed Eterna Capitale delle Arti. Da Napoleone all'Unità d'Italia.* Milan: Electa, 2003. An exhibition catalog (Galleria Nazionale d'Arte Moderna, Rome, Mar.–Jun. 2003).

SPALLETTI, ETTORE. *La carità educatrice di Lorenzo Bartolini,* in *Palazzo Pitti. La reggia rivelata* Eds. Gabriella Capecchi, Amelio Fara, Detlef Heikamp, and Vincenzo Saladino. Florence: Giunti, 2003. An exhibition catalog (Palazzo Pitti, Florence, Dec. 2003–Jan. 2005).

SPINOSA, NICOLA, ed. *All'Ombra del Vesuvio. Napoli nella veduta europea dal Quattrocento all'Ottocento.* Naples: Electa Napoli, 1990. An exhibition catalog (Castel Sant'Elmo, Naples, May–Jul. 1990).

Théodore Chassériau (1819–1854). Un autre romantisme. Paris: Reunion de Musées Nationeaux, 2002. An exhibition catalog (Galeries Nationales du Grand Palais, Paris; Metropolitan Museum of Art, New York).

TOMAN, ROLF, ed. *Neoclassicismo e Romanticismo. Architettura. Scultura. Pittura. Disegno 1750–1848.* Köln: Konemann, 2000.

WEIDNER, THOMAS, ed. *Jacob Philipp Hackert. Paesaggi del Regno.* Rome: Artemide, 1997. An exhibition catalog (Palazzo Reale, Caserta, Oct. 1997–Jan. 1998).

WILKIE, ANGUS. *Biedermeier.* New York: Cross River Press, 1987.

WILTON, ANDREW, AND ILARIA BIGNANINI, ed. *The Lure of Italy in the Eighteenth Century.* London: Tate Gallery Publishing, 1996. (Tate Britain, London, 1996; Palazzo delle Esposizioni, Rome, 1997).

ZANGHERI, LUIGI. *Storia del Giardino e del Paesaggio. Il Verde nella Cultura Occidentale.* Florence: Olschki, 2003.

Bibliography

Index

Index/Photo Credits

Photo Credits

© Archivio Giunti, Firenze; The Bridgeman Art Library/Alinari, Firenze; Corbis; Erich Lessing/Contrasto; Rabatti & Domingie Photography, Firenze.
Works from Italian State galleries and museums are reproduced by permission of the Ministry for Cultural Heritage and Actvities.
Front cover: © Archivi Alinari, Firenze (with permission from the Ministry for Cultural Heritage and Activities)
Back cover: © Erich Lessing/Contrasto
The publisher is prepared to fulfill any legal obligation regarding those images for which a source could not be found.